IMAGES
of America

PARKLAND HOSPITAL

ON THE COVER: The original Parkland Hospital was built at Oak Lawn and Maple Avenues in 1894. At far right, the Dallas city health officer, Dr. John Hicks Florence, is greeting nurses who are bringing in a patient from the city's first ambulance. The Florence family, shown on the front porch, lived on the first floor of the hospital in 1898. (Courtesy of the Dallas Public Library, Texas and Dallas History and Archives Division.)

IMAGES
of America

PARKLAND HOSPITAL

John W. Boyd, MD

ARCADIA
PUBLISHING

Published by Arcadia Publishing
Charleston, South Carolina

Library of Congress Control Number: 2015950115

For all general information, please contact Arcadia Publishing:
Telephone 843-853-2070
Fax 843-853-0044
E-mail sales@arcadiapublishing.com
For customer service and orders:
Toll-Free 1-888-313-2665

Visit us on the Internet at www.arcadiapublishing.com

This book is dedicated to the hundreds of men and women who have made Parkland Hospital and UT Southwestern Medical Center such an important part of Dallas history. It is not the brick buildings but the people who make this a great place of caring, research, and education.

CONTENTS

ACKNOWLEDGMENTS

It is impossible to honor all the people who made Parkland Hospital and Southwestern Medical School what they are today within the confines of a 128-page book. Hundreds of doctors, nurses, technicians, instructors, laboratory workers, residents, researchers, and community leaders deserve credit—many of them deserve their own books. The hospital's success also stemmed from thousands of dedicated employees ranging from administrators and accountants to engineers and maintenance staff. This book touches on only a few of those remarkable personalities.

This collection of historical images and stories would not have been possible without considerable assistance and support. Parkland's stories took place over several decades and are archived in many different locations and collections, some quite remote from Dallas. Pulling together such a rich 120-year history proved to be a far greater task than I envisioned at the onset. My sincere thanks and appreciation to the following individuals, libraries, universities, museums, and businesses for their contributions: Cameron Kainerstorfer, Krishna Shenoy, Genevieve Quick, April Foran, Adrianne Pierce, Cathy Spitzenberger, and Ben Rogers. Equally important in providing guidance and inspiration were Dr. John F. Harper and Thomas W. Mayo with the Literature + Medicine Conference in Dallas, Texas. Sara Miller, Mike Kinsella, and Stacia Bannerman, from Arcadia Publishing, helped guide me through the complexities of transforming stories and photographs into an actual printed book. Skeeter Hagler, Stephen Fagin, Mark Davies, Gary Mack, Catherine Bradley, Frank Trejo, Andrew Wayne, Mark Mathews, and Mark Foster were also instrumental in the completion of *Parkland Hospital*.

Finally, very special thanks to my family—Becky, George, and Maggy—for their encouragement and support.

The images in this volume appear courtesy of:

Parkland Health and Hospital System (PH)
University of Texas Southwestern Medical Center (UTSW)
The Sixth Floor Museum at Dealy Plaza (SFM)
Dallas Times Herald (DTH)
Fort Worth Star-Telegram (FWST)
Old Parkland (OP)
Dallas Public Library, Texas and Dallas History and Archives Division (DPL)
University of Texas at Arlington Libraries, Special Collections (UTA)
W.R. Poage Legislative Library, Baylor University (BU)
John F. Kennedy Presidential Library & Museum (JFK)
Author's collection (JWB)

Other photographers and image providers are indicated in the courtesy lines that follow the captions.

INTRODUCTION

In 1890, Dallas was home to one automobile and had no paved roads. Electricity, telephones, public schools, and sewer lines had only recently arrived. The town of about 38,000 was best known as a horse-trading town and the buffalo-hide capital of the world, and it was not known for its healthcare. Doctors on horseback, often with little training and no real medicines to offer, delivered what healthcare they could. Newspapers advertised snake oil and sarsaparilla cures for jaundice, indigestion, headaches, and hemorrhages. A single pill promised to "restore the vigor of men" and "relieve the nervousness of each monthly period" for women. The city-run hospital was a converted house in an "inconvenient and unsavory part of town." The city's sewage and ventilation were unreliable, and the hospital had no employed nurses. The *Dallas Almanac* described it as a place only for the "down and outers, the friendless, and emergency cases." The city also maintained "pest houses," where individuals and families thought to be contagious were housed, often against their will. With no medical care to offer, admission to the pest house was often a one-way ticket.

In 1894, the building of Parkland Hospital marked the start of modern healthcare in Dallas. Upon its completion, it was hailed as "the most substantial, capacious, and elegant hospital in the state." Doctors and nurses there primarily provided care for Dallas County's most needy, but they also accepted paying patients. By 1900, Dallas was expanding, as was understanding of health and disease. Surgical procedures and new medicines arrived on the scene, and the germ theory of disease became accepted. In what would become the first of many Parkland rebirths, voters approved a bond to create a new hospital. The 1913 brick Parkland Hospital was again hailed as the finest hospital in Texas, and that building still stands today.

Many medical schools came and went in early Dallas, with most schools dismissed as inferior in a 1910 review. Dr. Edward H. Cary became dean of the University of Dallas Medical Department and helped reorganize it into the Baylor College of Medicine in 1902. Parkland aligned itself with that medical school and staffed the hospital with its medical residents. That alignment helped Parkland provide the best, most modern medicine to its indigent patients, and it helped students at the medical school to get exposure to clinical patients during their training. Baylor Medical College of Medicine eventually reached a decision to leave Dallas in 1943. That same year, the Southwestern Medical Foundation, under the direction of Dr. Cary, made a dramatic and difficult decision; the foundation created, started, staffed, and chartered a new Southwestern Medical School within a few months. This had never been done before and has never been attempted again. It proved to be an interesting mix of creative thinking, very high medical standards, and funding from the business leaders of Dallas. The result was a medical school with one of the most stellar reputations for turning out bright graduates and world-renowned research and providing high-quality care for those in the Dallas area. Southwestern became affiliated with the University of Texas System in 1949. By the 1950s, age had once again caught up with Parkland and the associated Southwestern Medical School, which was still housed in temporary quarters. In 1954, Parkland Hospital relocated to a new facility on Harry Hines Boulevard, and Southwestern followed it in 1955.

The year 1963 proved to be a dark time for Dallas, which was forever branded as the city where Pres. John F. Kennedy was killed. The events at Parkland following the Kennedy assassination have filled many books and movies. Even today, new information continues to emerge and shed light on the events of that tragic day in November. After 1964, both Southwestern Medical School and Parkland entered a period of robust growth, matching that of Dallas, which then had a population of 500,000. Between 1955 and 2005, Southwestern expanded from two buildings to over 55 buildings on four campuses spread across 11.2 million square feet. Along the way, it nurtured six Nobel Laureates (more than any other teaching facility in the United States) and 23 members of the National Academy of Sciences. The full-time faculty grew to 2,360, with 959 medical school students and over 1,500 medical residents. Parkland developed the emergency room triage system now used throughout the world. It opened the first high-risk maternity unit in the nation and is home to one of the largest civilian burn units in the country.

In 2014, another defining time began for UT Southwestern, Parkland Hospital, and the original Parkland campus. The medical school closed its 50-year-old St. Paul Hospital in late 2014 and relocated 200 patients and services to the new 12-story, 460-bed, state-of-the-art William P. Clements Jr. University Hospital. In 2015, Parkland relocated across the street to a new campus, which has 862 private patient rooms and spreads across 2.5 million square feet, making it one of the largest hospitals in the world under one roof. The 1913 Parkland Hospital is also getting a significant renovation as it becomes one of Dallas's most distinguished addresses. After decades of sitting abandoned and neglected, "Old Parkland" was meticulously restored by Crow Holdings over the course of a nine-year project completed in 2015.

One

Parkland Hospital
Is Born, 1894

In 1890, the Dallas population was 38,067, with another 22,000 residing in the surrounding county. Horses were the primary mode of transportation, most roads were dirt, and electricity was a relatively new novelty. The practice of medicine was a crude frontier art with unregulated medical training that often lasted for a year or less. With few real medications, no vaccines, and no antibiotics, even the finest doctor had little to offer his patients. Popular treatments of the day included calomel (mercury chloride) and small doses of arsenic. The germ theory was still just a theory. Surgical death rates were over 50 percent, and appendicitis was usually a fatal disease. Most of those receiving blood transfusions died. Anyone who registered with the Dallas city health officer as a doctor could practice medicine—no degree or proof of training was required.

In 1872, Dallas opened its first city hospital in the red-light district at Wood and Houston Streets. The three doctors who worked there asked only to be reimbursed for their supplies in exchange for caring for the city's poor. Two years later, it was relocated to a 25-by-50-foot house at Columbia Avenue and South Lamar Street. Male, female, and pediatric patients were all housed in a common 18-bed ward, which also served as the operating room. There were no nurses, and the only medical equipment was what the doctor brought in his bag. A city inspector declared the premises, which had no window screens and unreliable sewage, to be "in a filthy sodden condition." In 1893, Dallas voters approved a $40,000 bond to build the new and modern city hospital that would become Parkland.

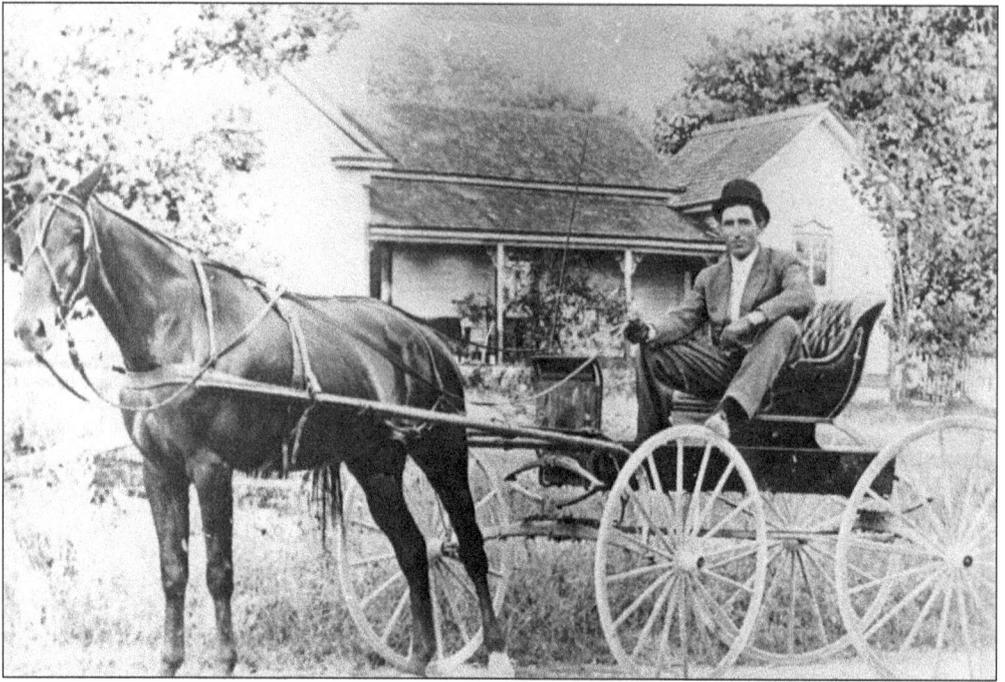

Dr. Wayne Robinson, a Horse-and-Buggy Doctor. In the 1890s, most who could afford medical care had a doctor visit their house. Hospitals were believed to be for the penniless, friendless, and those lacking a family. Dr. Robinson is said to have delivered 10,000 babies in his career. (PH.)

THE NEW PARKLAND HOSPITAL, DALLAS, TEXAS.

SURGICAL STAFF.

DR. A. M. ELMORE,
Assistant Surgeon.

DR. V. P. ARMSTRONG, Surgeon in Charge.

DR. J. R. BRIGGS,
Consulting Eye, Ear, Nose and Throat Surgeon.

DR. M. M. EDMONSON,
Consulting Orthopœdic Surgeon.

The most substantial, capacious and elegant Hospital in the State. All the modern improvements. For particulars see page 133. For terms of admission and particulars, as to surgical cases, Address, Dr. V. P. Armstrong, Surgeon in Charge, Dallas, Texas.

Advertisement for Parkland Hospital. In 1893, Dallas voters approved a $40,000 bond to build a new city hospital. The hospital was constructed on a 17-acre park at Oak Lawn and Maple Avenues, and thus called Parkland. The hospital's advertisements boasted, "Every room and ward supplied with hot and cold water and a bath tub. It has a complete and perfect system of electric lights." At the time, Parkland was considered to be well out in the country. (PH.)

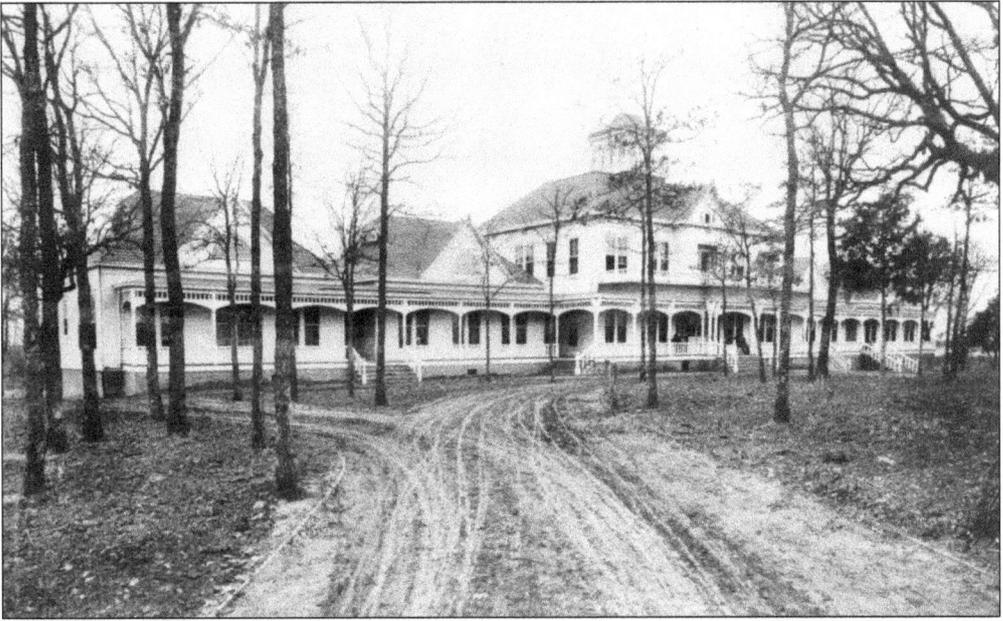

PARKLAND HOSPITAL OPENS ON MAY 19, 1894. The hospital opened with six separate wards, including one for women, children, and—as was the custom of the day—blacks. Although it primarily served as a charity hospital, the second floor was reserved for paying citizens. The rooms on the second floor resembled hotel rooms more than wards and charged $7 to $12 per week for room, food, medicine, and nurse care. *Dallas Magazine* called Parkland "the most substantial, capacious and elegant hospital in the state." (DPL.)

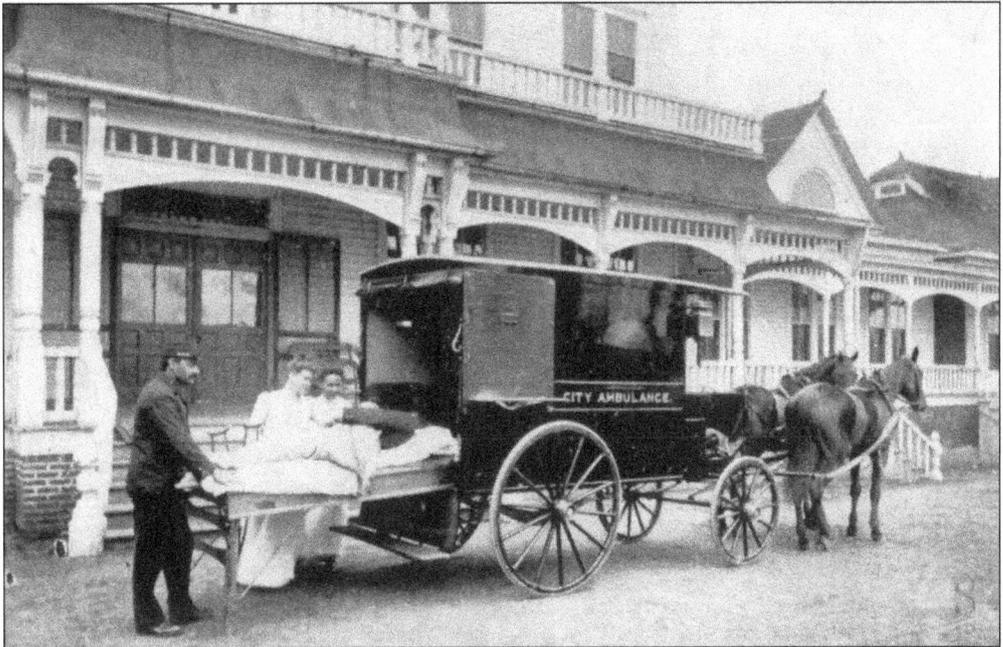

THE CITY'S FIRST AMBULANCE. Nurses are shown bringing in a patient from the hospital's first ambulance, a horse-drawn wagon purchased in 1894. In 1899, they added rubber tires to the carriage "as a necessary act of humanity." (OP.)

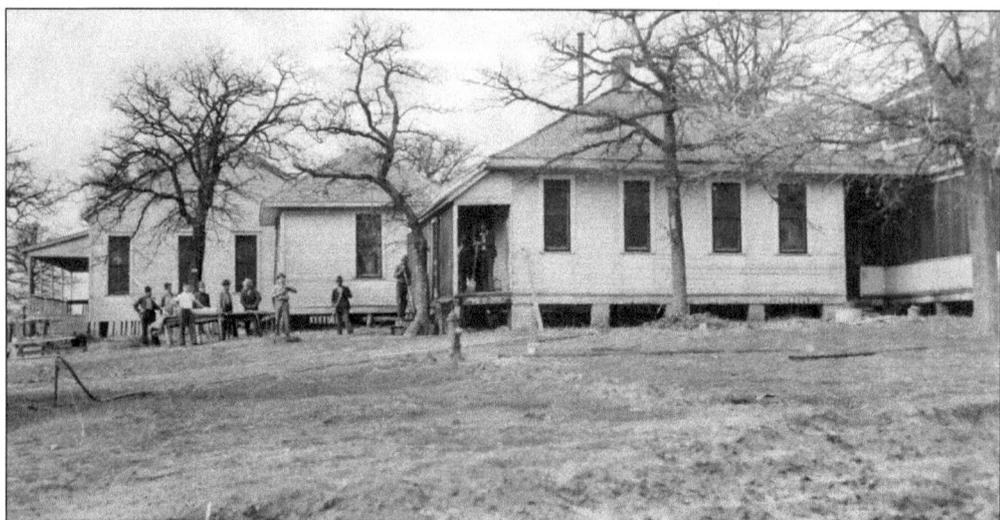

WOODLAWN HOSPITAL. Woodlawn Hospital opened about a mile west of Parkland in 1913, replacing the Union Hospital. It primarily served as an isolation hospital for patients with tuberculosis and smallpox. Medical students, interns, and student nurses from Parkland also rotated through Woodlawn. The Union and Woodlawn Hospitals replaced the city-operated pest houses, where those believed to be contagious or infectious were gathered up and housed, sometimes with their families. The primary goal of the pest houses was to remove contagious people from public spaces; these houses did not provide any medical care. (DPL.)

BABY CAMP ON PARKLAND CAMPUS, 1914. Around 1913, nurse Mary Foster Smith began the Dallas Graduate Nurses Baby Camp. The camp had tents on the Parkland campus, where the nurses offered medical care to infants from poor families. In 1914, the tents were replaced with the cottage shown here. The baby camp is considered to be the origin of the Children's Medical Center of Dallas. (PH.)

RADIOLOGY EXAM
ROOM. X-ray
equipment was
cutting-edge
technology in the
early 1900s. (UTSW.)

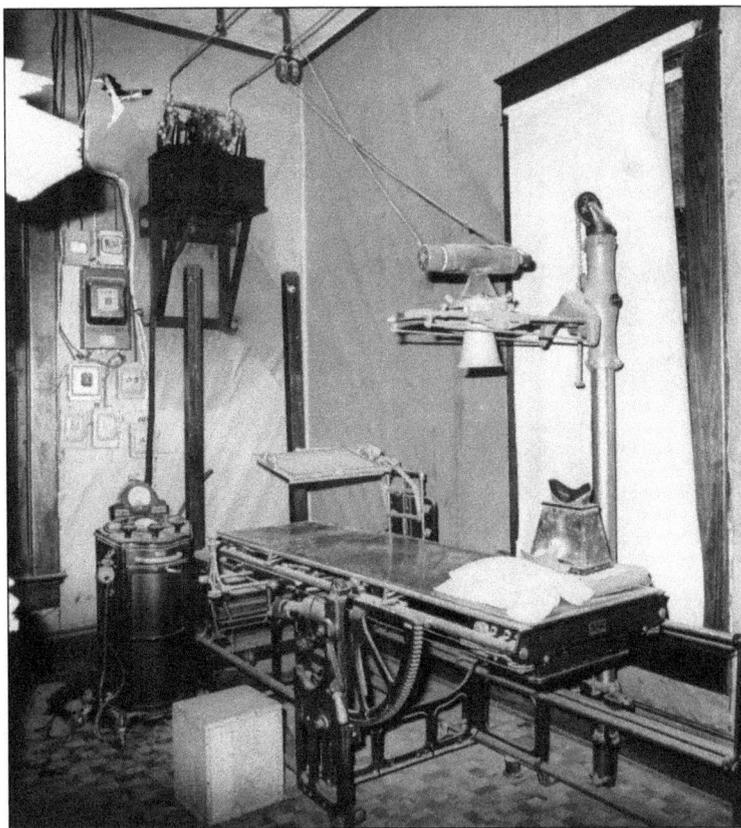

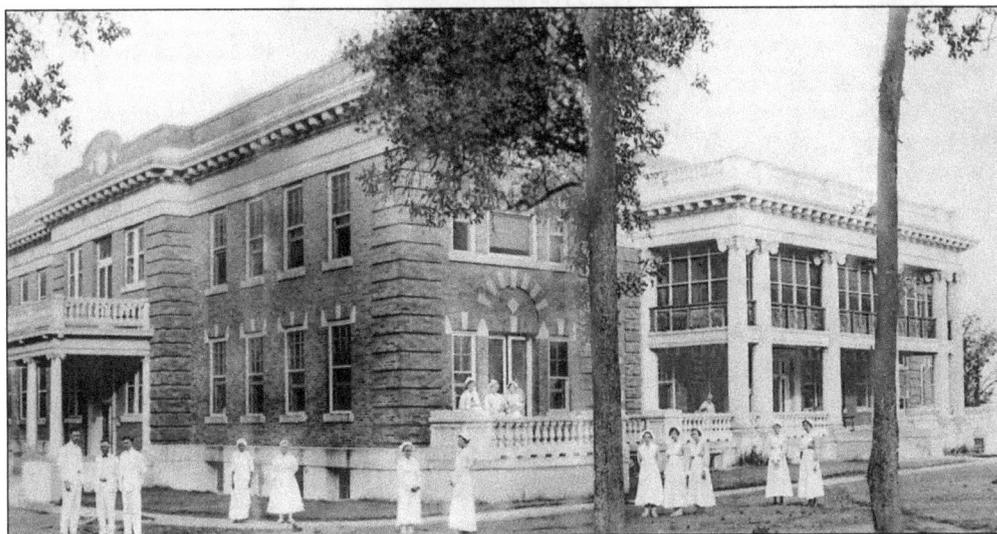

OPENING DAY, FEBRUARY 1, 1914. By 1910, the Dallas Medical Society had dismissed the original Parkland Hospital wooden structure as "outdated, without modern construction, unsanitary and insecure against wind and fire." In 1911, a meningitis epidemic overwhelmed the hospital's capacity. After passage of a $100,000 bond in 1913, the cornerstone for the new Parkland was laid on March 18, and a new brick Parkland Hospital opened on February 1, 1914. The old, wooden Parkland continued to serve as an isolation hospital until it was destroyed by fire in 1918. (OP.)

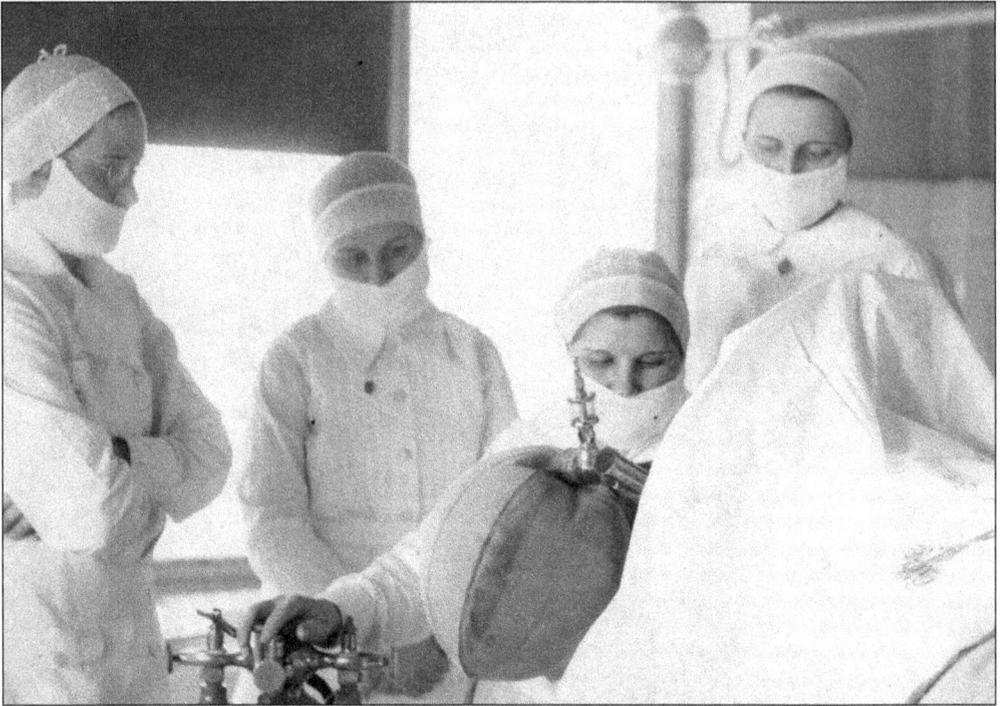

OPERATING ROOM. Nurses observe a surgical patient being anesthetized. (UTSW.)

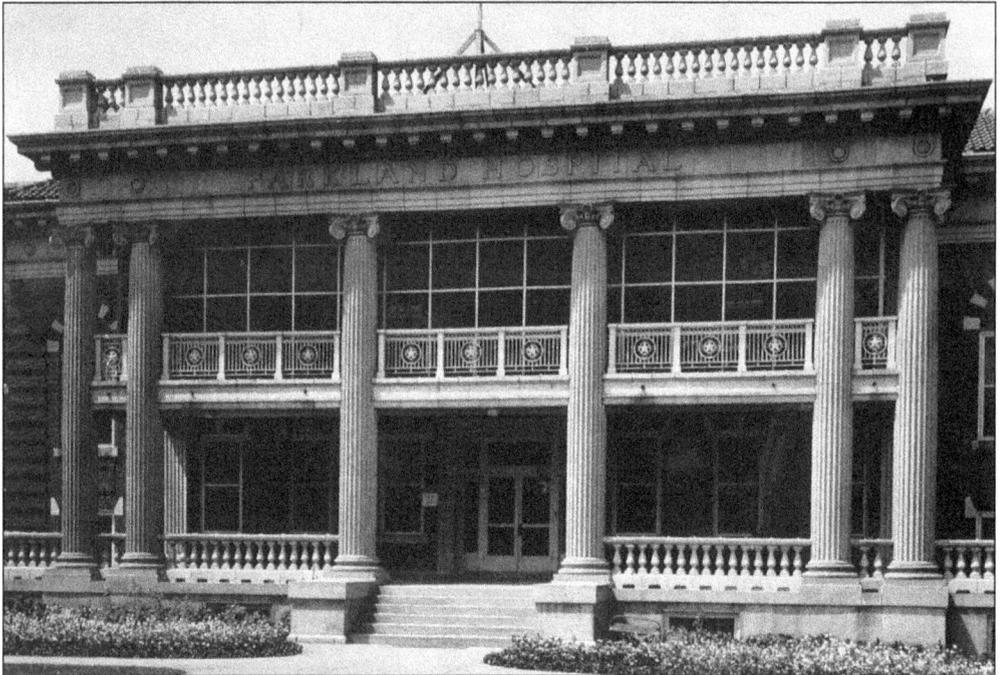

PARKLAND'S FRONT ENTRANCE. Herbert Greene designed the 1913 Parkland Hospital in a classic Revival style with Georgian influence. Both the hospital and the landscaped grounds were a strong statement of style for Dallas. By 1936, all of the original wooden Parkland buildings had been replaced by brick structures. (PH.)

PARKLAND GROUNDS. This walkway led from the Nurses Quarters to Parkland Hospital. The trees and landscaping of the Parkland campus were very elegant for a public hospital. (UTSW.)

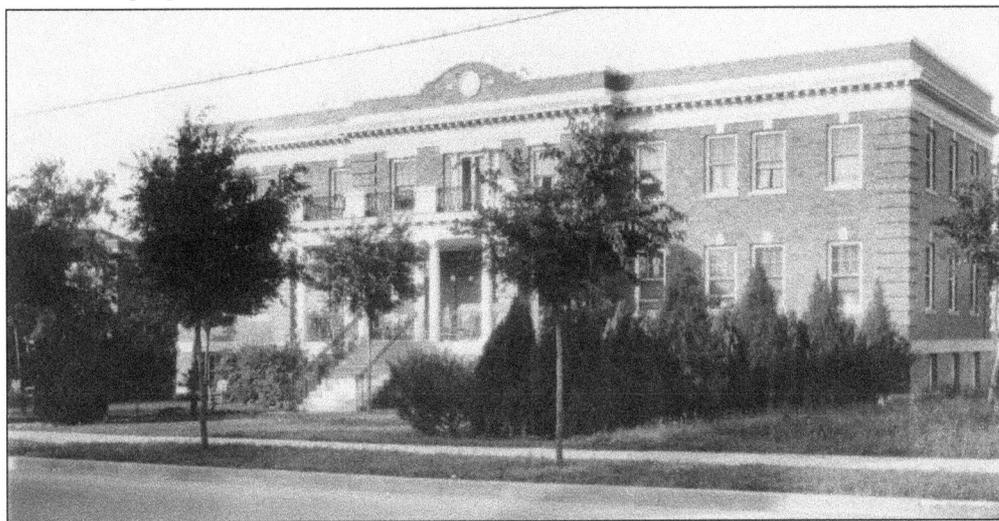

NURSES QUARTERS ON PARKLAND CAMPUS. The same year the new hospital opened, in 1914, the Parkland School of Nursing started. At the time, it was common for nursing schools to be affiliated with hospitals rather than universities. Hospitals routinely provided room and board for nurses and nursing students. The Nurses Quarters were completed in 1921, and a third story was added in 1930. About 35 female nurses resided on each floor and shared a single telephone. The housemother maintained strict curfew hours for the nurses. (DPL.)

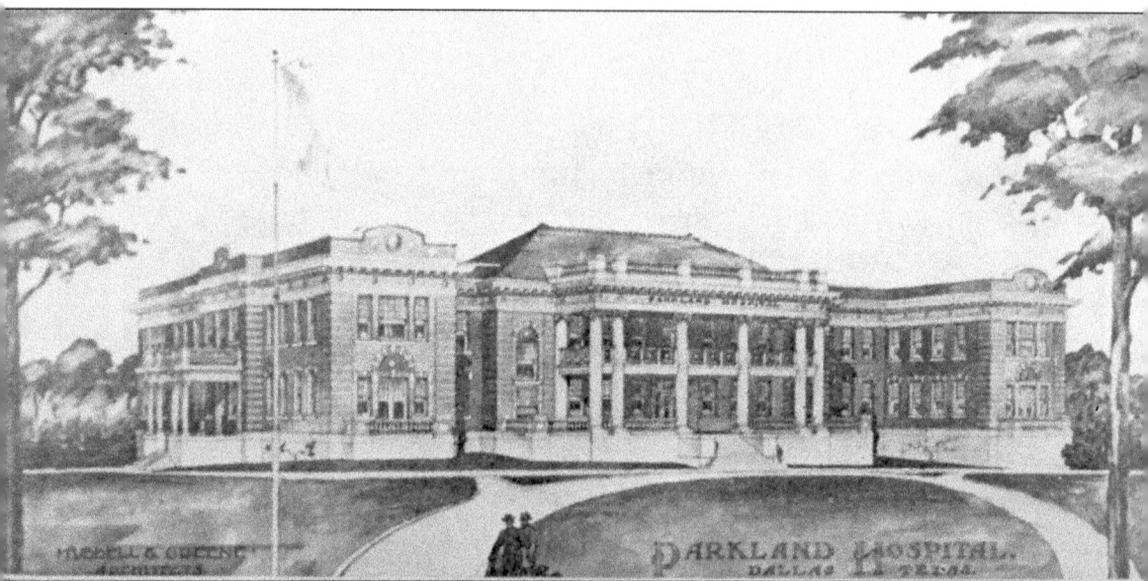

Parkland Hospital. Completed Dec. 1, 1913.

PARKLAND HOSPITAL POSTCARD. After the new Parkland Hospital was officially completed in December 1913, it primarily served the city's poor. In the 1930s, the Great Depression resulted in overcrowding and overworked staff at Parkland as the area's indigent population grew. Emergency-room visits swelled from about 10,000 in 1930 to over 94,000 by 1937. By then, the hospital had expanded to include 338 beds and 36 bassinets (nursery beds). (OP.)

BAYLOR SCHOOL OF MEDICINE RESIDENTS AT PARKLAND. A major milestone in Parkland's history came in 1916, when the Parkland Hospital and the Baylor School of Medicine agreed that Baylor would provide half of the hospital's staff. The other half of the staff consisted of Dallas County Medical Society members in "good standing." (DPL.)

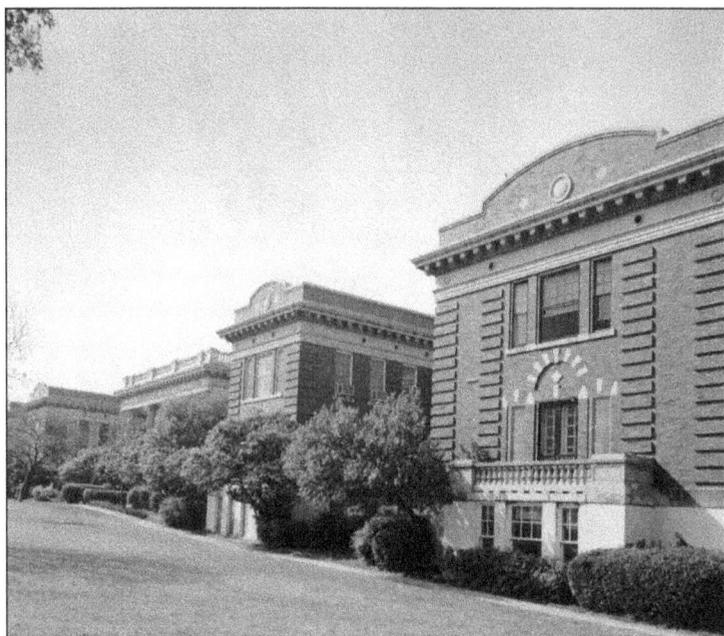

SIDE VIEW OF PARKLAND EXPANSION. As the hospital's patient population increased, Parkland constructed expansion wings on both the east and west sides in the 1920s and 1930s. (UTSW.)

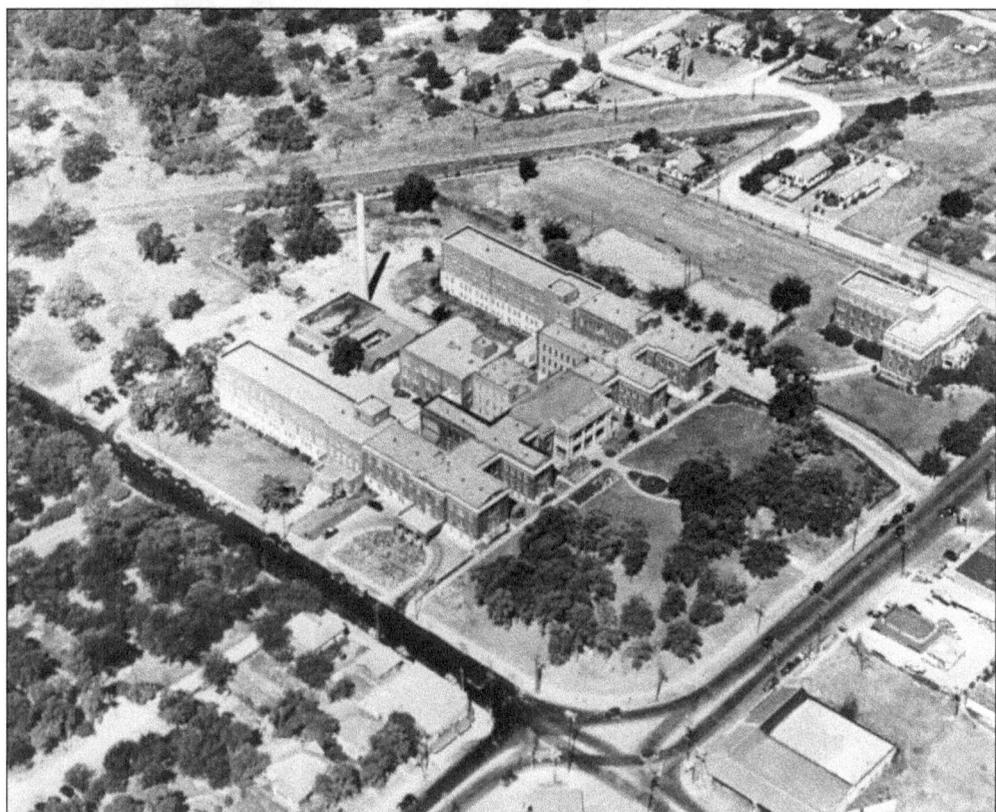

AERIAL VIEW, C. 1940. The Parkland campus expanded dramatically between 1914 and the 1940s. The Baylor School of Medicine remained in a separate facility several miles east of the hospital. (UTA.)

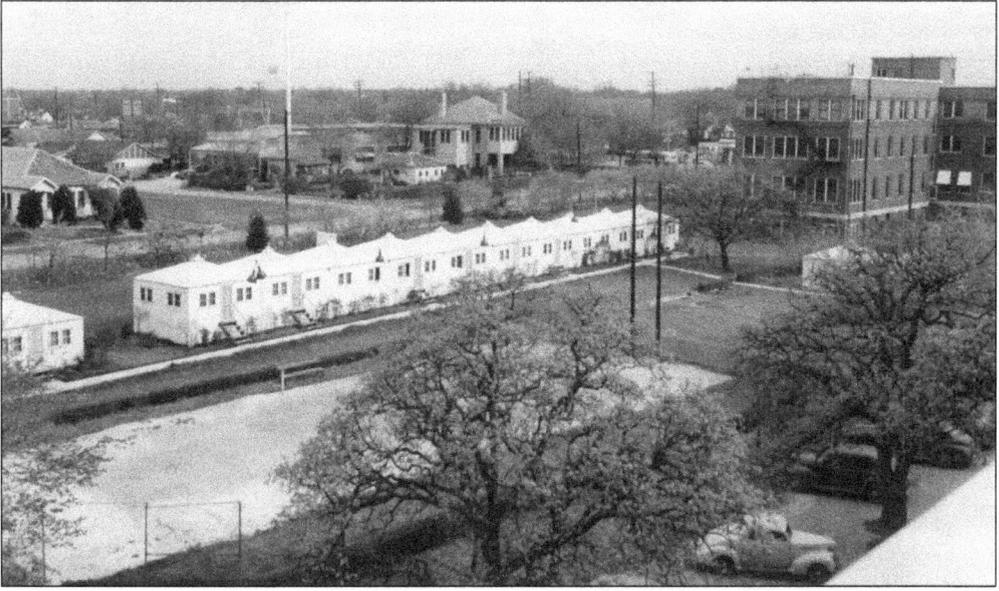

VICTORY HUTS BEHIND PARKLAND, C. 1945. Prefabricated temporary housing was built behind the Parkland Nurses Quarters for injured servicemen returning from World War II. These huts later served as overflow housing for nurses. (UTSW.)

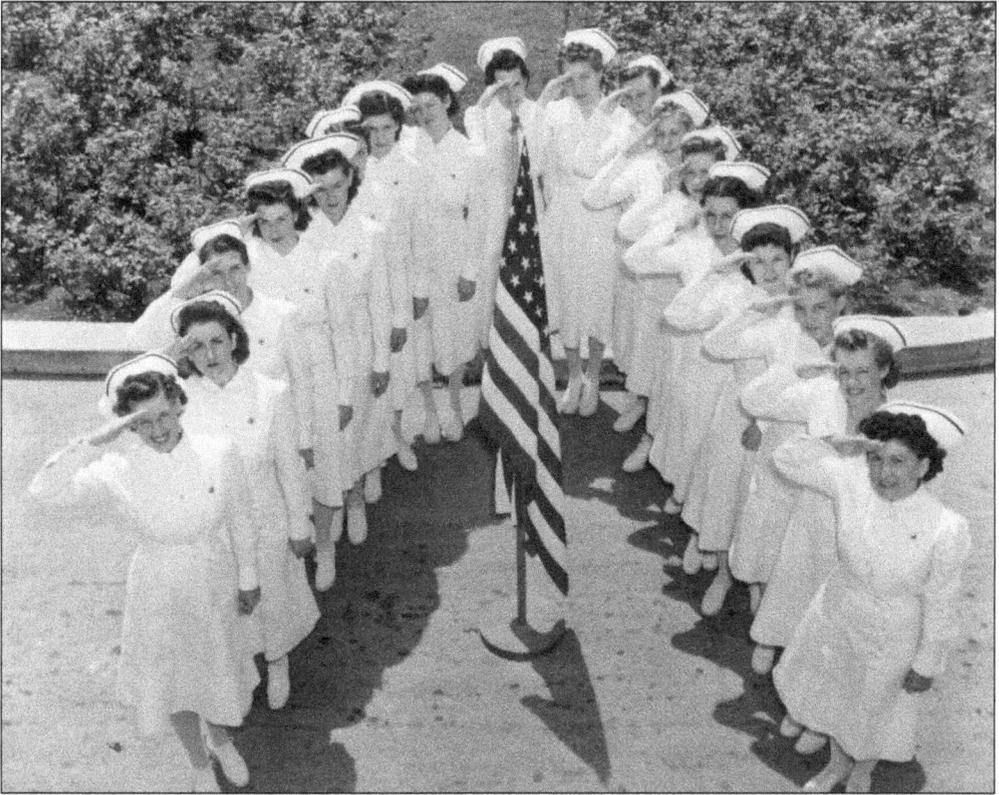

VICTORY NURSES. Parkland nurses, wearing proper attire for the time, salute in a V-formation around an American flag. (OP.)

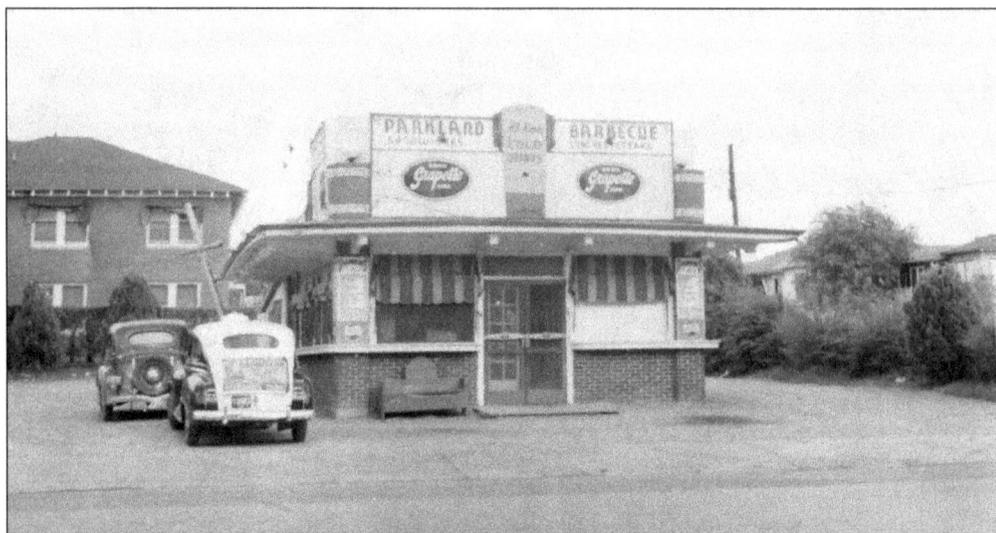

PARKLAND BBQ DRIVE-IN, 1948. When Parkland was first built, it was considered to be way out in the country. As the area around it gradually transformed into a real neighborhood, stores and restaurants along Maple and Oak Lawn Avenues appropriated the Parkland name. (UTSW.)

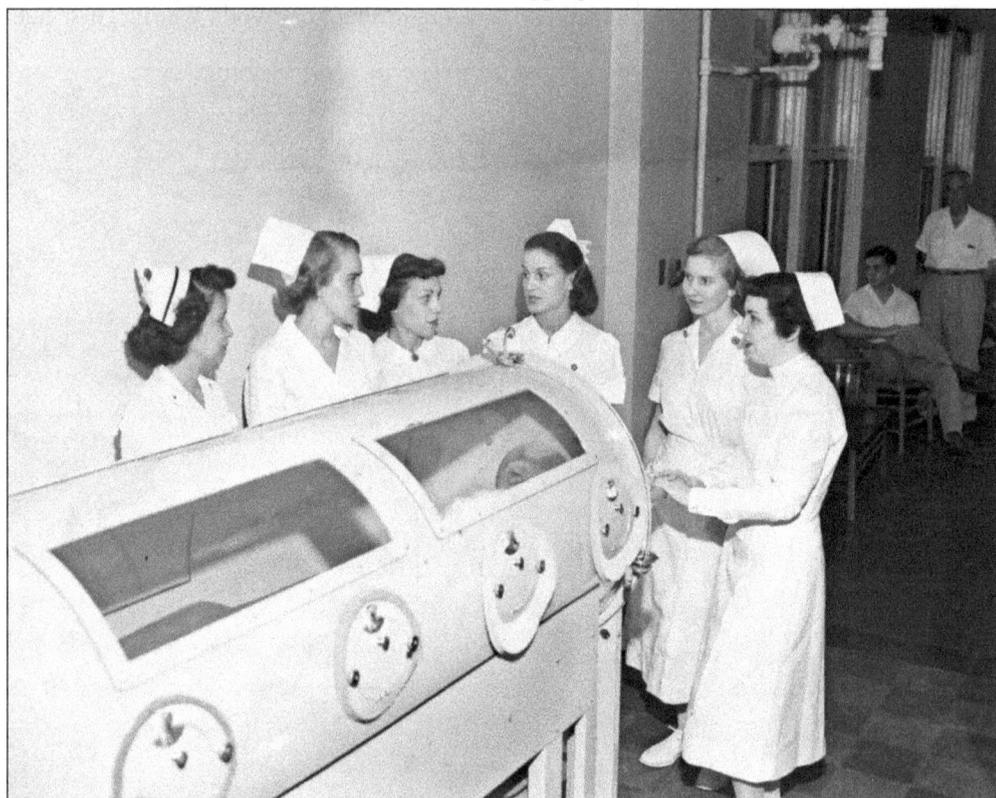

IRON LUNG TRAINING. Along with World War II, the 1940s brought a polio epidemic to Texas. Parkland was one of few hospitals prepared and equipped to handle polio patients. Polio attacked the neuromuscular system of its victims, leaving some unable to breathe. The iron lung created intermittent negative pressure around the patient's chest to assist with breathing. (DPL.)

POLIO PATIENT IN AN IRON LUNG. Parkland nurses bring 16th-birthday wishes and cards to Mary Sides, who was in an iron lung on the Parkland polio ward. (DPL.)

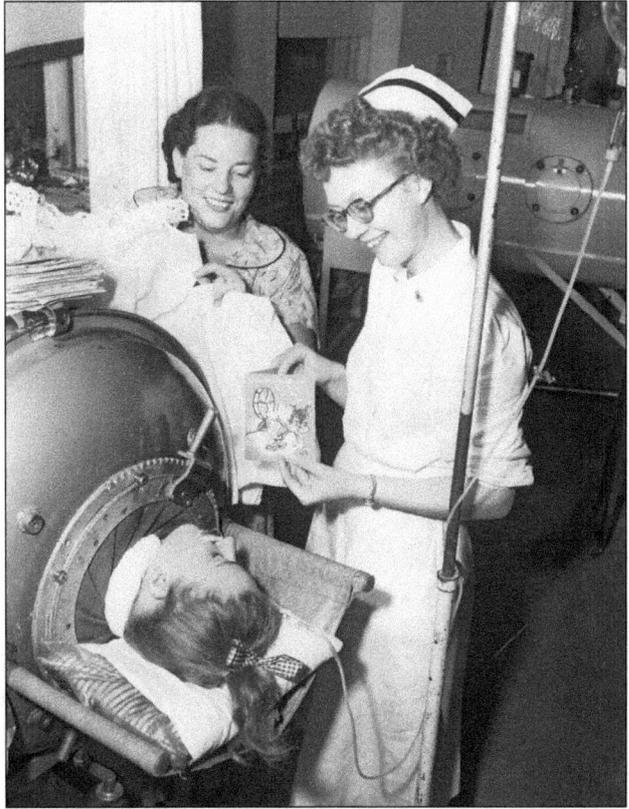

PARKLAND, C. 1950. Medical students and residents are pictured here in a group discussion. After 1943, the hospital and Southwestern Medical School shared the same campus at Oak Lawn and Maple Avenues. (UTSW.)

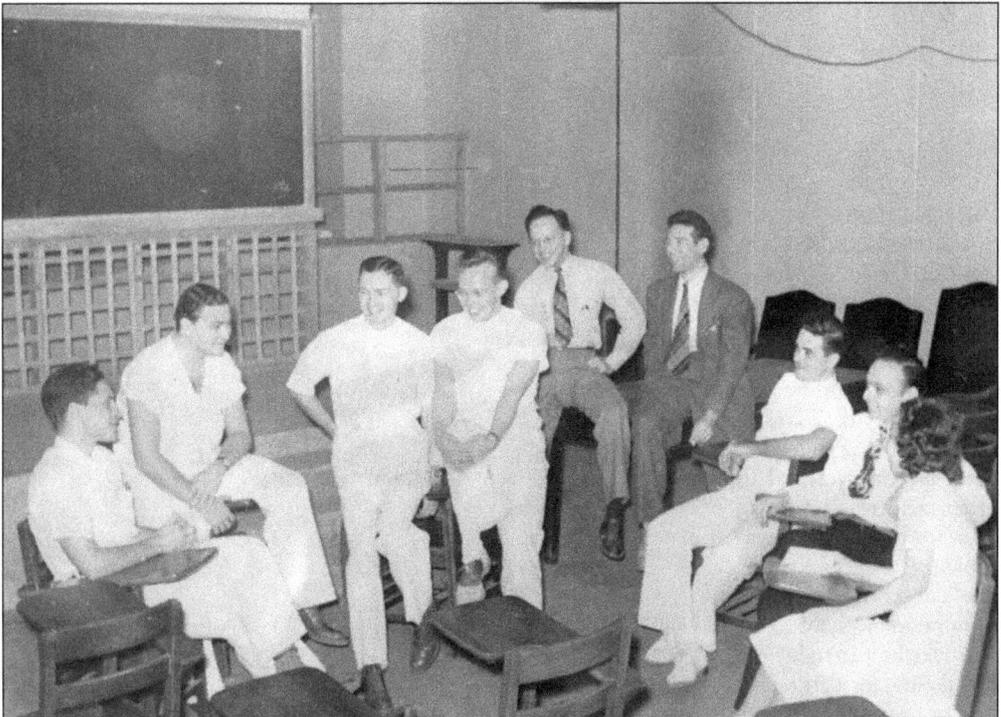

21

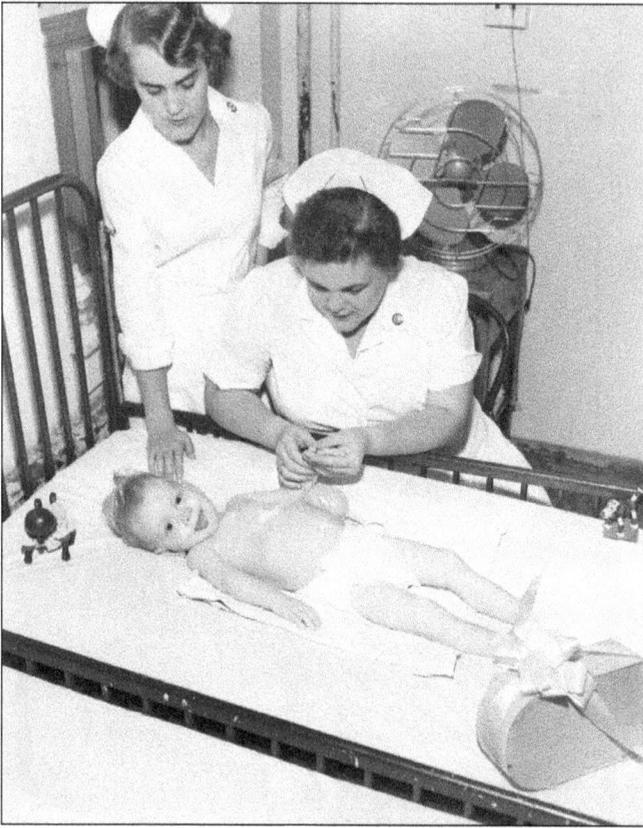

PARKLAND NURSES WITH A BABY, 1951. Parkland provided pediatric care for many decades. The Children's Medical Center, which is part of the Parkland Hospital campus, now manages most pediatric patients. (DPL.)

PARKLAND AND SOUTHWESTERN MEDICAL SCHOOL CAMPUS, 1950. A significant medical campus developed around Parkland with the additions of Southwestern Medical School, Texas Children's Hospital, the Scottish Rite Hospital, and other facilities. But the overcrowded hospital was showing its age, and the medical school was housed in temporary plywood barracks (upper right). It was time for Parkland to move on. (UTA.)

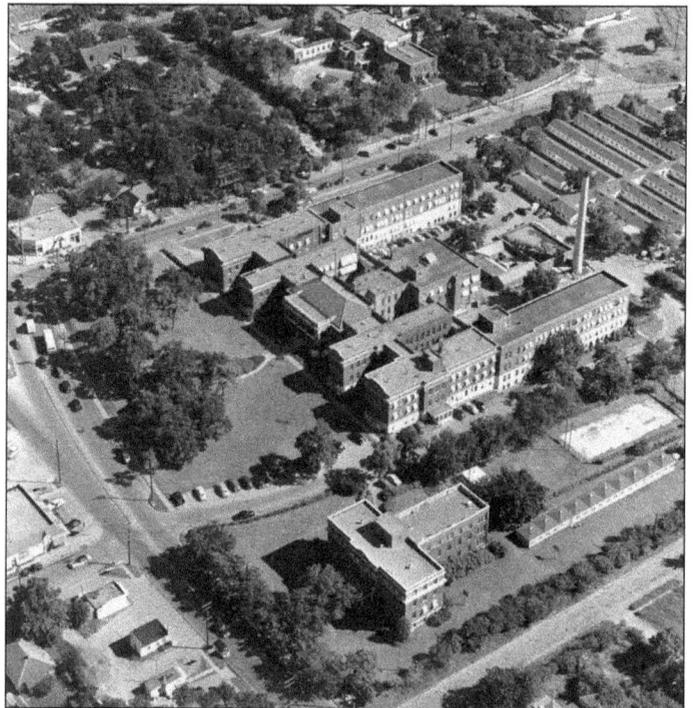

**New Parkland Ground-
Breaking Ceremony,
1952.** The new facility,
constructed on Harry Hines
Boulevard, was named
Parkland Memorial Hospital
in honor of the veterans of
World War II. (UTSW.)

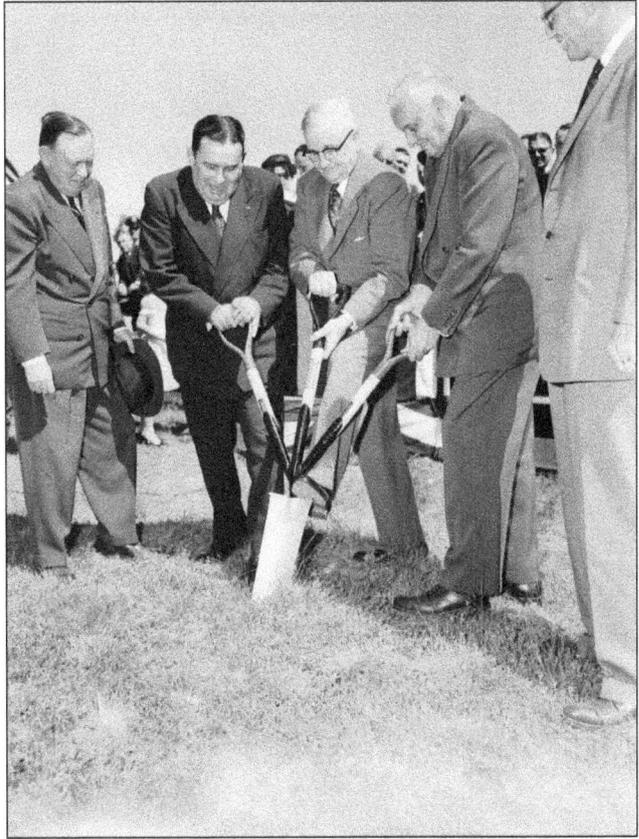

**Parkland Construction,
c. 1952.** The construction of
Parkland Memorial Hospital
took place from 1952 through
1954; the construction of the
Southwestern Medical School's
Basic Science Hall and the
Parkland School of Nursing
were also underway on the
same campus. (UTSW.)

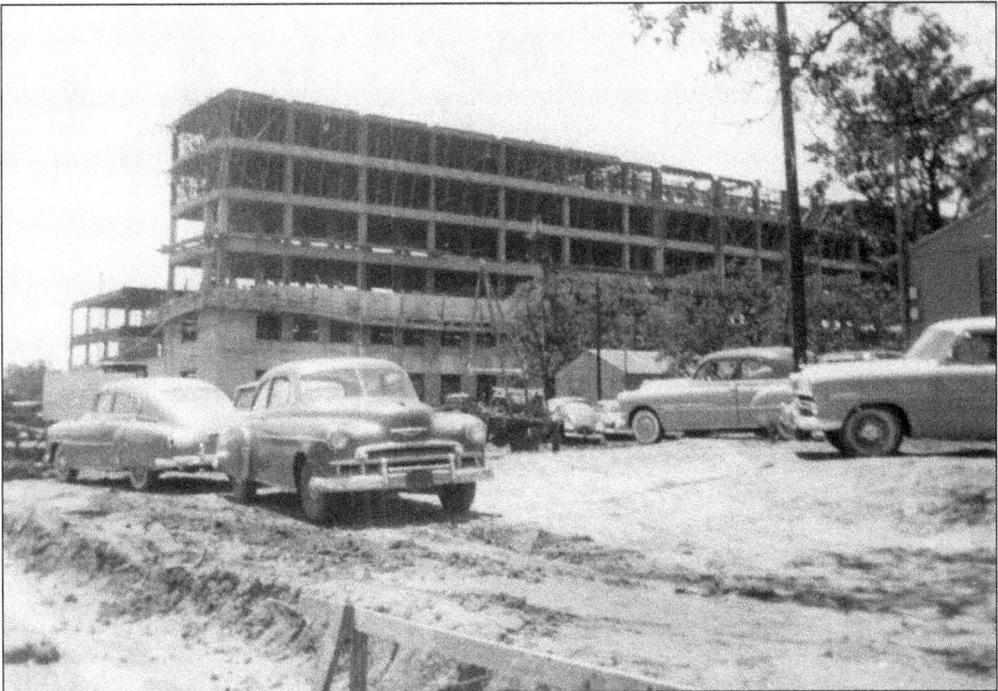

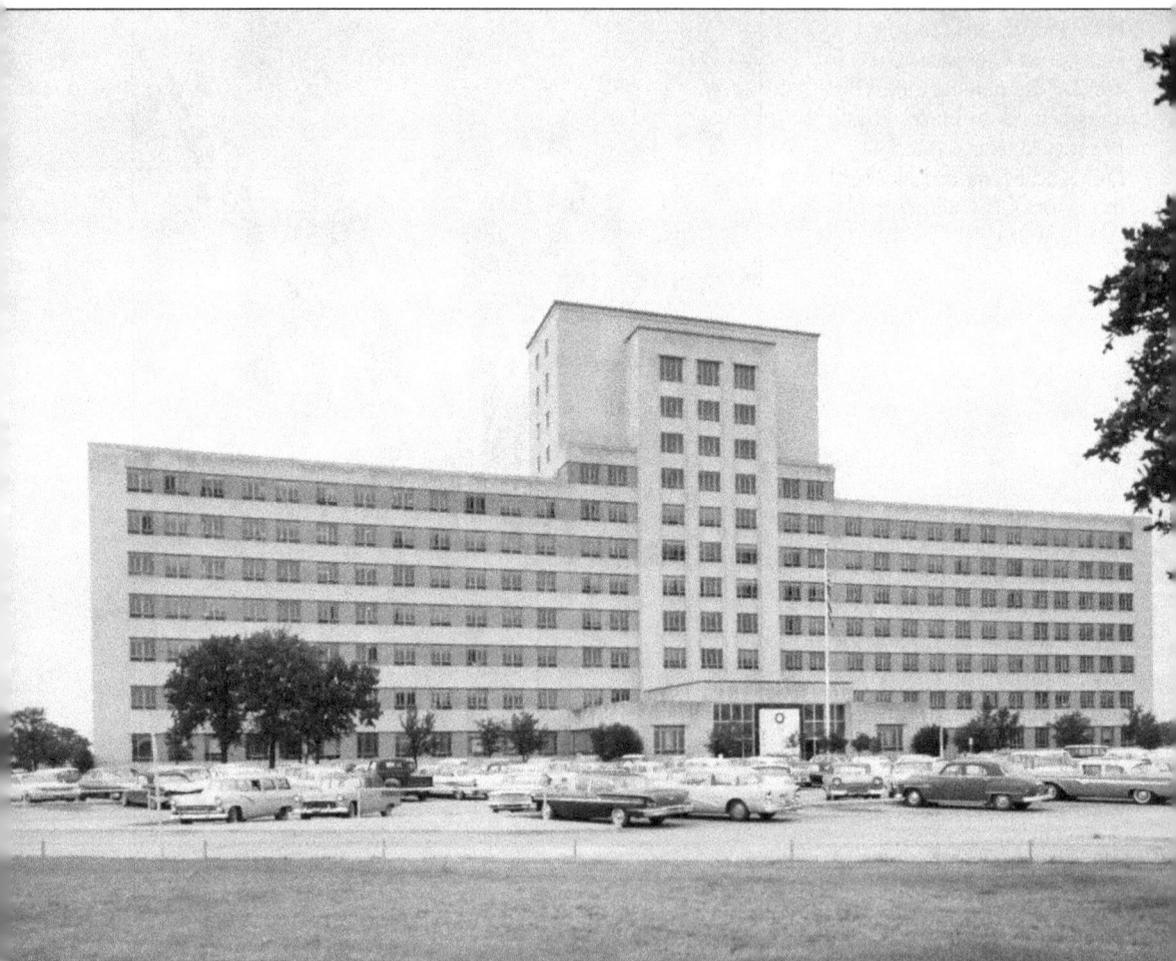

PARKLAND MEMORIAL HOSPITAL, C. 1955. The new hospital began receiving patients from the old Parkland on September 25, 1954. During the hospital's first year on Harry Hines Boulevard, the staff at Parkland admitted 14,719 patients, treated 57,256 emergency-room patients, and delivered over 4,000 babies. (PH.)

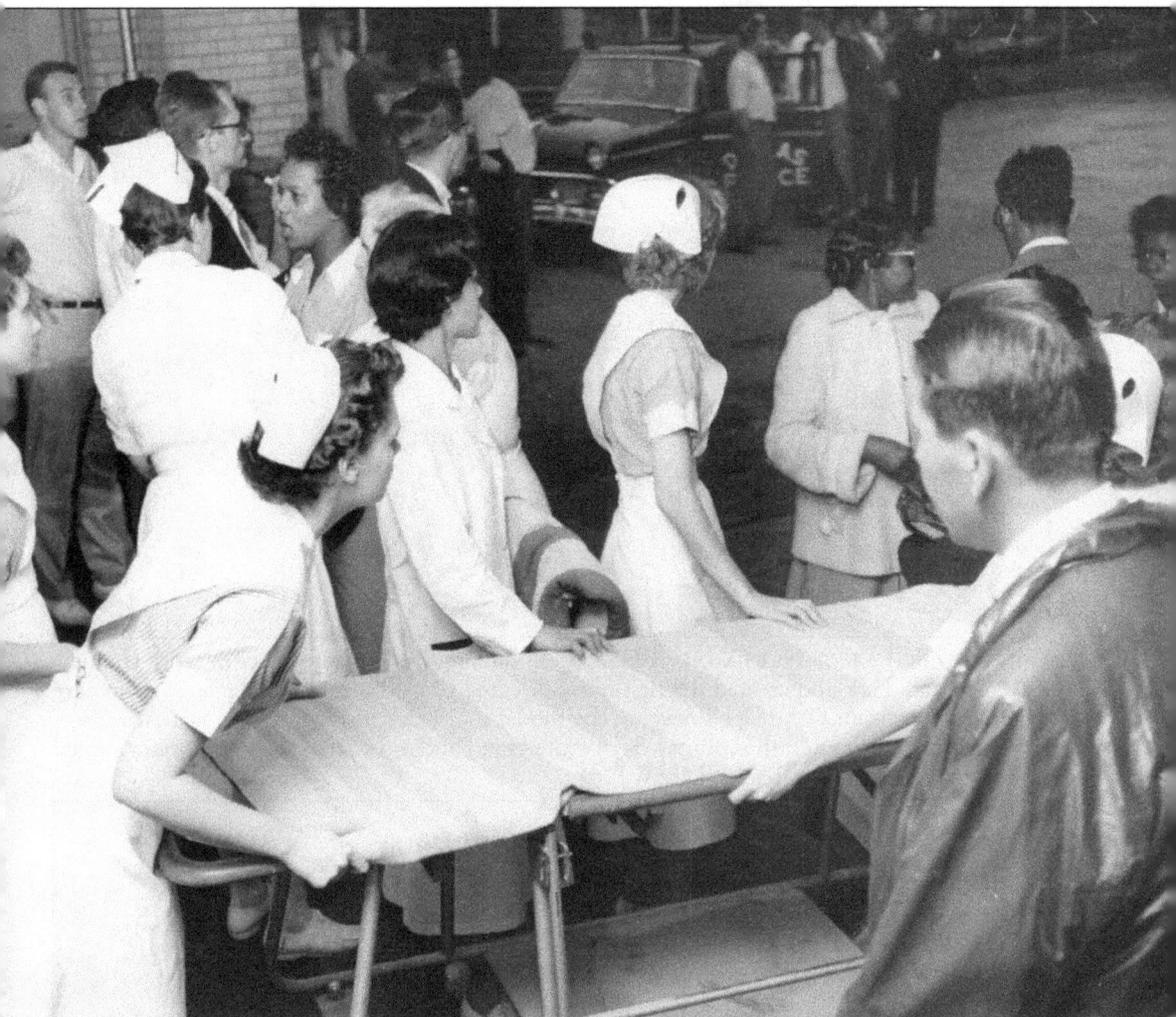

NURSES AWAIT TORNADO VICTIMS, 1957. On April 2, 1957, Parkland's emergency room provided care for 175 tornado victims in two hours after barely escaping the tornado, which destroyed some 500 homes in just a few minutes. (DPL.)

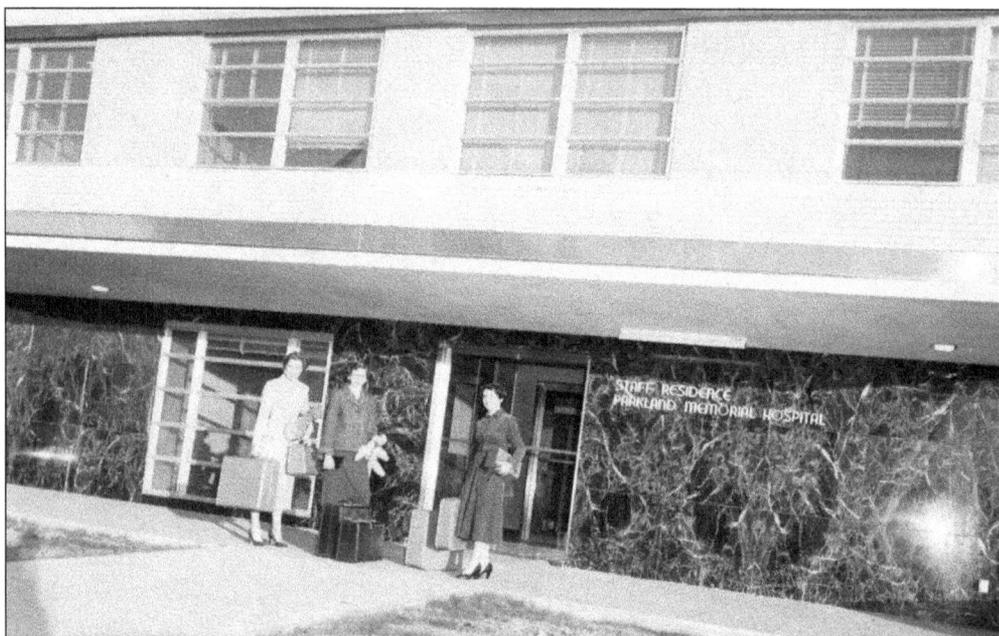

PARKLAND SCHOOL OF NURSING, C. 1955. These nursing students are checking into the new residence hall. Parkland created the first nurse-directed triage system for emergency-room care when Doris Nelson, RN, helped develop the model in 1962; it is now used in virtually every major emergency room in the country. That same year, Parkland started the first 24-hour staffed operating room in north Texas. (UTSW.)

NURSING STUDENTS IN THE DORMITORY, 1955. The Parkland School of Nursing closed shortly after the hospital relocated to Harry Hines Boulevard. Most nursing schools became affiliated with universities, and Texas Women's University (TWU) took over the Parkland Hospital program. The TWU facility remains part of the medical school's campus today. (UTSW.)

26

NURSING CLASSROOM, 1955. This same classroom later became a makeshift pressroom following the assassination of Pres. John F. Kennedy in 1963; for more information, see pages 60 and 61. (UTSW.)

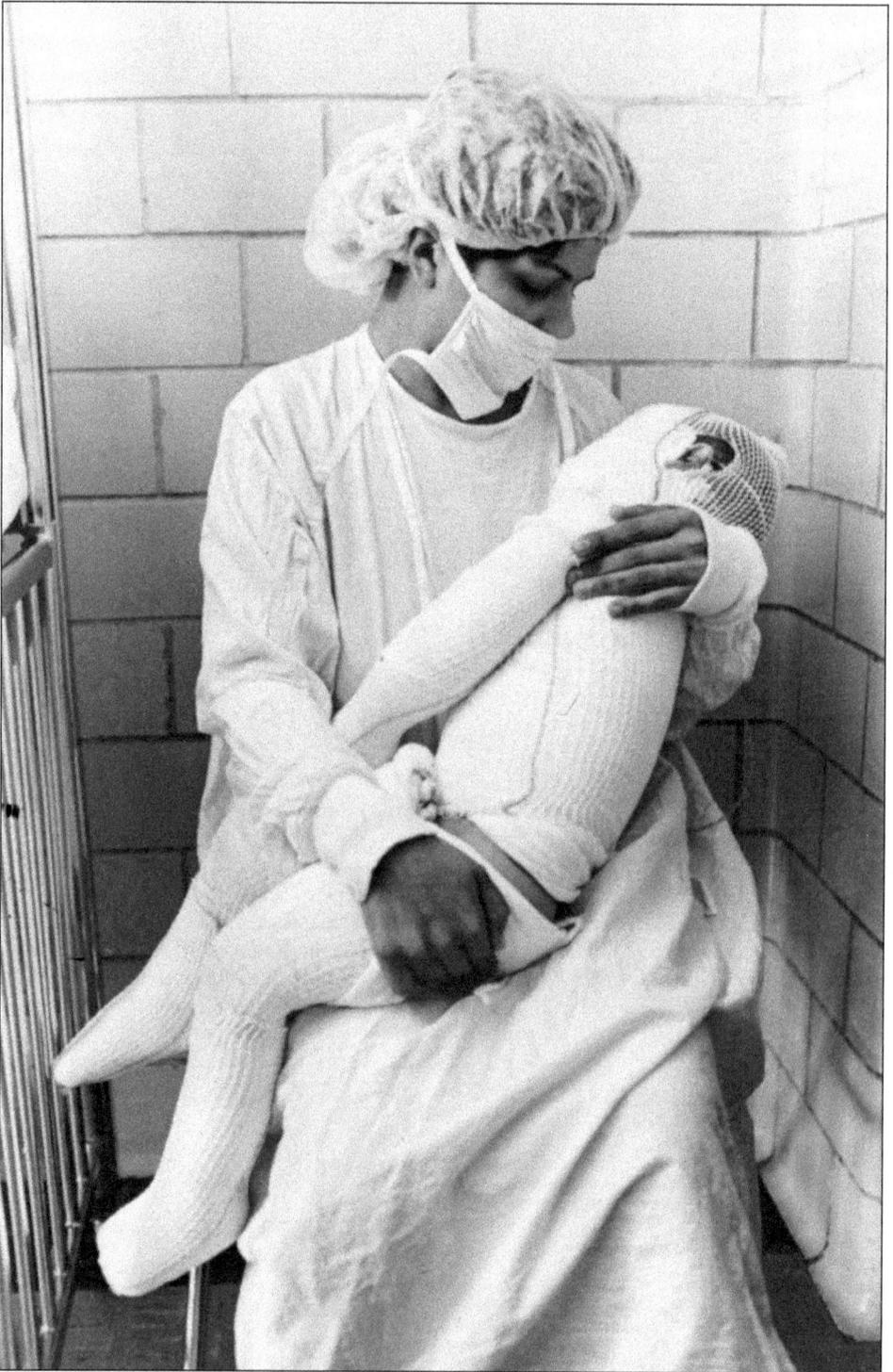

PARKLAND MEMORIAL HOSPITAL BURN UNIT, C. 1977. In 1961, Parkland opened one of the nation's largest civilian burn units under the direction of Dr. Charles Baxter. A decade later, the hospital opened the first pediatric burn unit in north Texas. (UTSW.)

Two

SOUTHWESTERN
MEDICAL SCHOOL

The early 1900s brought a number of medical schools to the Dallas area. There were considerable differences in school admission requirements, length of training, and ability to interact with hospital patients. In 1902, Dr. Edward Cary, a New York–trained ophthalmologist, returned to Dallas for a short trip. He was persuaded to teach a course at the University of Dallas Medical Department and became dean of the school within a year. Dr. Cary merged the medical school into Baylor University and began a contract to provide doctors to Parkland Hospital. By 1918, Baylor College of Medicine was the only surviving medical school in north Texas.

Dr. Cary had an even greater vision—to transform the hospital and medical school into one of the world's greatest medical centers. After the sudden decision by Baylor College of Medicine to leave Dallas in 1943, Dr. Cary's vision had many obstacles to overcome. With determination and support from Dallas business leaders, Cary swiftly began the Southwestern Medical School in an abandoned junior high school. Despite its excellent reputation, the school's financial struggles continued for another decade, and the school was temporarily housed in plywood barracks.

During this time, another influential physician arrived on the scene—Dr. Donald W. Seldin. His arrival coincided with worsening conditions at both the medical school and hospital, and the dream of a new medical center remained distant. While many others were leaving, Seldin saw potential and opportunity. As Parkland and Southwestern moved to Harry Hines Boulevard in the mid-1950s, Seldin and others rose to become major influences who helped shape the success that UT Southwestern continues to command today.

The medical school has had many names over the past seven decades. Southwestern Medical College was founded by the Southwestern Medical Foundation in 1943. After affiliating with the University of Texas in 1949, it became Southwestern Medical School of the University of Texas. In 1954, the name changed to The University of Texas Southwestern Medical School; this was amended to The University of Texas Southwestern Medical School at Dallas in 1966. As the school expanded to offer more degrees, it became the University of Texas Health Science Center at Dallas in 1972. This "center" included Southwestern Medical School, the Graduate School of Biomedical Sciences, and the School of Allied Health Professionals. Today, it is known as UT Southwestern Medical Center.

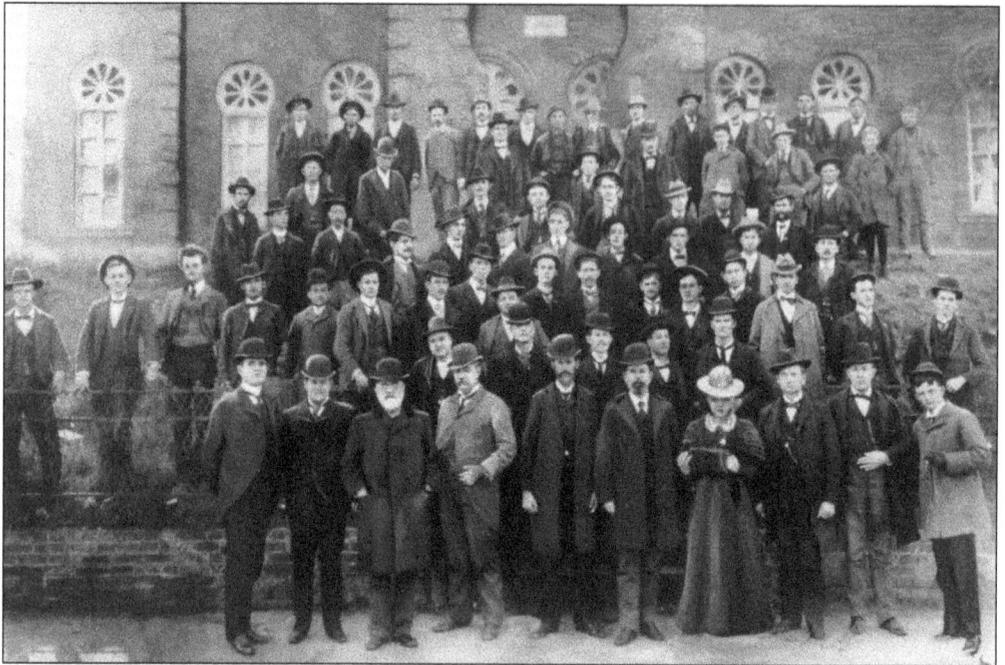

UNIVERSITY OF DALLAS MEDICAL DEPARTMENT, C. 1900. On November 19, 1900, when the University of Dallas Medical Department began its school in the abandoned Temple Emanuel Synagogue on Commerce Street (across from the current Adolphus Hotel), there was no "University of Dallas" in existence. Dr. Charles M. Rosser (third from left in the first row) was the dean of this first graduating class, which included one female student. (UTSW.)

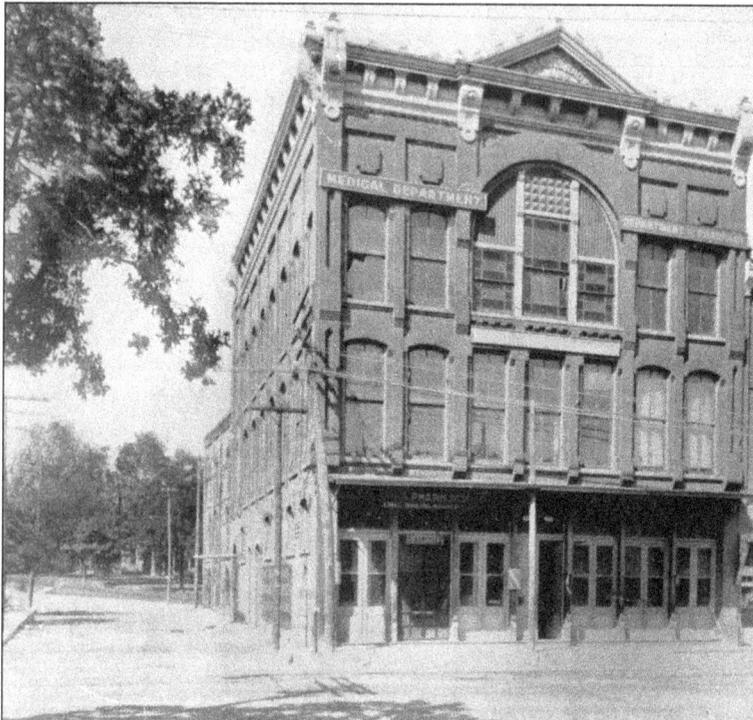

FIRE DESTROYS THE MEDICAL DEPARTMENT. After a fire destroyed the University of Dallas Medical Department school in 1902, the school moved to 435 South Ervay Street. Three times per week, medical school students traveled in a horse-drawn wagon to attend to patients at Parkland Hospital. (UTSW.)

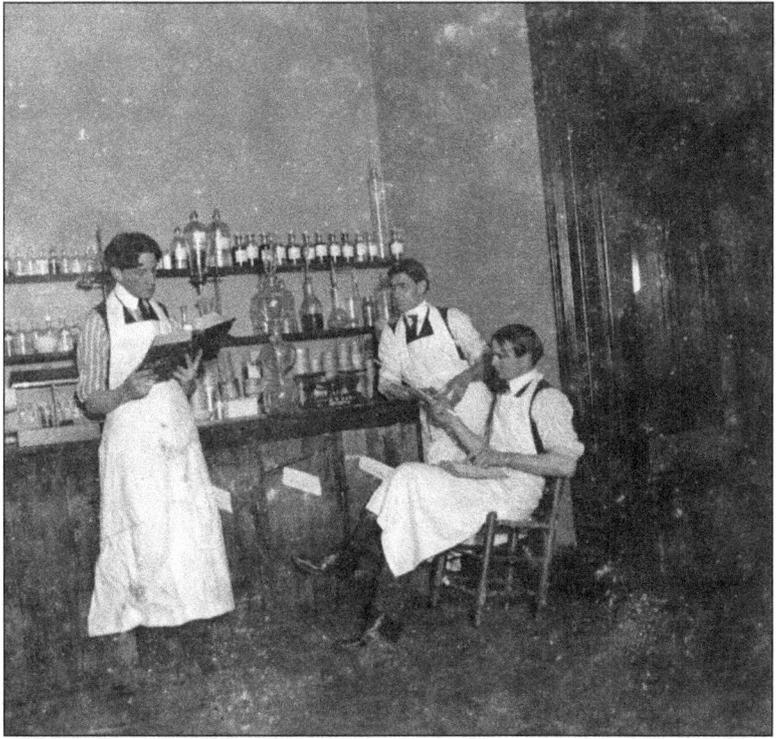

STUDENTS AT DALLAS MEDICAL COLLEGE, C. 1902. In 1902, several members of the University of Dallas Medical Department left and started the Dallas Medical College, located at 319 Commerce Street, which closed two years later. Several other medical schools existed in Dallas and Fort Worth in the early 1900s. (UTSW.)

DR. EDWARD H. CARY. Dr. Cary attended Bellevue Hospital Medical College in New York, considered one of the finest medical schools in the country at the time. When the Dallas native briefly returned in 1902 to care for his ailing mother, he agreed to teach at the University of Dallas Medical Department and became dean of the school within six months. Dr. Cary would become one of the most dynamic medical influences on Dallas and the United States. (UTSW.)

DR. EDWARD H. CARY WITH BAYLOR UNIVERSITY COLLEGE OF MEDICINE STAFF, 1920. Dr. Cary believed it was necessary for any reputable medical school to be affiliated with a major university. Cary united the University of Dallas Medical Department with Baylor University in 1903 and continued to serve as dean of the school until 1920. In 1910, Abraham Flexner released a report reviewing over 150 medical schools in North America. Most Texas schools received a brutal review, and by 1918, Baylor was the only surviving medical school in north Texas. (UTSW.)

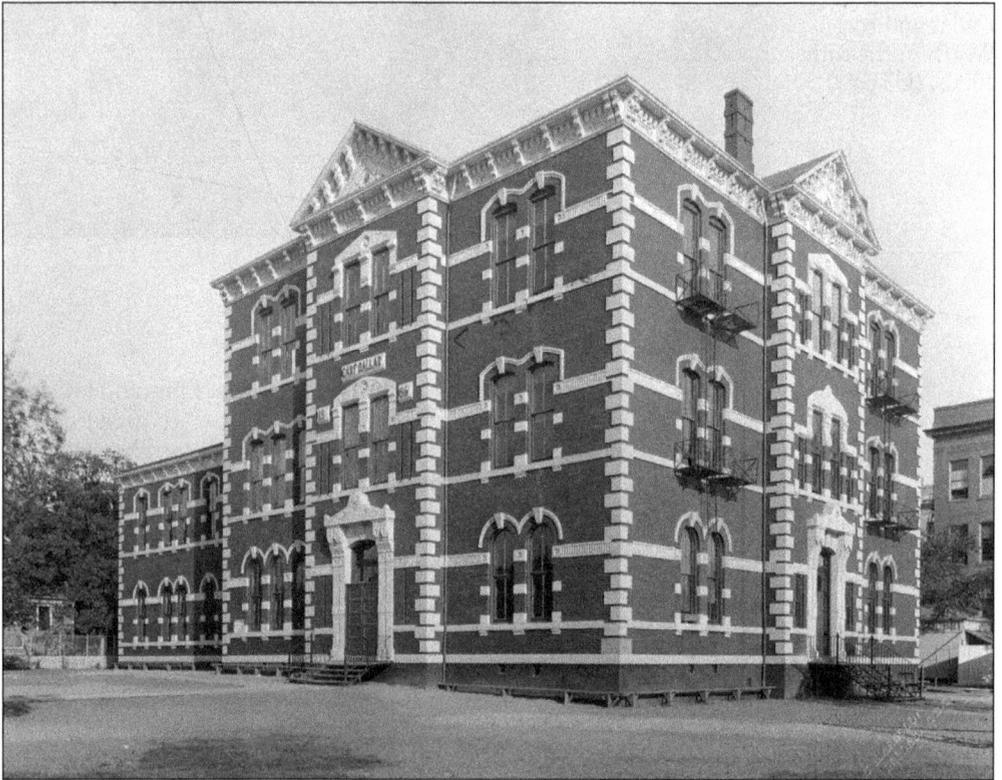

BAYLOR UNIVERSITY COLLEGE OF MEDICINE, 1930. In 1922, the Baylor University College of Medicine relocated to this former East Dallas City Hall building at Gaston Avenue and Hall Street. Interest in the medical college increased after Parkland Hospital opened its new building, billed as "one of the best equipped institutions of its kind in the southwest," in 1914. Dr. Edward H. Cary became president of the Dallas County Medical Society in 1910, president of the Texas Medical Association in 1917, and president of the American Medical Association in 1932. In 1923, he funded the construction of the Medical Arts Building in downtown Dallas, one of the tallest buildings in Texas at the time and the only skyscraper in the world dedicated to medical offices. (UTSW.)

SOUTHWESTERN MEDICAL FOUNDATION. By the late 1930s, Baylor University College of Medicine was having ongoing financial problems, and Parkland Hospital was becoming crowded and showing its age. Dr. Edward H. Cary was determined to turn the medical school and Parkland into one of the world's greatest medical centers. On January 21, 1939, Dr. Cary—along with Karl Hoblitzelle, E.R. Brown, and Dr. Hall Shannon—created the Southwestern Medical Foundation to promote a new medical center. The Southwestern Medical Foundation seal was incorporated into the Southwestern Medical College seal (pictured) in 1943. (UTSW.)

KARL HOBLITZELLE. The Southwestern Medical Foundation made plans for a new $25-million medical center on Harry Hines Boulevard, with Parkland Hospital and Baylor University College of Medicine as the cornerstones. While many community leaders made significant contributions, much of it came from one social and cultural figure—Hoblitzelle. He built the Majestic Theater in Dallas in 1921, and his family ran the Interstate Amusement Company. (UTSW.)

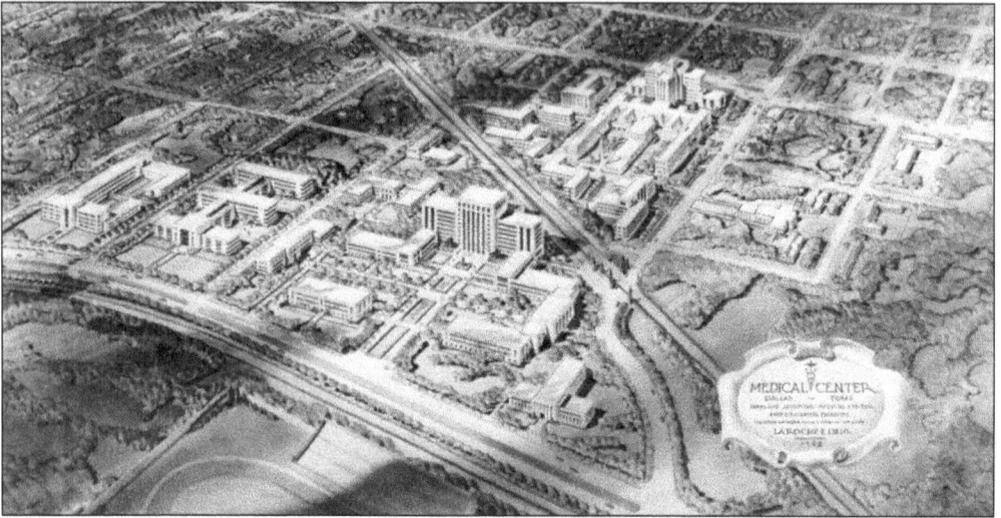

PLANS FOR THE NEW MEDICAL CENTER. Plans for the Parkland Hospital and Baylor University College of Medicine medical center were drawn up on March 11, 1942, but blending a privately-funded, religion-based medical school with a public hospital proved to be challenging. On April 27, 1943, negotiations broke down, and Baylor announced it would move to Houston. The school's last class graduated a few weeks later, and Dallas was suddenly without a medical school. (UTSW.)

SOUTHWESTERN MEDICAL SCHOOL'S FIRST CLASS. After Baylor decided to leave Dallas, Dr. Edward H. Cary and the new Southwestern Medical Foundation sprang into action and committed themselves to opening a medical school. Dr. Cary's drive and experience, combined with Karl Hoblitzelle's ability to energize the Dallas financial community, moved things at an amazing pace; within a few months, they raised $1.7 million, purchased 26 acres next to Parkland Hospital on Maple Avenue, signed a 25-year contract to provide medical services to Parkland, and enrolled 277 students. Southwestern Medical School was accredited on December 15, 1943, and opened its doors with a superior A rating. The first graduating class—pictured at the former Alex W. Spence Junior High School on March 20, 1944—had 61 students, including 38 Army and 15 Navy officers. (UTSW.)

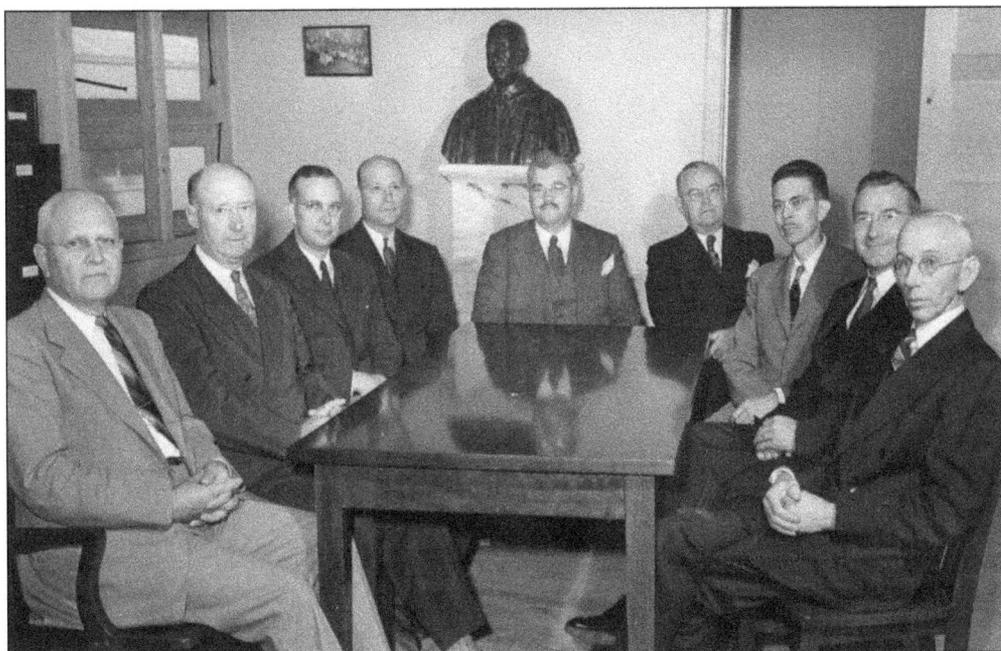

SOUTHWESTERN MEDICAL SCHOOL FOUNDING FACULTY, 1943. Seated in front of a statue of Dr. Edward H. Cary are, from left to right, Joseph Hill, Robert Lackney, George Caldwell, Joseph Hill, Donald Slaughter, Lewis Waters, Herbert Tidwell, MacDonald Fulton, and William Looney. Local doctors donated books and equipment to help the medical school get started. Within a year, Dr. Cary had attracted some of the nation's top medical leaders to the faculty, including Drs. Tinsley Harrison, William Mengert, Gladys Fashena, Arthur Grollman, and Morton Mason. (UTSW.)

DR. GLADYS FASHENA, 1940. Dr. Fashena became the first female faculty member of the Southwestern Medical School's pediatric department when it opened in 1943. Dr. Fashena originally taught at the Baylor University College of Medicine but joined the Southwestern faculty when Baylor relocated to Houston. She was a pioneer in the field of pediatric cardiology. (UTSW.)

35

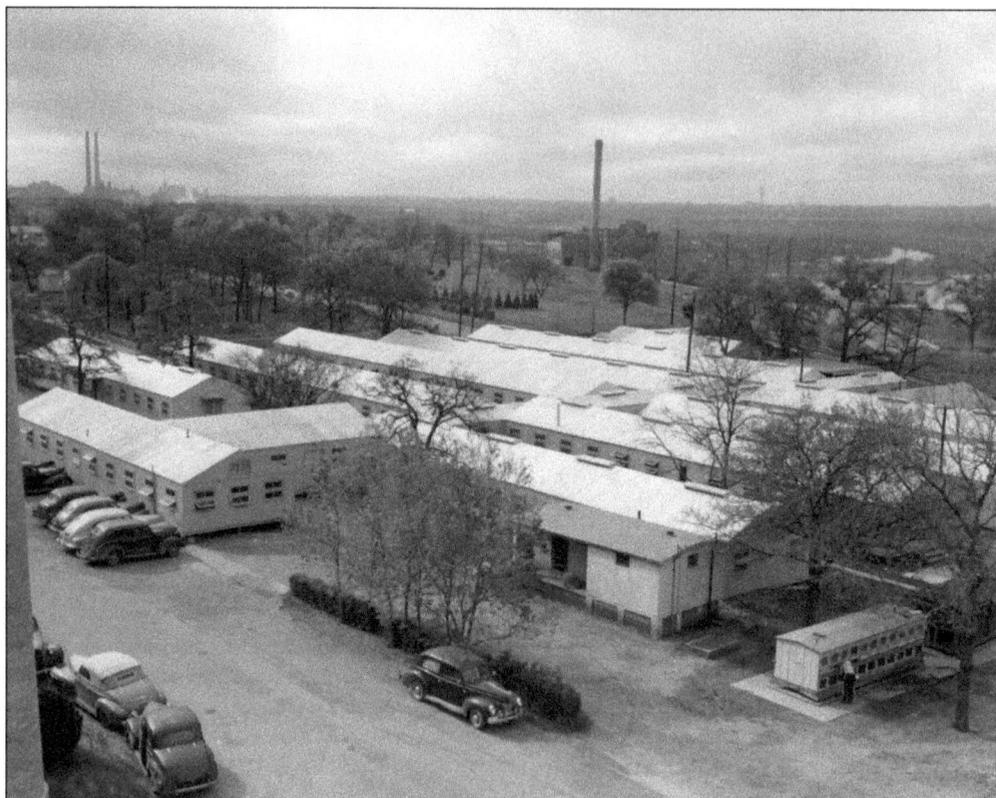

SOUTHWESTERN MEDICAL SCHOOL, 1944. After the attack on Pearl Harbor on December 7, 1941, the country became deeply involved in World War II. Doctors were in high demand by the armed services, which were happy to help build the new Southwestern Medical School campus. The military's Eighth Service Command agreed to build prefabricated plywood barracks next to Parkland Hospital in July 1943. On September 27, 1943, the first classes were held in the three-quarter-inch plywood buildings, which quickly earned a nickname—the shacks. (UTSW.)

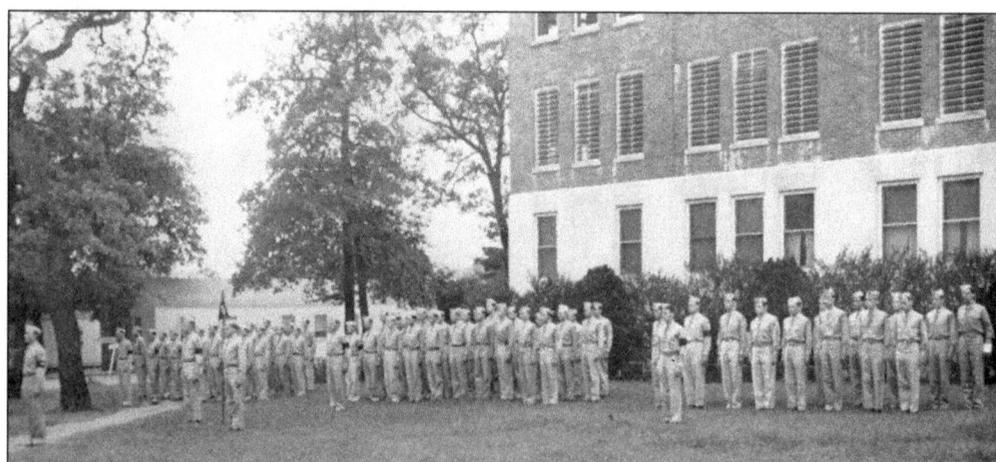

SOUTHWESTERN MEDICAL SCHOOL STUDENTS, C. 1945. The first few years of the school's operation coincided with World War II, and all male students were required to be in the military. (UTSW.)

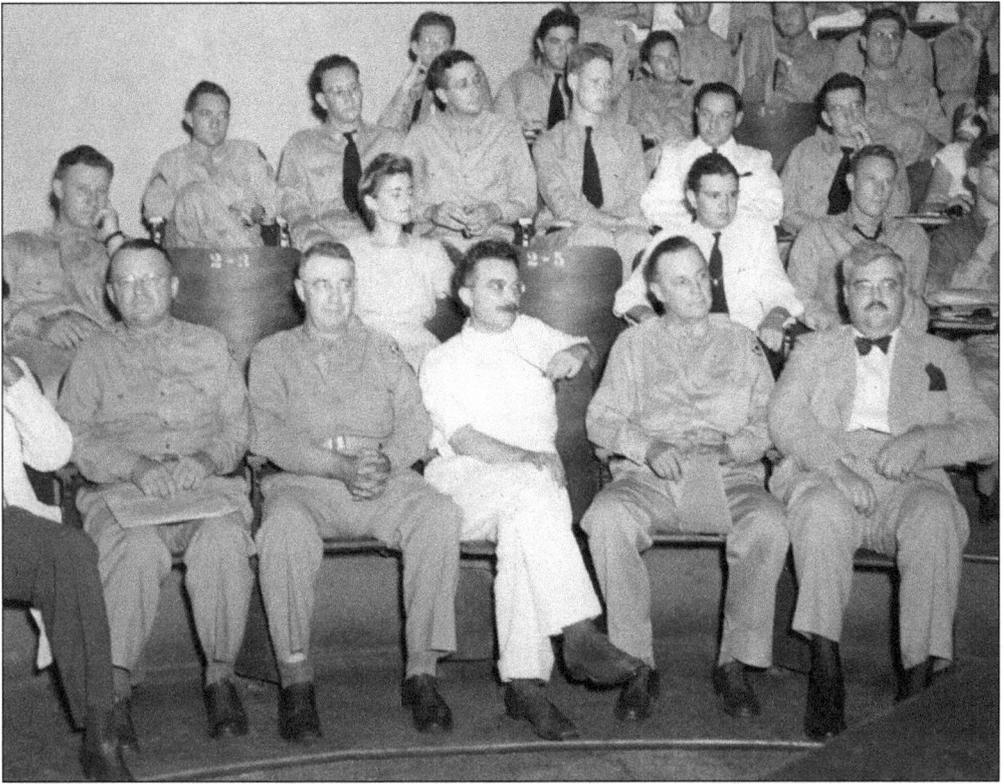

MILITARY MEDICAL STUDENTS. Nearly all Southwestern Medical School students and teaching staff served in the military during World War II. (UTSW.)

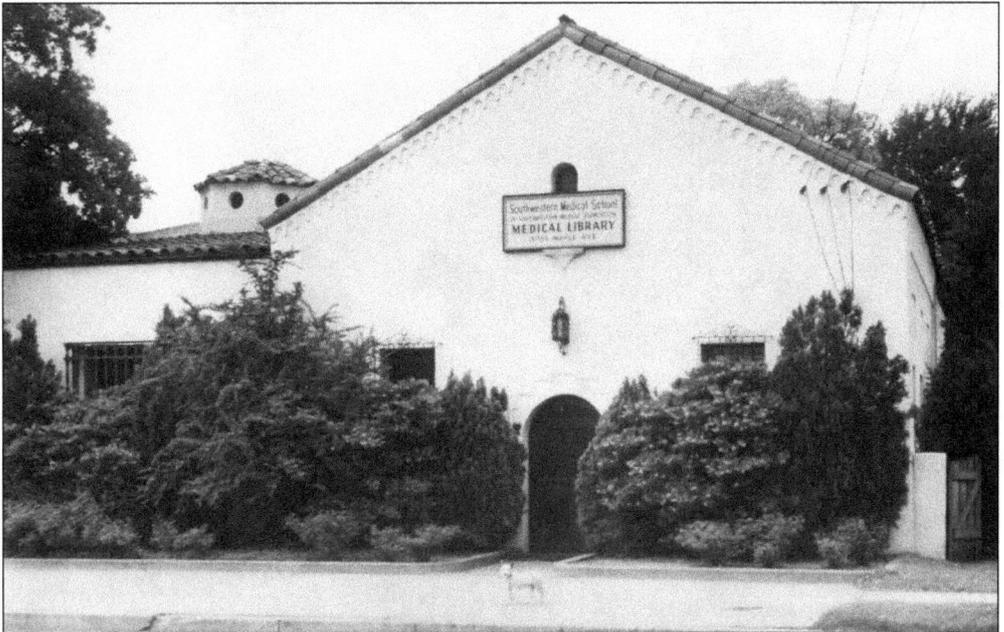

SOUTHWESTERN MEDICAL SCHOOL MEDICAL LIBRARY, 1945. The medical school library and the Medical Arts department were located in separate buildings. (UTSW.)

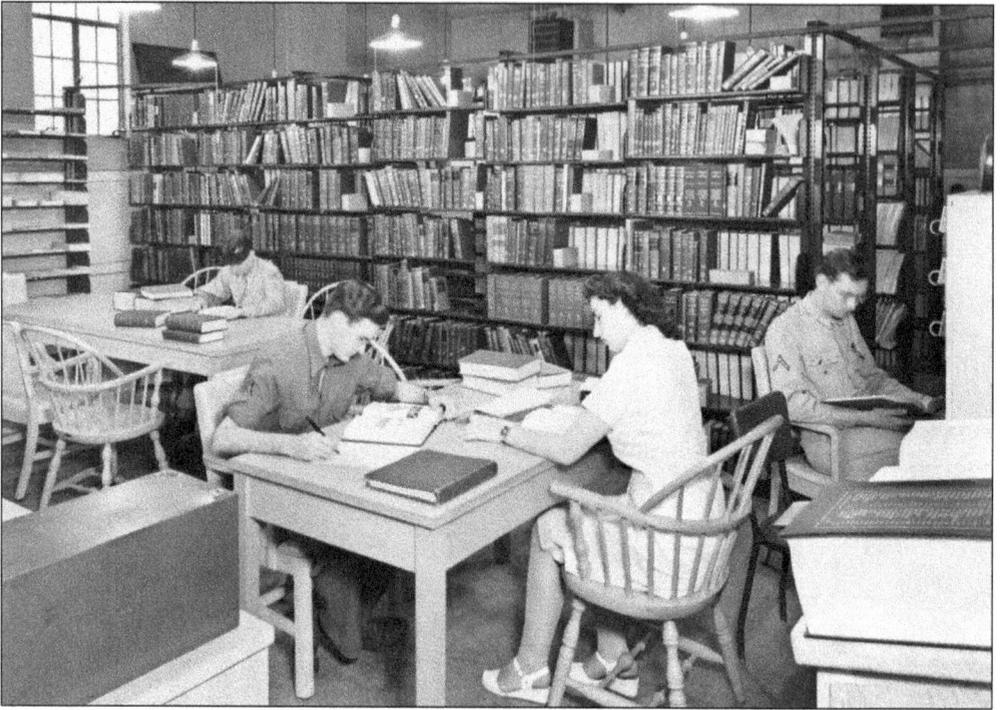

LIBRARY STUDENTS, 1945. Women were a rare sight at medical schools in 1945. (UTSW.)

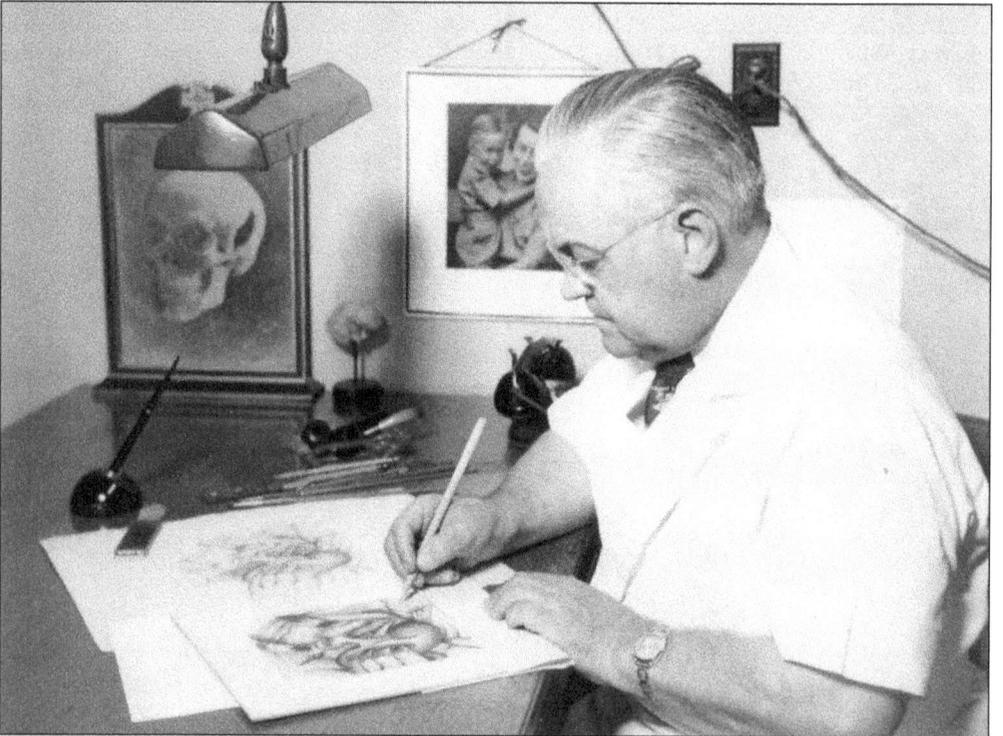

MEDICAL ARTS. Lewis Waters (pictured here around 1946) is credited with starting the Medical Arts degree program at Southwestern Medical School in 1943. (UTSW.)

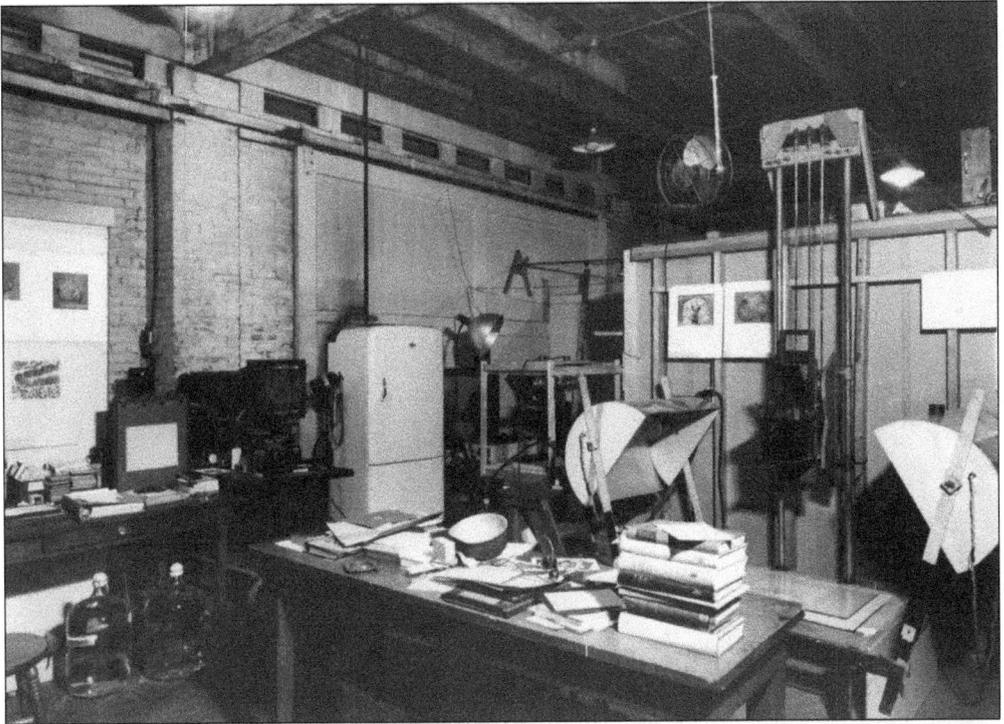

MEDICAL ARTS PHOTOGRAPH LAB, 1946. The Medical Arts building was located at 3802 Maple Avenue, near Parkland Hospital. Medical arts remain an important part of the program at UT Southwestern. (UTSW.)

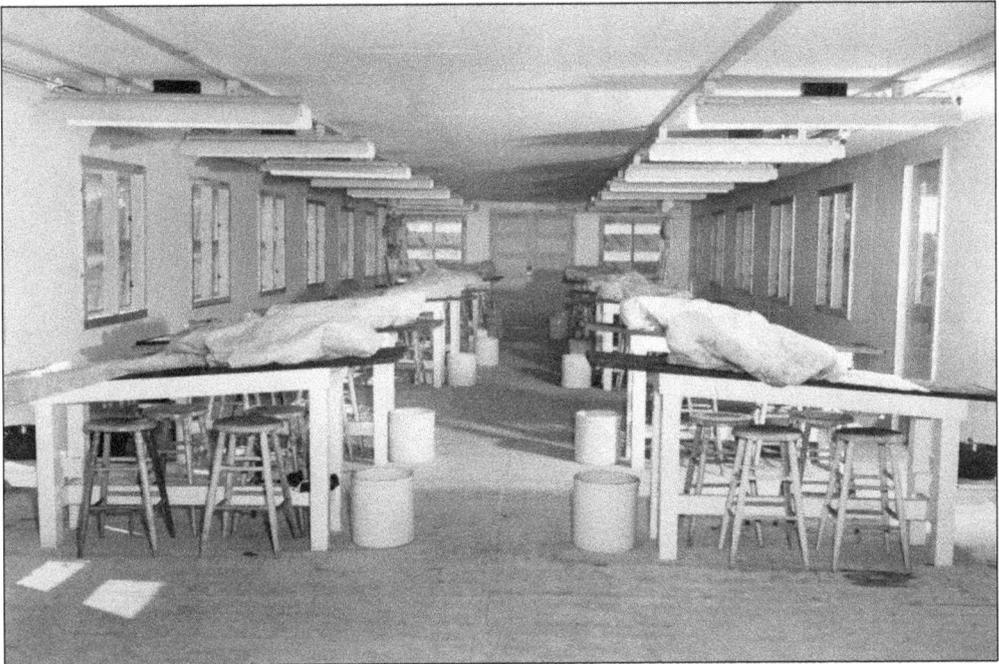

SHROUDED CADAVERS, C. 1945. Cadavers await students in the anatomy building at Southwestern Medical School. (UTSW.)

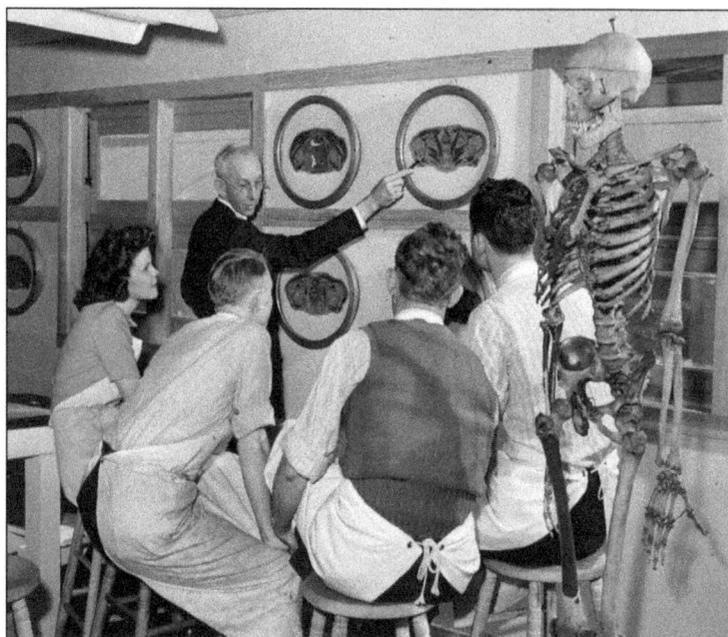

ANATOMY LAB WITH DR. WILLIAM LOONEY, 1944. Dr. Looney was a part of the founding faculty at Southwestern Medical School. (UTSW.)

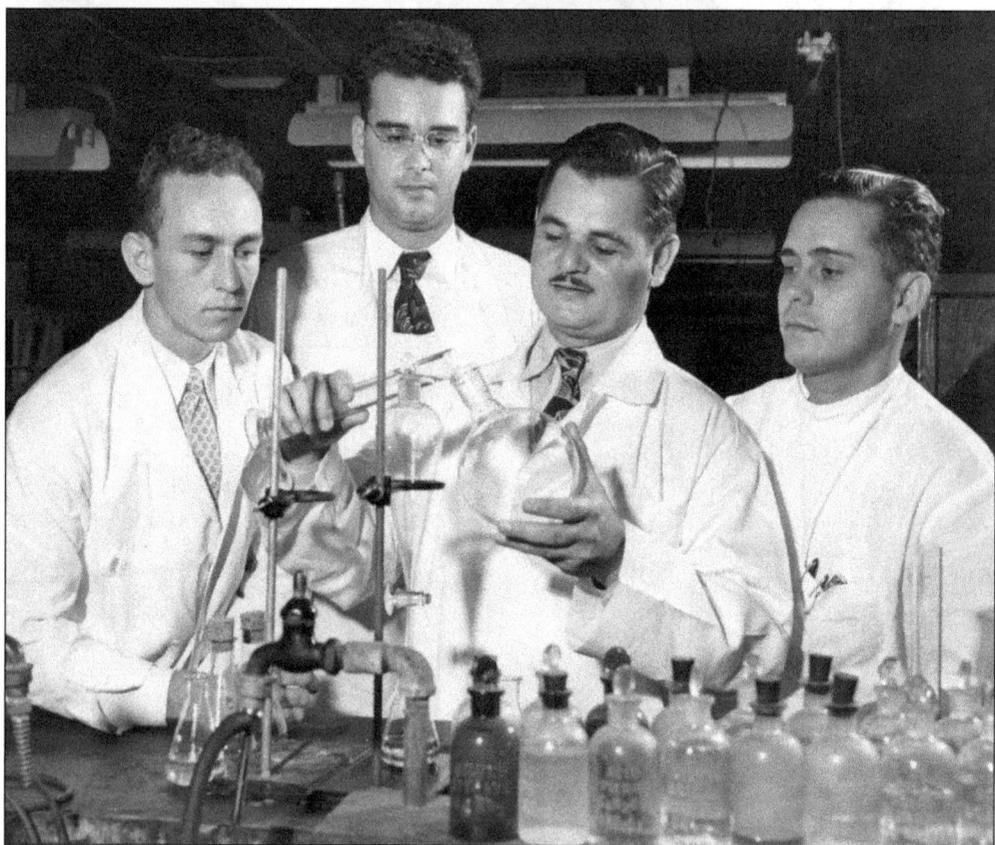

SOUTHWESTERN MEDICAL SCHOOL LAB, 1947. Medical students observe an instructor in a chemistry lab. (UTSW.)

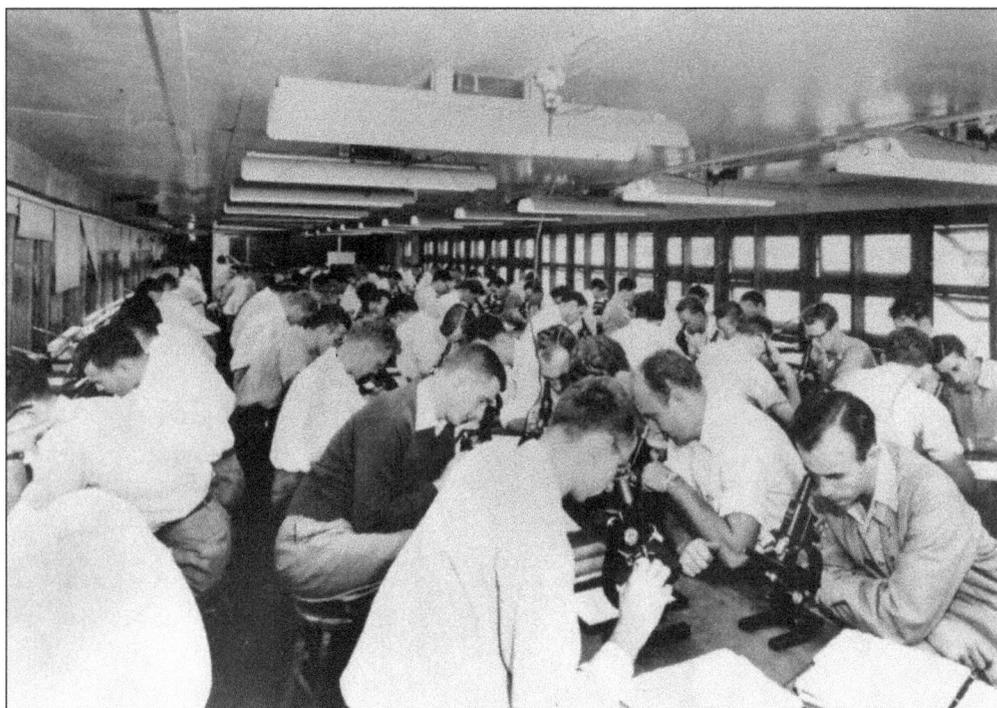

STUDENTS STUDYING WITH MICROSCOPES, 1945. In this crowded classroom, medical students are studying at their microscopes. The shacks were not air-conditioned, heating was inadequate, and the roof frequently leaked. (UTSW.)

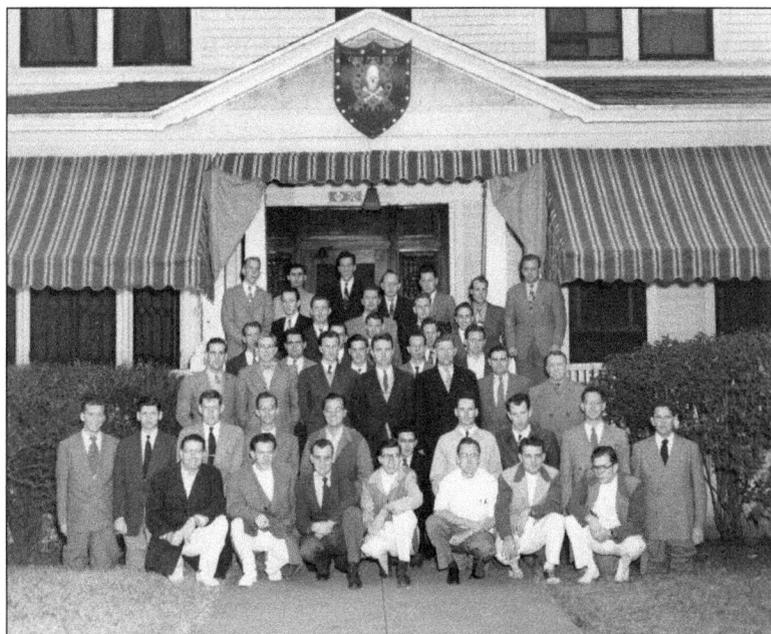

FRATERNITY LIFE, 1948. Members of Southwestern Medical School's Phi Chi fraternity gather outside their house at 2512 Maple Avenue. (UTSW.)

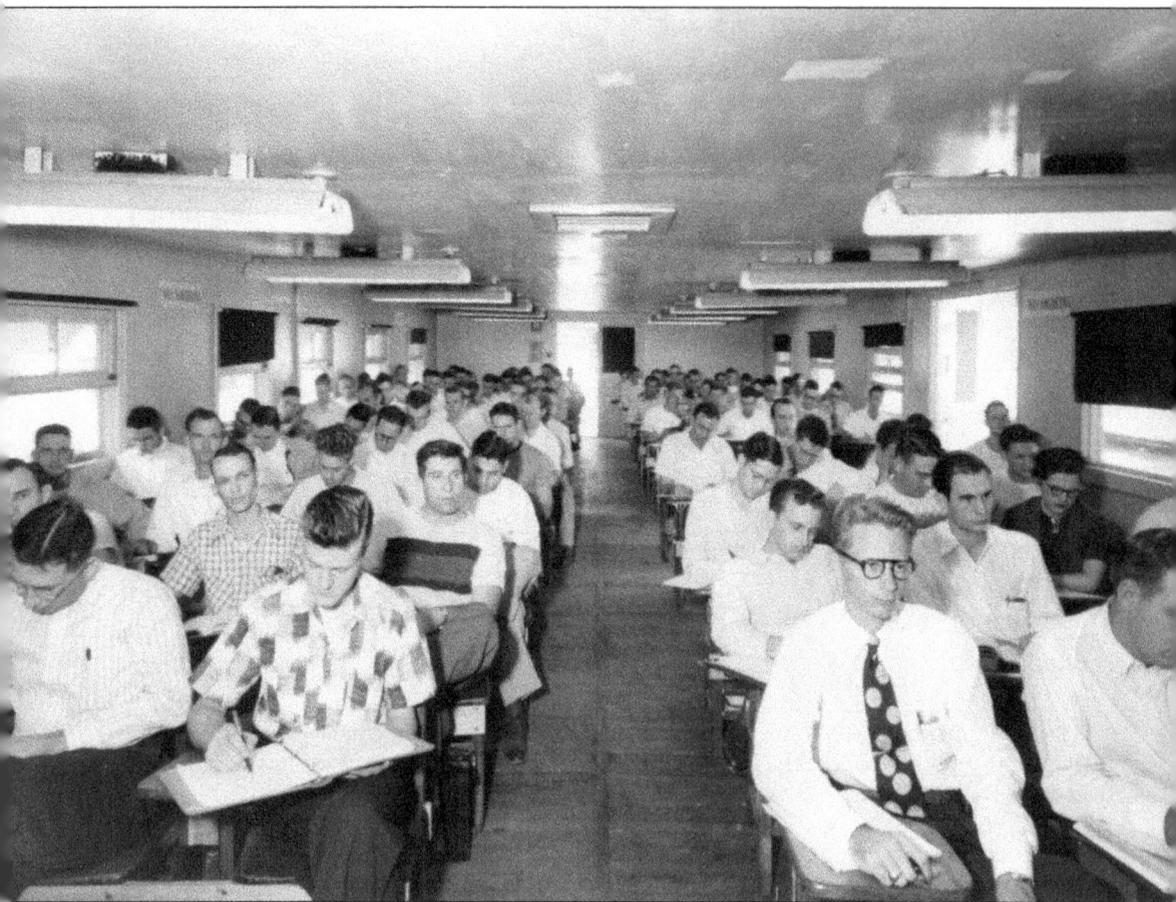

LECTURE HALL. The plywood lecture hall was located next to the railroad tracks, and lectures had to be paused several times throughout the day as trains passed. (UTSW.)

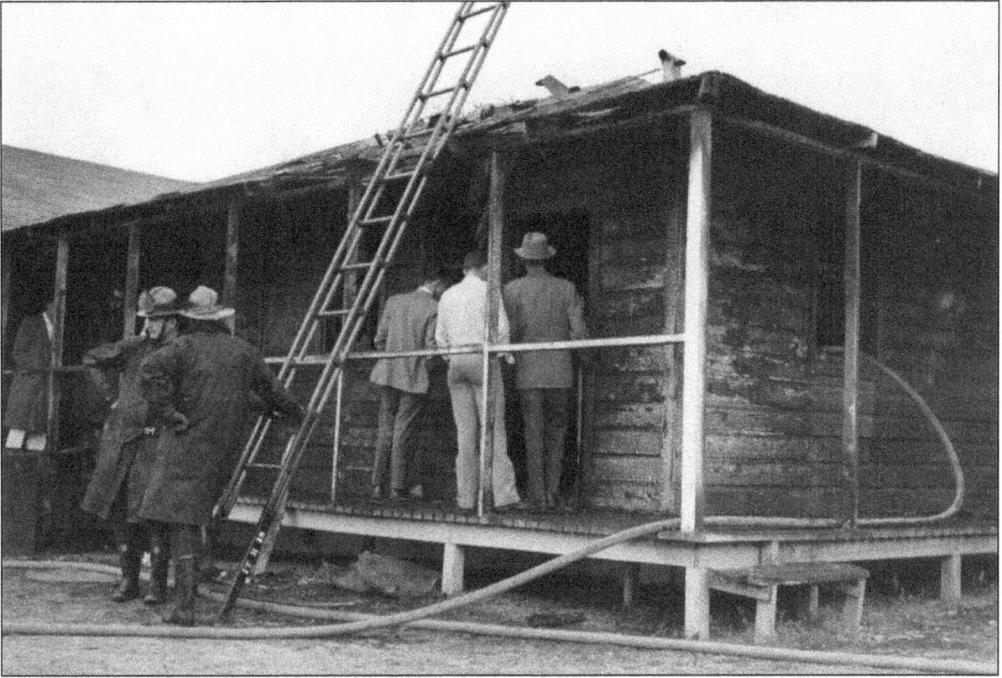

SOUTHWESTERN MEDICAL SCHOOL FIRE, 1948. Medical students and firemen inspect fire damage. (UTSW.)

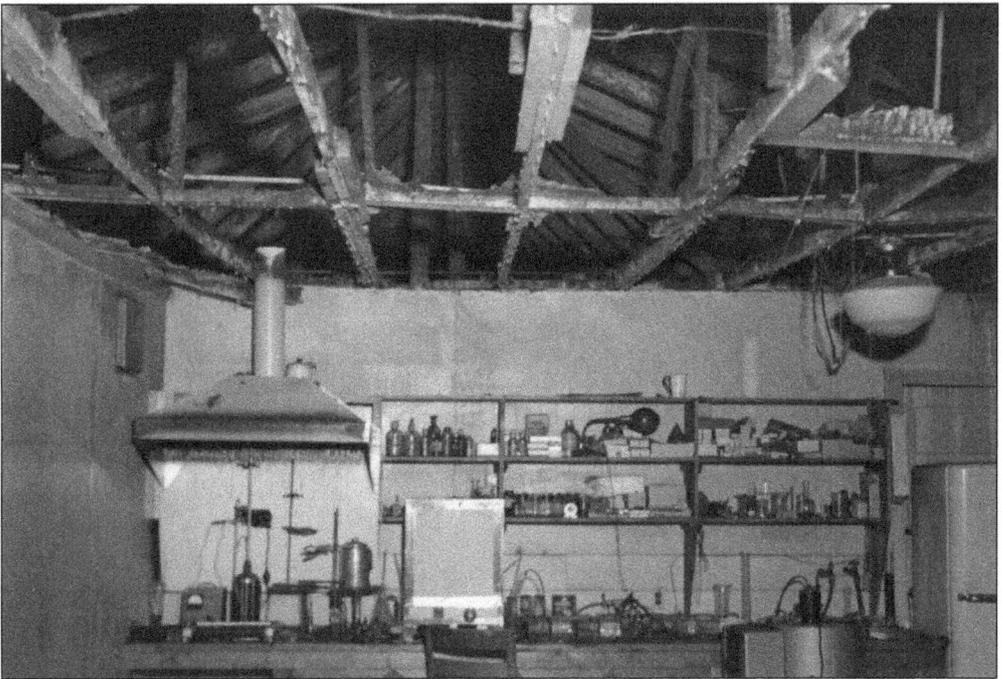

FIRE DAMAGE. By the late 1940s, the shacks were showing their age after enduring years of fires, water leaks, decay, and broken windows. (UTSW.)

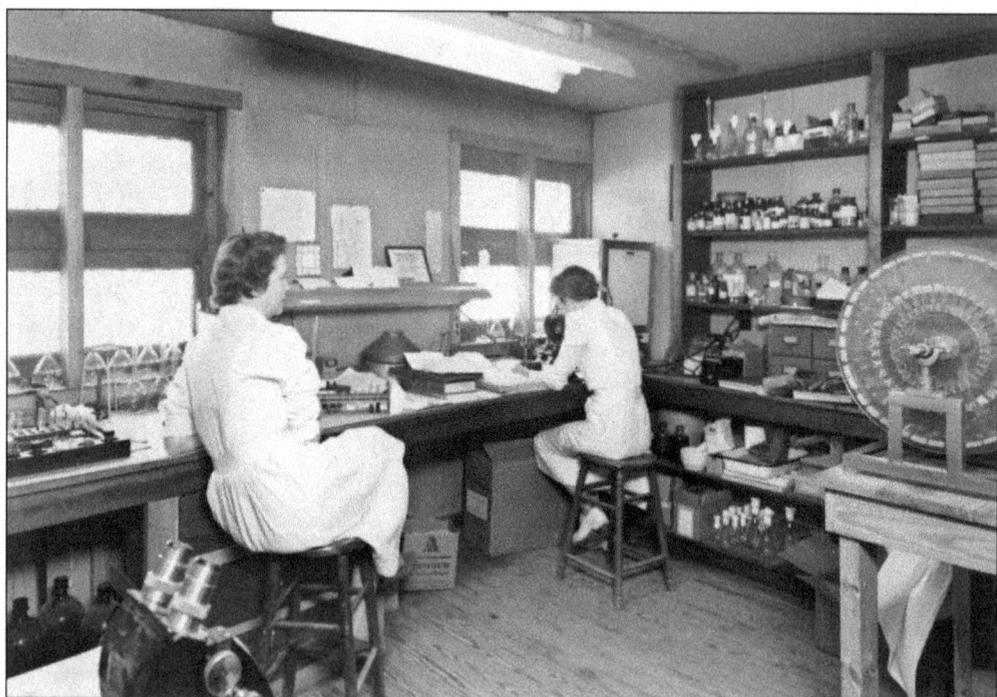

RESEARCH LAB, 1948. From the beginning, Southwestern Medical School was committed to research and garnered worldwide acclaim. The school's mission has always included education, patient care, and research. Despite the appearance of the plywood laboratory, significant contributions to research were made there. (UTSW.)

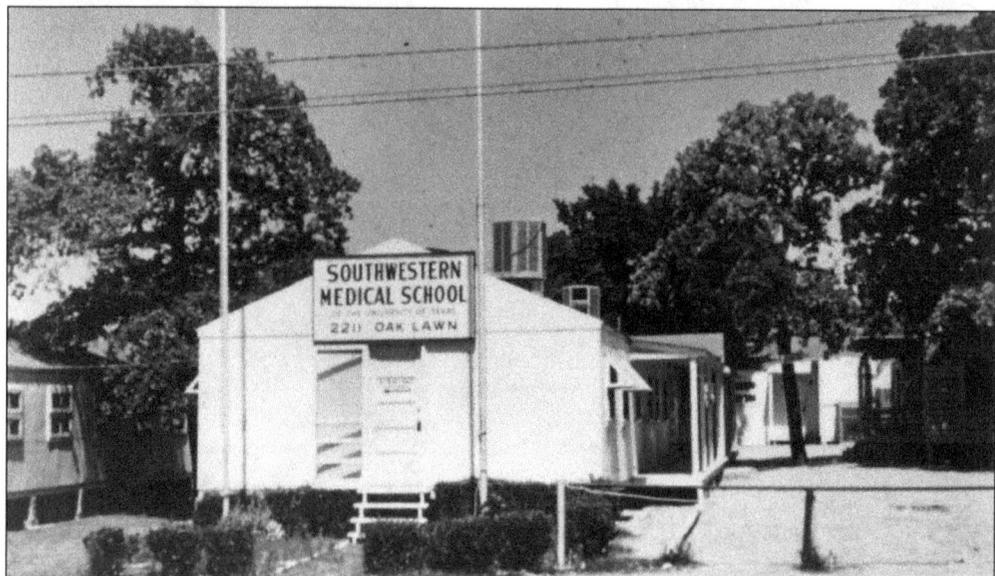

UNIVERSITY OF TEXAS SIGN AT SOUTHWESTERN MEDICAL SCHOOL. Affiliation with a major university was essential for success, according to Dr. Edward H. Cary, and on September 18, 1949, he signed over the ownership of the land, buildings, equipment, and grants to the University of Texas. In the first of many name changes, the school officially became Southwestern Medical School of the University of Texas. (UTSW.)

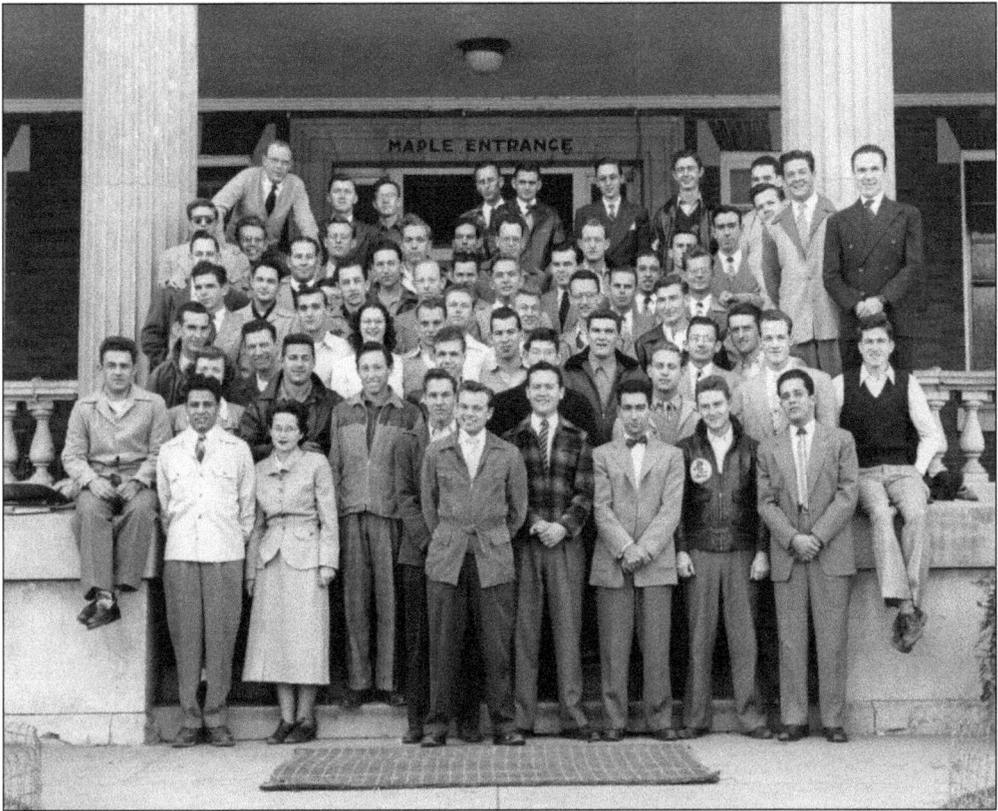

THE CLASS OF 1952. In this 1949 photograph, the future graduating class of 1952 poses on the steps of Parkland Hospital. (UTSW.)

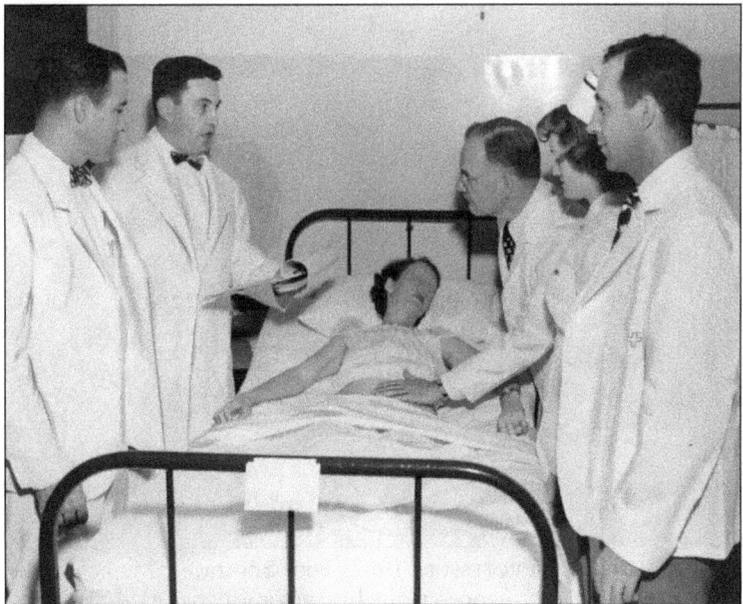

ROUNDS AT PARKLAND, 1950. Southwestern Medical School students and residents gained clinical experience at Parkland Hospital. Dr. William F. Mengert (third from right) was a prominent OB/GYN physician on the faculty. The school's medical-arts department obscured this patient's identity in an early act of patient privacy. (UTSW.)

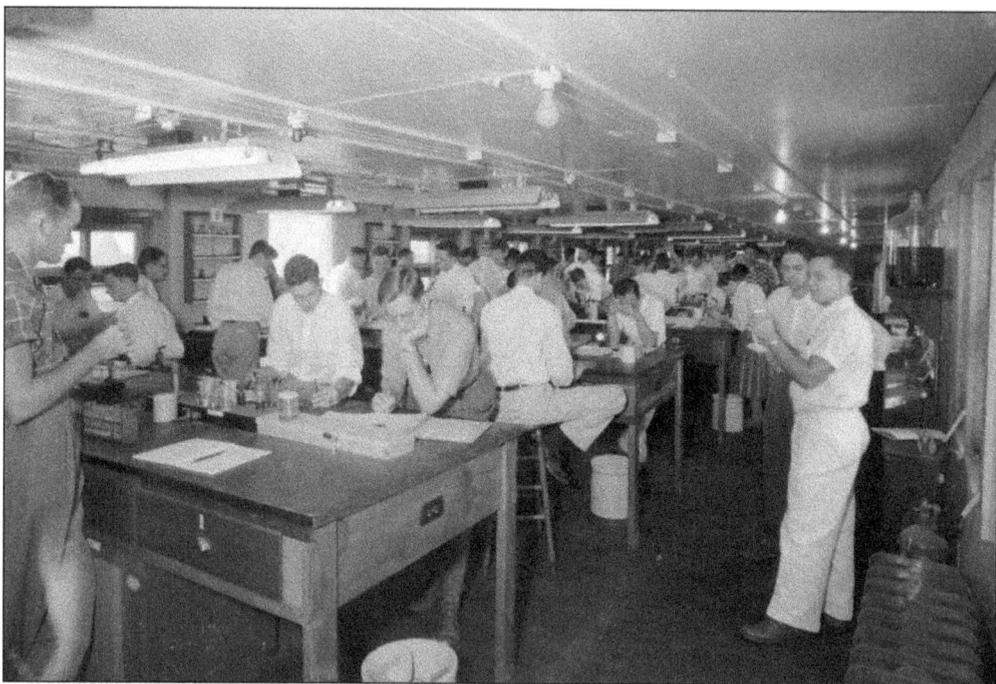

CHEMISTRY LAB, 1951. By the 1950s, military uniforms were less prominent on the Southwestern campus. (UTSW.)

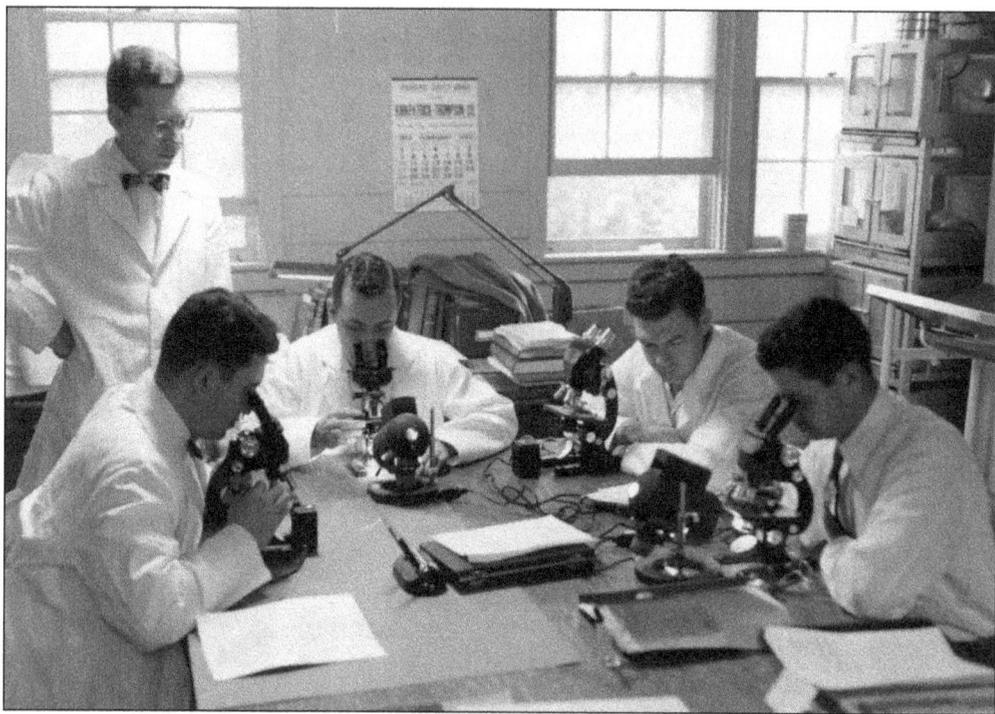

STUDENTS WITH A PROFESSOR, 1952. Four Southwest Medical School students are pictured studying at their microscopes as the instructor watches. (UTSW.)

Dr. Seldin Arrives. When Dr. Donald W. Seldin arrived from Yale University in January 1951, Southwestern Medical School was in a state of advanced decay, and the planned construction of the new school was on the back burner. Upon Dr. Seldin's arrival, he saw the dilapidated plywood buildings and assumed he was at the wrong place. Dr. Seldin sought directions from a nearby gas station and described what he saw; the attendant replied, "That's it, that's the medical school." (UTSW.)

Decaying Shacks. Around the time of Dr. Seldin's arrival, many faculty members were leaving Southwestern for more up-to-date medical schools. Seldin's own department chief left, and for a time, Seldin was the only member of the Internal Medicine Department. "It was kind of lonely," he recalled. Many other departments had no chairman, and the dean of the medical school had also vacated his position. It would take time for Southwestern to realize the financial and physical benefits of affiliating with the University of Texas. (UTSW.)

INTERIOR OF LAB, 1950S. While the school's dilapidated conditions may have tempted Dr. Donald W. Seldin to leave, he saw potential and opportunity in Dallas. Dr. Seldin became the intellectual heart and soul of Southwestern Medical School as he carried on the mission started by Dr. Edward H. Cary. Seldin has been called "one of the two most impactful figures in the history of medicine" by Eugene Braunwald, from Harvard Medical School, and "the only truly great man I know" by a former student. (UTSW.)

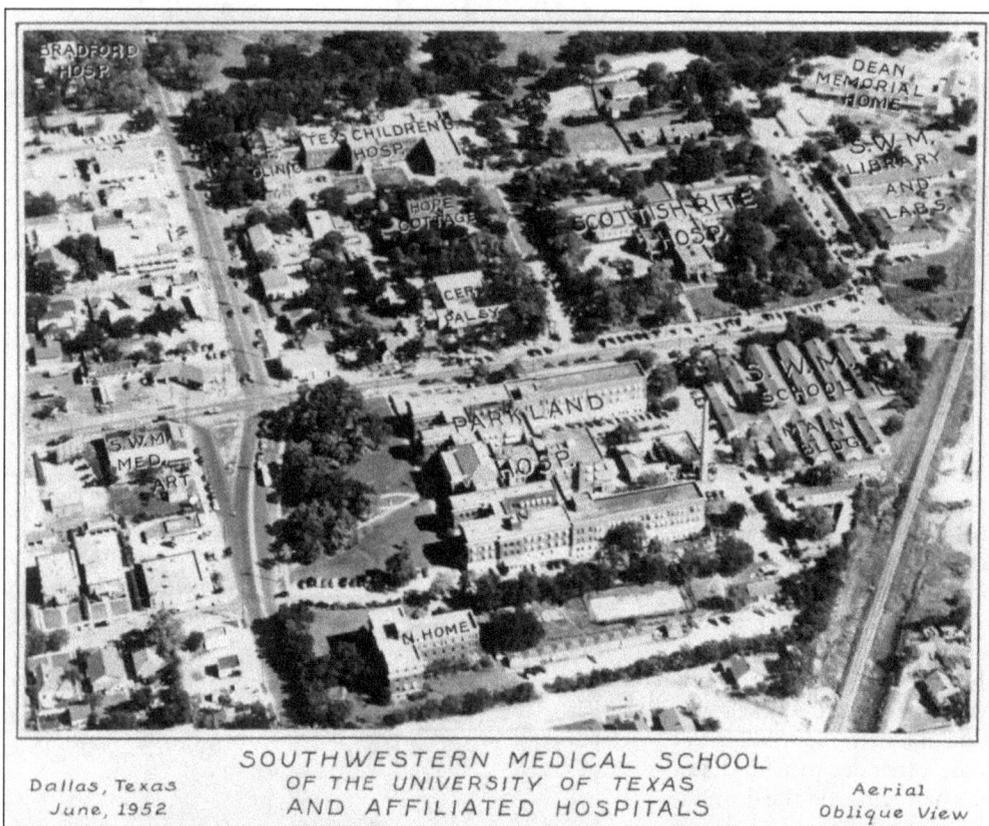

SOUTHWESTERN MEDICAL SCHOOL
OF THE UNIVERSITY OF TEXAS
AND AFFILIATED HOSPITALS

Dallas, Texas
June, 1952

Aerial
Oblique View

THE DEVELOPING MEDICAL CENTER. Despite the declining physical condition of Southwestern Medical School, an impressive medical center had sprouted around Southwestern and Parkland Hospital. By 1952, Texas Scottish Rite Hospital, Texas Children's Hospital, Hope Cottage, Bradford Hospital, and other medical-related businesses had buildings in the surrounding neighborhood. (UTSW.)

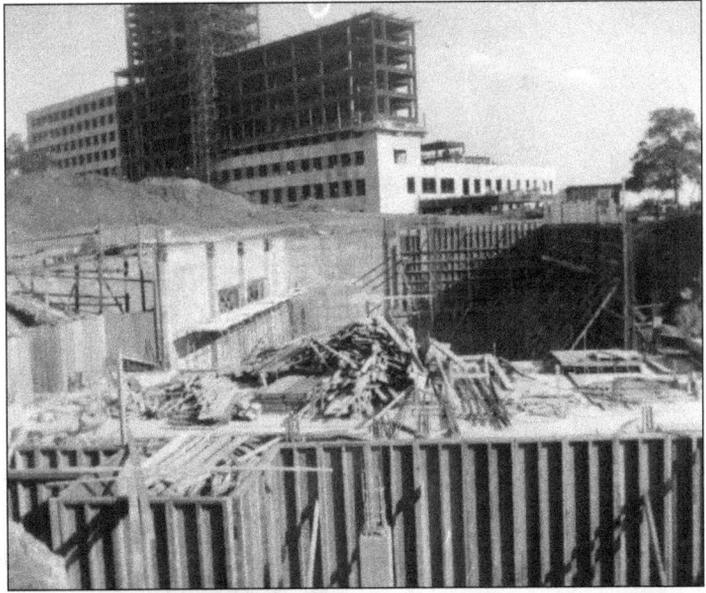

CONSTRUCTION FINALLY BEGINS. With the arrival of Dr. Donald W. Seldin and the start of construction on the new Parkland Memorial Hospital and Southwestern Medical School, hopes began to rise again for Southwestern. Parkland opened its doors on Harry Hines Boulevard on September 25, 1954, and the school's Basic Science Hall opened on the same campus in 1955. (UTSW.)

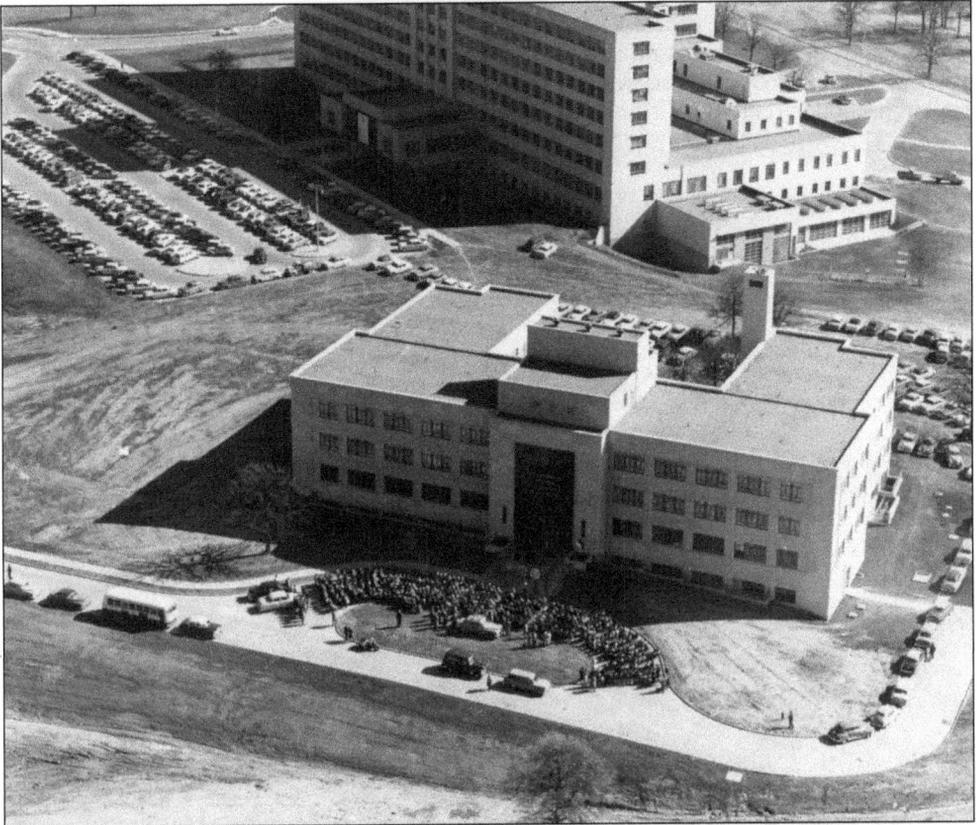

DEDICATION OF SOUTHWESTERN MEDICAL SCHOOL ON HARRY HINES BOULEVARD. In 1955, Southwestern Medical School relocated into its new Basic Science Hall next to Parkland Memorial Hospital. Dr. Seldin and most of the school's faculty would have to wait until 1958, when the Hoblitzelle Clinical Science Building was completed, to finally leave the shacks. (UTSW.)

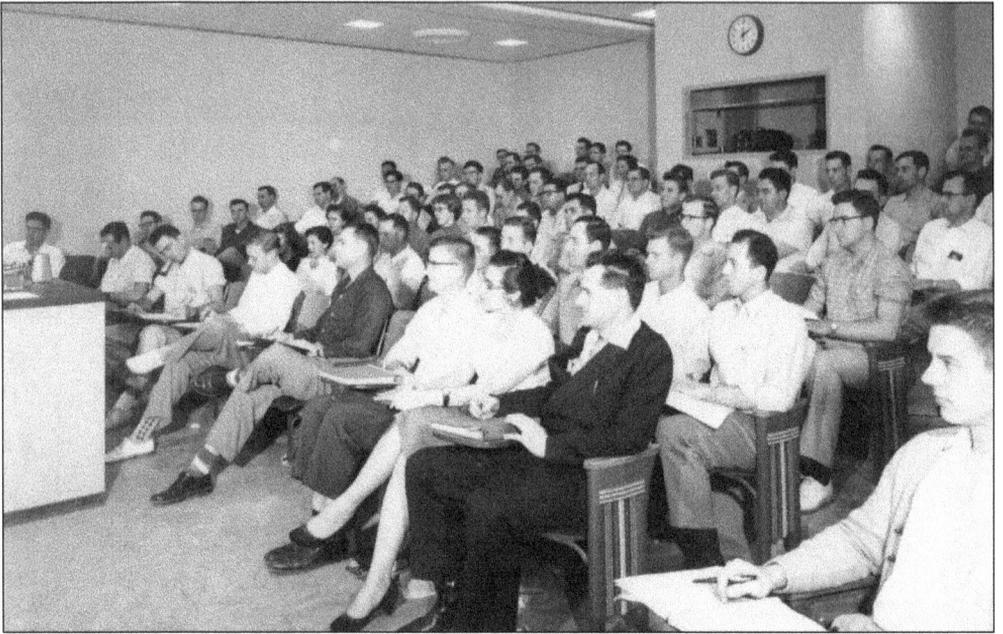

DR. EDWARD H. CARY LECTURE HALL. Dr. Cary died in 1953, prior to the completion of his grand vision. In 1960, the Basic Science Hall was renamed the Edward H. Cary Basic Science Hall in his honor. (UTSW.)

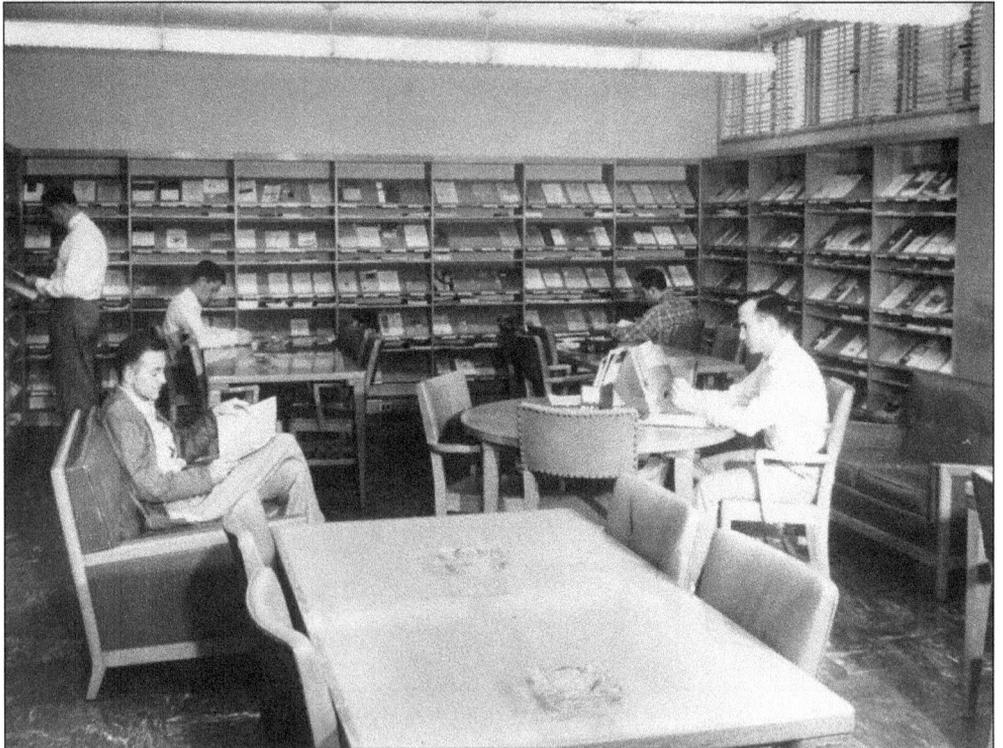

DR. EDWARD H. CARY LIBRARY. The new Southwestern Medical School facilities were a vast improvement over the old shacks. (UTSW.)

STUDENTS IN THE MEDICAL SCHOOL LOBBY, 1950s. In the 1950s, women made up less than 10 percent of the medical students in the United States. Female enrollment in medical schools increased in the 1960s and is now near 50 percent. (UTSW.)

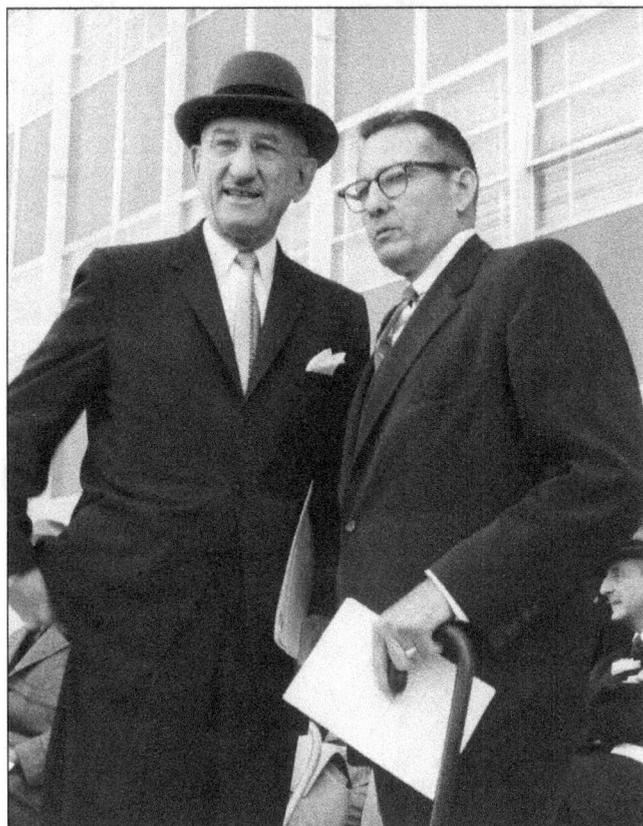

KARL HOBLITZELLE CLINICAL SCIENCE BUILDING DEDICATION, APRIL 16, 1959. Medical school dean Atticus J. Gill (right) and Fred F. Florence (left) presided over the dedication. Florence was a major contributor to the school, and the Fred F. Florence Bioinformation Center was named for him in the 1970s. After Dr. Edward H. Cary's death in 1953, Hoblitzelle became the second president of the Southwestern Medical Foundation. (UTSW.)

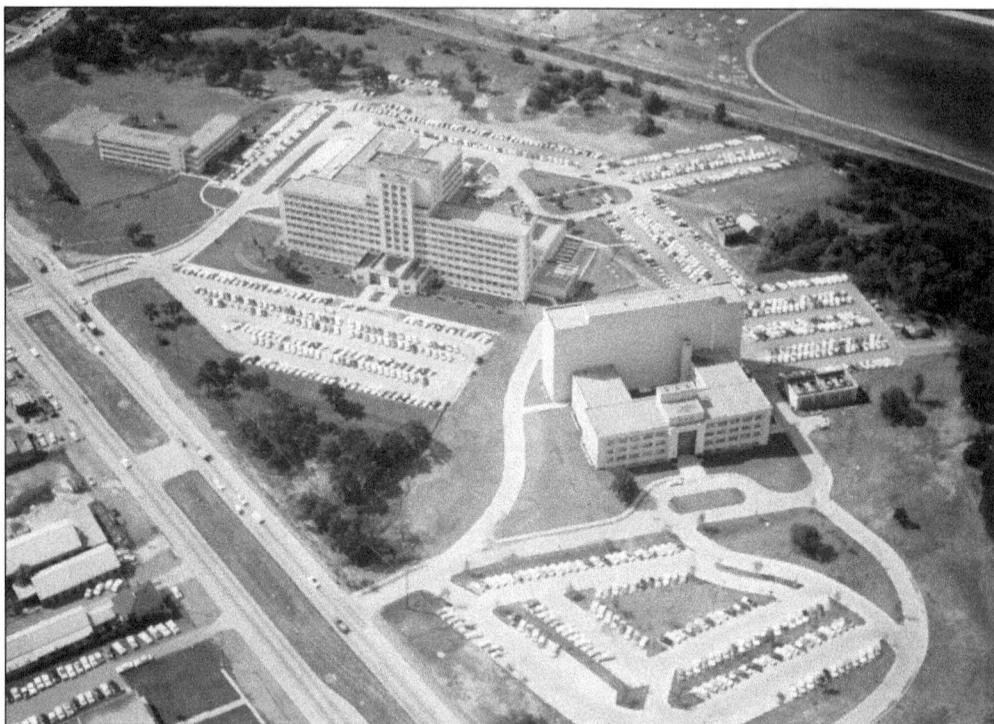

KARL HOBLITZELLE CLINICAL SCIENCE BUILDING. Following the 1958 completion of the Hoblitzelle Building, located directly behind the Edward H. Cary Basic Science Hall, the faculty relocated to the Harry Hines Boulevard campus. By 1959, the school had 500 students, 100 faculty members, a budget of $4 million, and a campus spread across 250,000 square feet. Parkland Memorial Hospital also opened the state's first pediatric infectious disease department that year. (UTA.)

THE SHACKS CLOSE. With the faculty relocated to the Hoblitzelle Building, the old Southwestern Medical School shacks finally closed. (UTSW.)

Three

JFK AND PARKLAND, 1963

"Ahead of the 1964 election, Texas governor John Connally suggested to Pres. John F. Kennedy and Vice Pres. Lyndon Johnson a visit to win voters in the Lone Star State. The November 1963 trip would start in San Antonio then move to Houston, Fort Worth, Dallas, and on to Austin for a fundraising dinner. There would be a speech in every city with live broadcast coverage. While Johnson was a great help to Kennedy in attracting voters across the South, Texas Democrats were divided over state and national policies, hence the need for a meet-and-greet tour to unify the party. Open motorcades, weather permitting, were scheduled at every stop, and First Lady Jacqueline "Jackie" Kennedy, who rarely made such appearances, joined the entourage.

Dallas was a concern, where Kennedy lost to Richard Nixon in 1960, and a small but influential group of extremists railed against almost everything Kennedy did and stood for. Candidate Lyndon Johnson was spat on in 1960, and a housewife struck United Nations ambassador Adlai Stevenson with her protest sign just a few weeks before Kennedy's visit. Both events were deemed unusual, but few expected a physical threat to the president.

Rifle shots changed that, and, in some ways, forever changed Dallas and Parkland Hospital. In the brief three hours Jackie Kennedy was in Dallas, almost half of them were spent at Parkland Hospital, where doctors tried in vain to save her husband's life. Although more than 50 years have passed, every November 22, residents and visitors still remember and wonder what might have been."

Gary Mack
July 29, 1946–July 15, 2015
Curator, The Sixth Floor Museum at Dealey Plaza

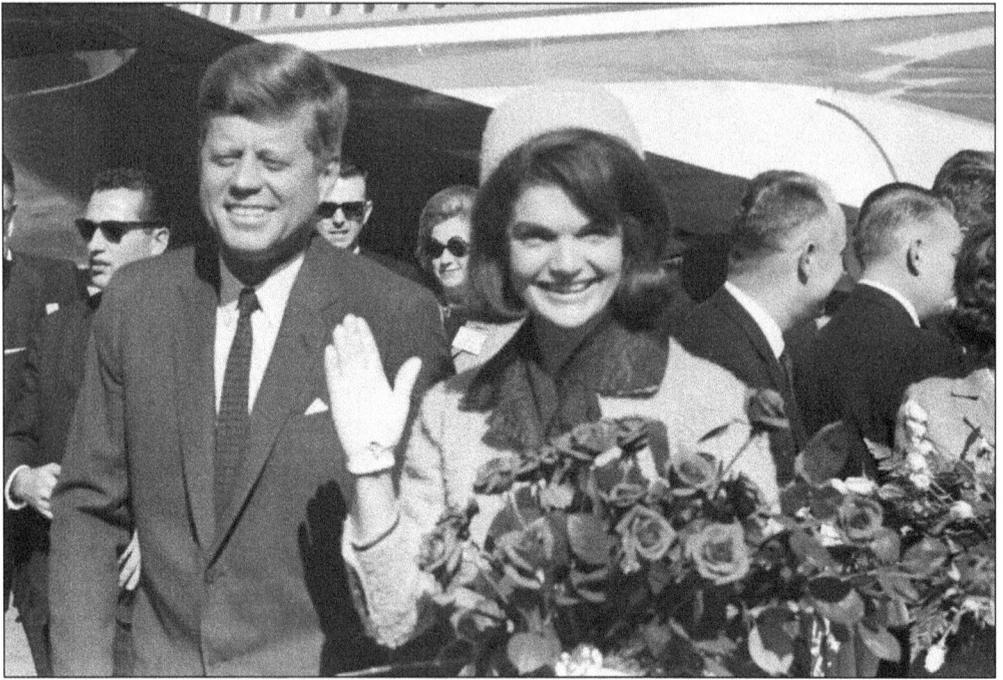

THE KENNEDYS ARRIVE, NOVEMBER 22, 1963. Air Force One arrived at Dallas Love Field about 11:40 am, after a short trip from Carswell Air Force Base. After clouds and drizzle in Fort Worth, a sunny sky greeted the Kennedys in Dallas. Jackie would return to Love Field about three hours later in a new world, with a new president, and her husband in a casket. She would spend nearly half of her brief and tragic visit to Dallas at Parkland Memorial Hospital. (SFM; photograph by Tom Dillard.)

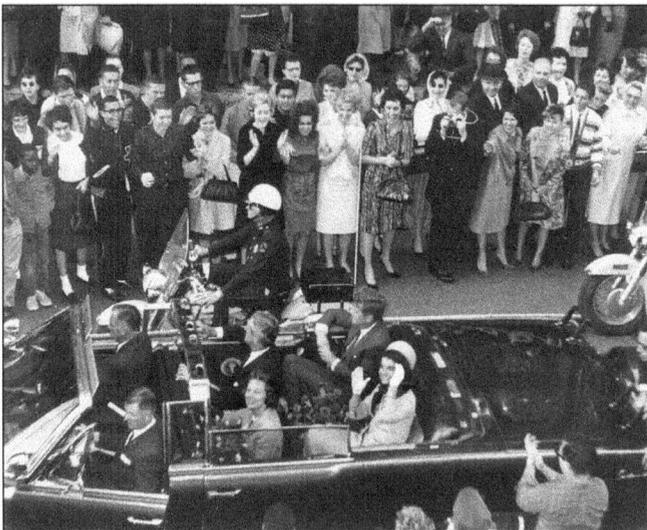

THE PRESIDENTIAL LIMOUSINE MOTORCADE PASSES THE ADOLPHUS HOTEL. The pleasant late-November weather permitted the motorcade to travel through Dallas with the top down on the 1961 Lincoln Continental limousine in which the Kennedys rode. The route was chosen to permit the maximum number of people to see the president and first lady. Seated in front of the Kennedys are Texas governor John Connally and First Lady Nellie Connally. (Arthur Douglas Foster.)

THE SNIPER'S NEST. The Kennedy presidency ended in Dallas around 12:30 p.m. on November 22, 1963, after shots were fired from this sixth-floor window at the Texas School Book Depository. Lee Harvey Oswald was charged with assassinating Pres. John F. Kennedy with a Carcano 6.5-millimeter Italian rifle. This is The Sixth Floor Museum at Dealy Plaza as it appears today. (SFM.)

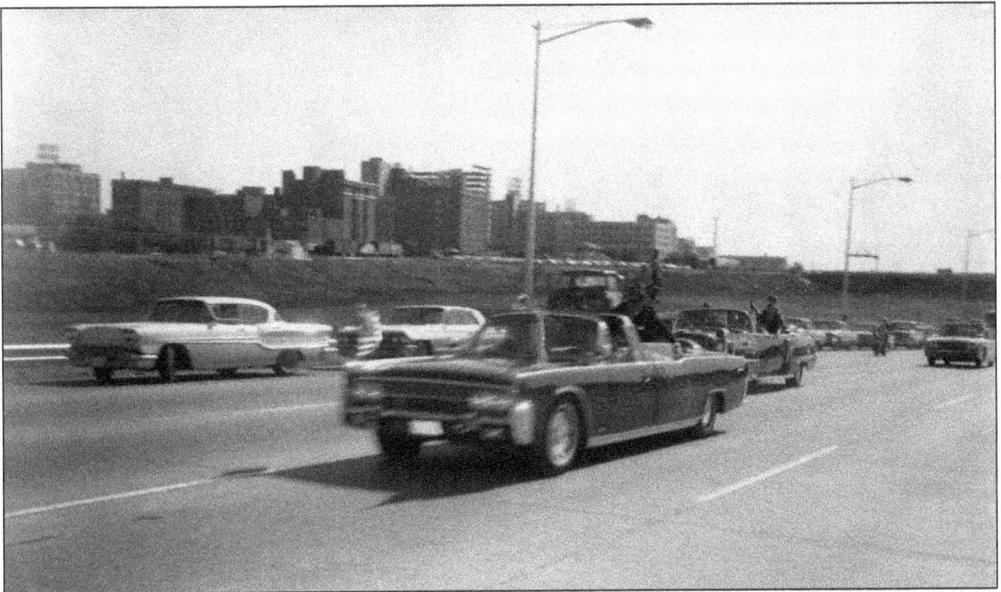

PRESIDENTIAL LIMOUSINE SPEEDING TO PARKLAND MEMORIAL HOSPITAL. After gunshots injured President Kennedy, the limousine sped off with Jackie Kennedy trying to comfort her husband and the federal agent holding onto the back of the car. Texas governor John Connally, who was seated in front of Kennedy, was also hit by the sniper. Secret Service agents had their guns drawn as they rode in the escort car following the limousine. (SFM; DTH Collection.)

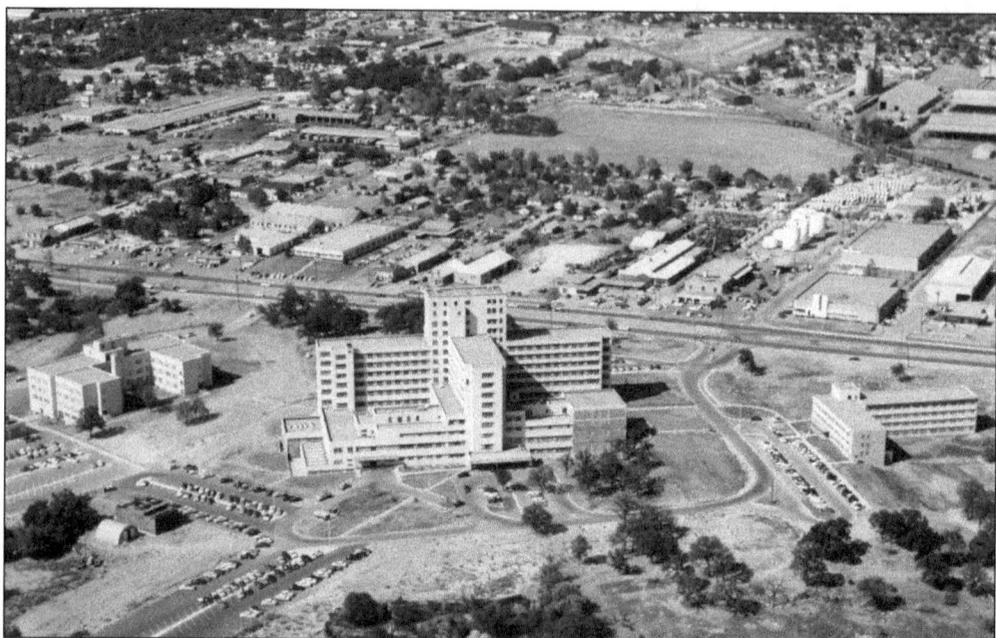

PARKLAND MEMORIAL HOSPITAL, EARLY 1960S. The emergency-room entrance is in the center of the photograph, which shows the back of the hospital. Parkland Hospital was a three-mile drive from the downtown Dallas presidential parade route. The emergency room was notified by police radio that the injured president was en route. (DPL.)

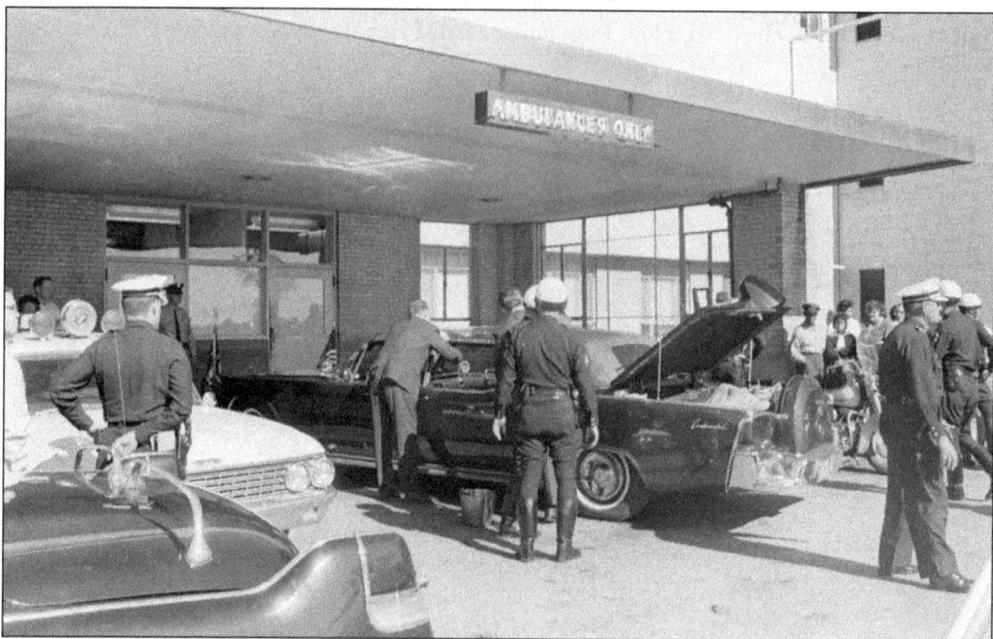

PRESIDENTIAL LIMOUSINE AT THE PARKLAND EMERGENCY ROOM. The presidential limousine arrived at the emergency room's ambulances-only parking area about 12:35 p.m. The gravely injured president and Texas governor John Connally were taken to Trauma Rooms One and Two, respectively. This same 1961 Lincoln Continental limousine remained in service until 1977, serving Presidents Johnson, Nixon, and Ford. (JFK; photograph by Cecil Stoughton.)

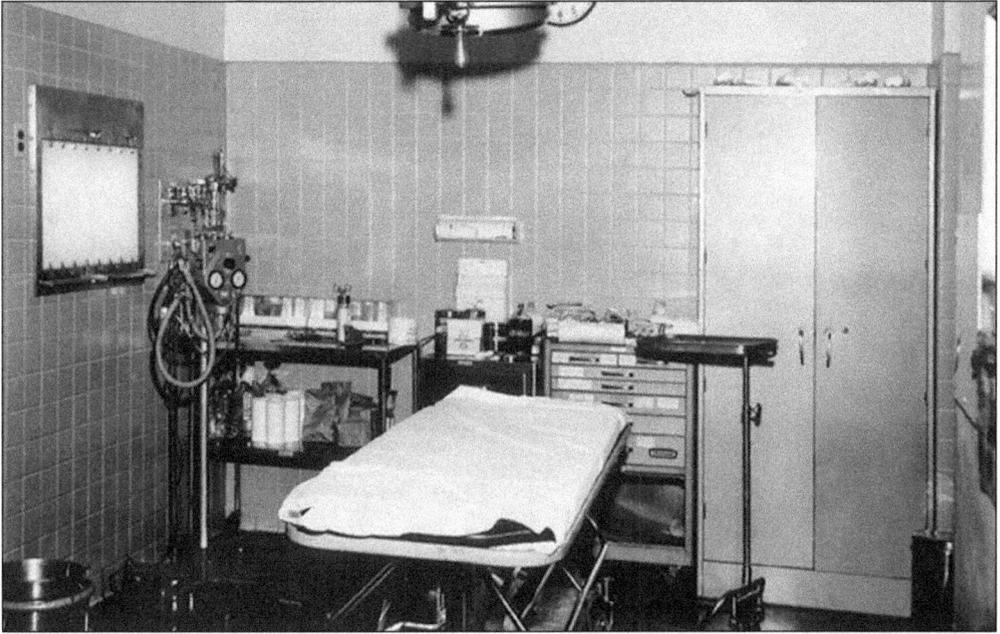

TRAUMA ROOM ONE, 1963. About 16 Parkland doctors and several ER nurses provided care for President Kennedy after his arrival around 12:35 p.m. In the following 25 minutes, the doctors and nurses placed a breathing tube, performed a tracheostomy, inserted chest tubes, and surgically placed several IVs. A heart tracing was never established on the EKG, and despite the staff's efforts, President Kennedy remained a dusky color and pulseless. Jackie Kennedy kept vigil outside Trauma Room One, occasionally trying to enter to be near her mortally wounded husband. (UTSW.)

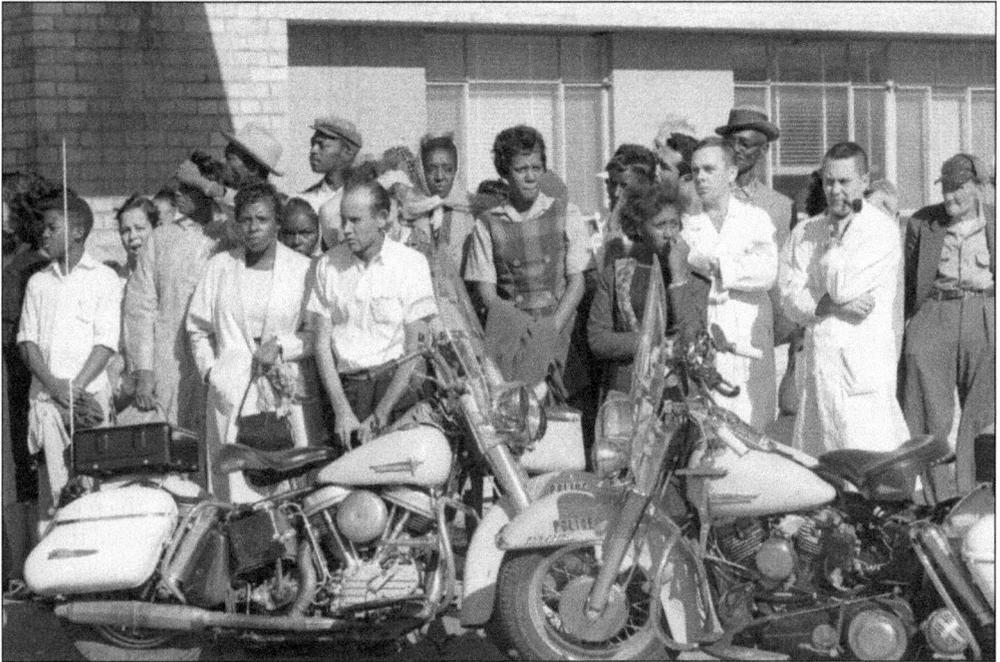

WAITING FOR NEWS OUTSIDE THE EMERGENCY ROOM. Hospital staff, patients, citizens, and press gathered in the parking lot to await news of the president's condition. (SFM; DTH Collection.)

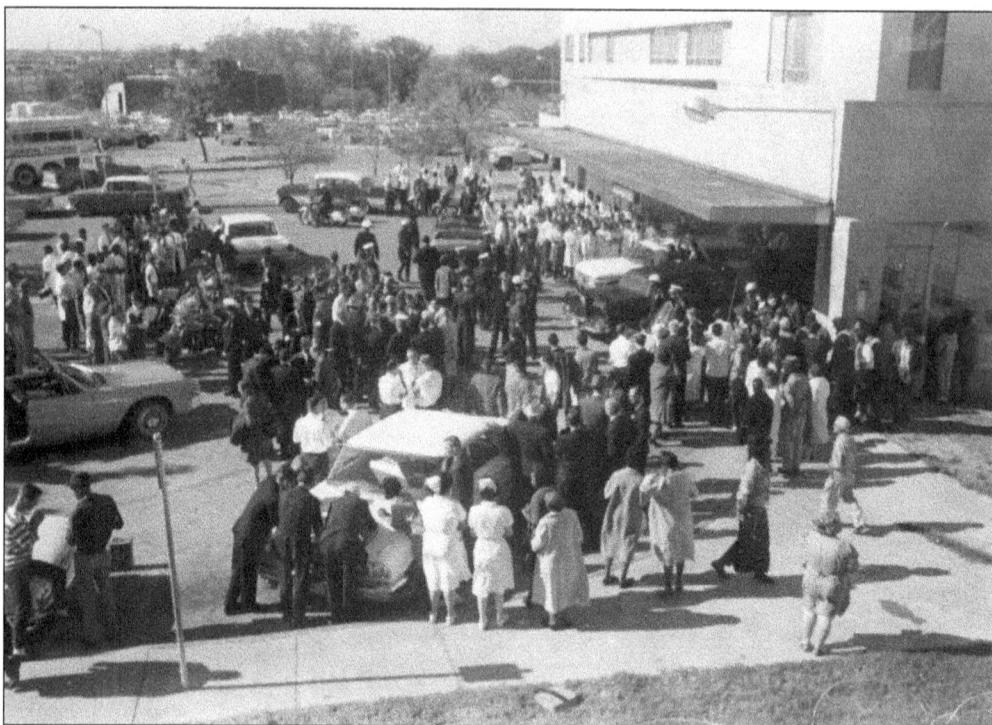

CROWDS GATHER AT PARKLAND MEMORIAL HOSPITAL'S EMERGENCY ROOM. The arrival of the hearse was an ominous sign. Within 40 minutes of Pres. John F. Kennedy's arrival at Parkland, the hospital's flag had been lowered to half-staff. (UTA; photograph by FWST.)

KENNEDY'S DEATH CERTIFICATE. President Kennedy was "blue-white ashen in color" and had no "palpable pulse" according to Dr. Charles Carrico, the first doctor to evaluate JFK. Anyone else may have been declared dead on arrival, making Kennedy's time of death a bit arbitrary, but the transfer of presidential powers and the importance of receiving last rites meant Kennedy's time of death had to be stated precisely. Around 1:00 p.m., the team of physicians concluded that further efforts at resuscitation would not be beneficial. Perhaps more importantly, 1:00 p.m. was also the time Fr. Oscar Hubers completed Kennedy's last rites. (Dallas County.)

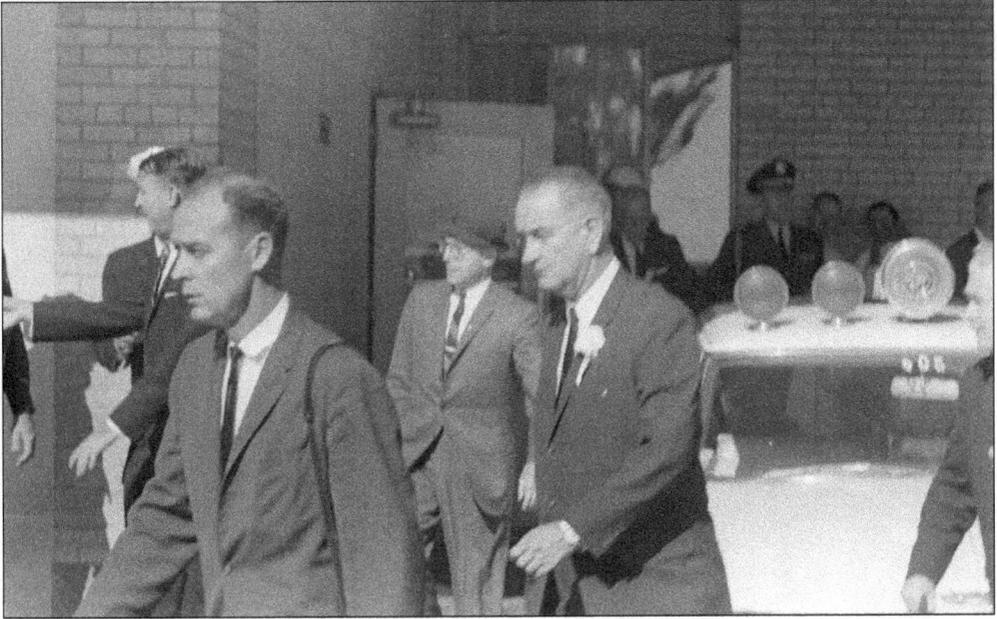

YOUNGBLOOD AND JOHNSON EXIT PARKLAND. When Vice Pres. Lyndon B. Johnson's rental limousine arrived at Parkland, he and his wife, Lady Bird, were quickly escorted by Secret Service into a small, guarded exam room. Johnson was told that Kennedy would probably die, but he did not witness the shooting and was cut off from the activity in Trauma Room One. The Secret Service believed the assassination could be a larger plot, with the vice president as the next target. Secret Service agent Rufus Youngblood (at left in the foreground) recalled, "We didn't know if this is one man, two men, a gang, or an army." LBJ was repeatedly urged to get back to Love Field and fly to the White House. Johnson refused to budge without proof the president was dead; he would not leave his ailing president behind for his own safety. At 1:26 p.m., the Johnsons finally left Parkland under heavy security. Youngblood insisted that Johnson crouch below window level for the duration of the drive to Love Field. (SFM; DTH collection.)

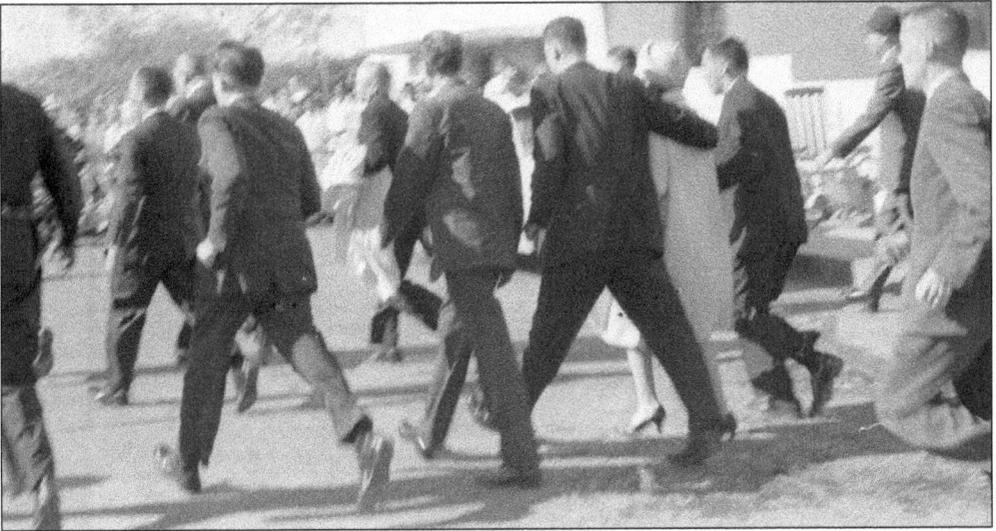

LADY BIRD JOHNSON LEAVES PARKLAND. Lady Bird Johnson (in white dress and hat) recalled her escort out of Parkland as a "swift and tense walk." (SFM; DTH collection.)

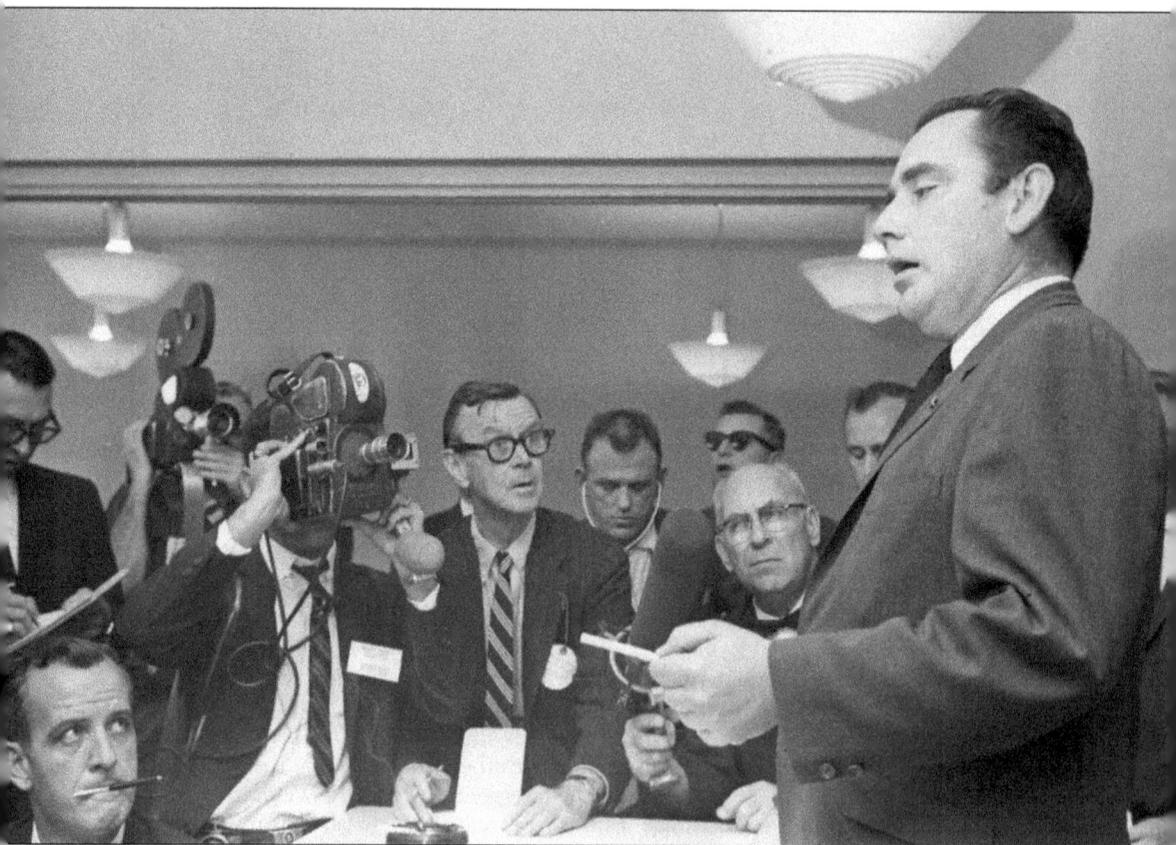

THE WORLD LEARNS PRESIDENT KENNEDY IS DEAD. Lyndon Johnson and the Secret Service instructed White House assistant press secretary Malcolm Kilduff to delay announcing Kennedy's death until Johnson was out of Parkland and on his way to the relative safety of Air Force One. A classroom near the emergency room was hastily converted into the press room shown in this photograph. The first radio broadcast announcing President Kennedy's death was made at 1:22 p.m. Walter Cronkite delivered the first televised announcement at 1:38 p.m. (SFM; DTH collection.)

PARKLAND'S FLAG AT HALF-STAFF.
Even before Lyndon Johnson
left Parkland Memorial Hospital
and the official press conference
announcement was made, the
hospital's flag had been lowered
to half-staff. (UTA; FWST.)

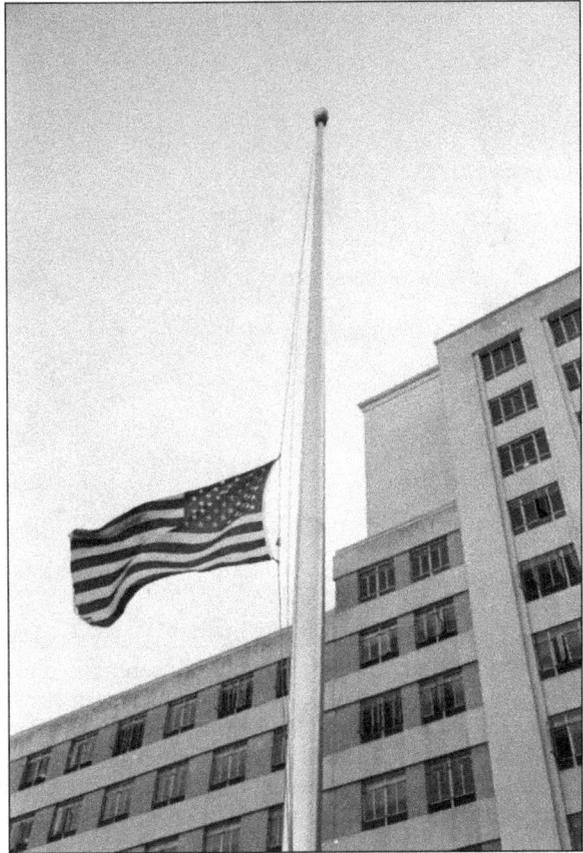

**PARKLAND DOCTORS DISCUSS
KENNEDY'S TREATMENT.** After
Malcolm Kilduff made the initial
announcement about President
Kennedy's death, Parkland Memorial
Hospital doctors explained the steps
they took in their attempts to save
the president's life. (UTA; FWST.)

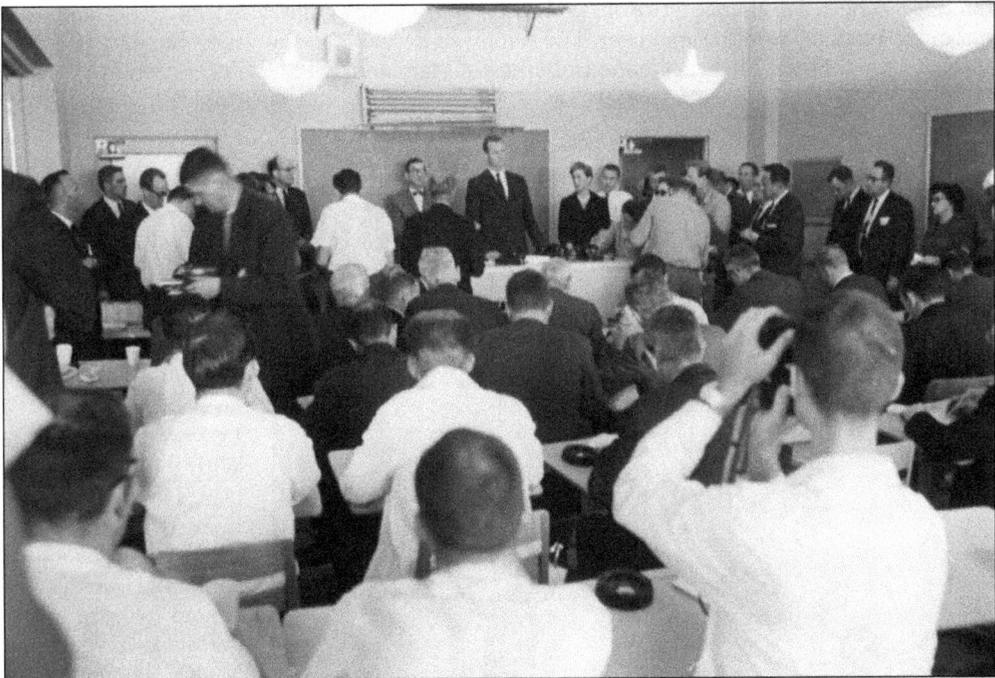

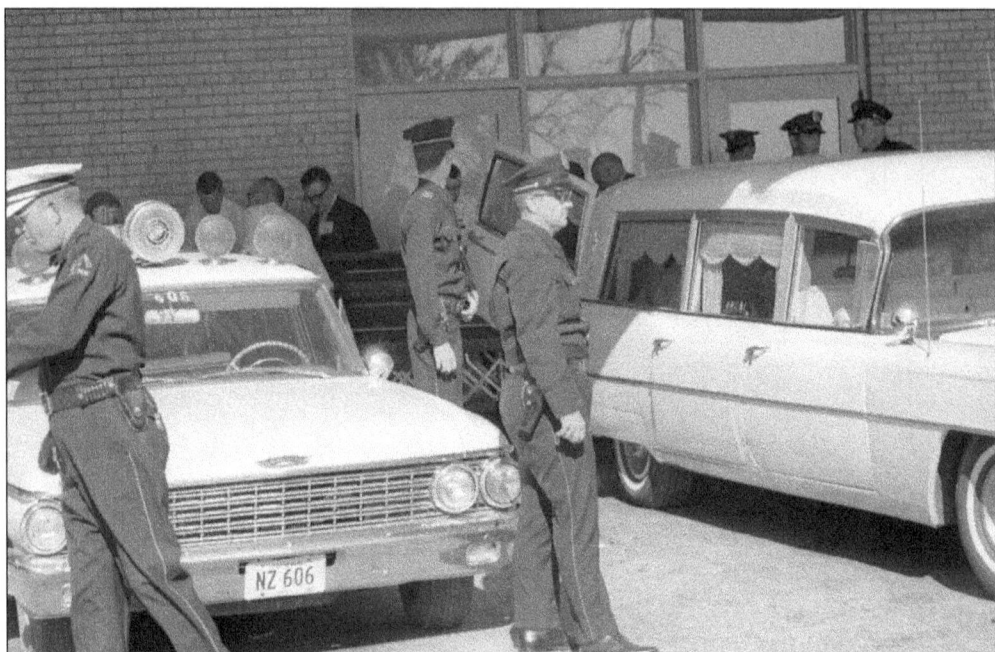

THE AUTOPSY ARGUMENT. Lyndon Johnson refused to depart on Air Force One without Jackie Kennedy; she refused to leave Parkland without her husband's body. This created a dilemma for federal agents. Getting Johnson to the relative safety of Air Force One at 30,000 feet meant that Jackie and the body of John F. Kennedy both had to be on board. As federal agents rushed Kennedy's casket to the waiting hearse, Dr. Earl Rose, medical examiner, physically confronted the agents. Dallas law required that an autopsy be performed on all homicide victims, and Dr. Rose was determined to stop the agents from taking the body away from Parkland before it had been autopsied. A heated exchange broke out in the emergency room's hallway; federal agents (and their automatic weapons) won the argument. The autopsy of Kennedy's body was eventually performed at the National Naval Medical Center in Bethesda, Maryland. (SFM; DTH collection.)

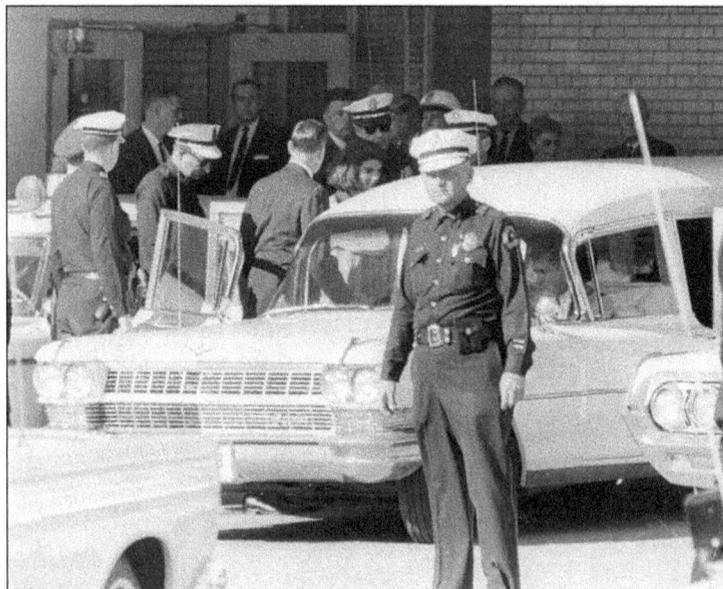

JACKIE KENNEDY LEAVING PARKLAND. With the casket loaded and Jackie Kennedy on board, the hearse left Parkland Hospital around 1:40 p.m. (SFM; *Dallas Morning News* Collection.)

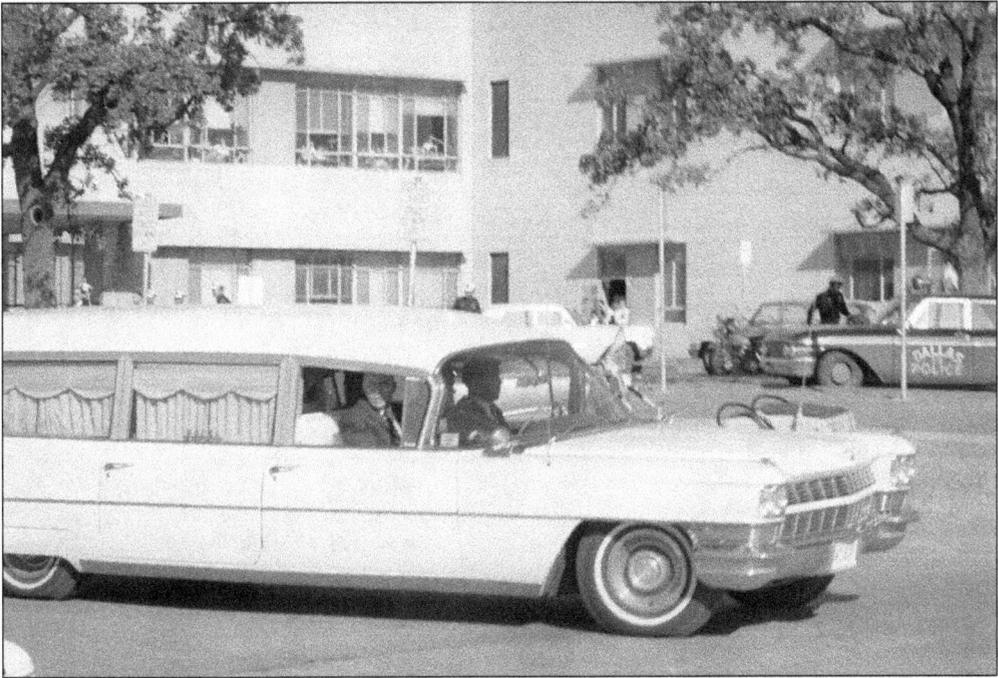

THE HEARSE LEAVES PARKLAND FOR LOVE FIELD. Jackie Kennedy and the body of Pres. John F. Kennedy arrived at Love Field around 2:14 p.m. Lyndon B. Johnson was administered the presidential oath of office by Judge Sarah T. Hughes at 2:40 p.m., and Air Force One departed Dallas at 2:46 p.m., about three hours after it had arrived. (SFM; DTH Collection.)

TEXAS GOVERNOR SIGN. Texas governor John Connally sustained injuries to his chest, wrist, and thigh. How three bullets fired from the sixth floor of the depository could have created so many injuries remains an ongoing debate and a never-ending topic of discussion amongst conspiracy theorists. While Connally accepted the general conclusions of the Warren Commission, he was never convinced of their ballistic report. He was treated in Trauma Room Two, then taken to the operating room. During his recovery at Parkland Memorial Hospital, he continued to act as governor, and he placed this cardboard sign in his hospital room. (Blanche Connally Kline and SFM.)

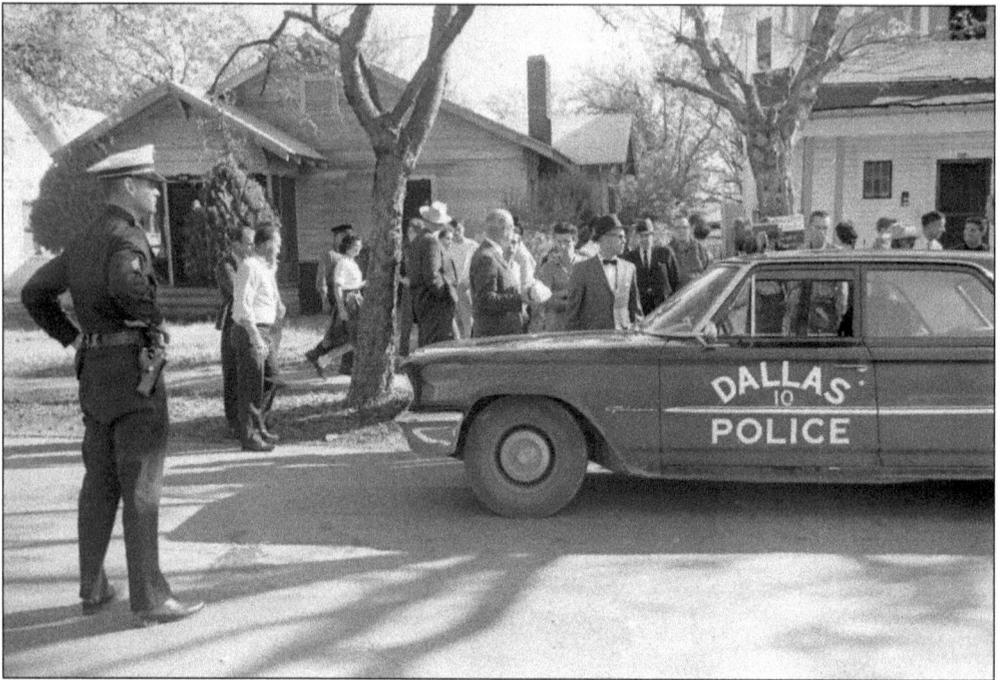

OFFICER J.D. TIPPIT MURDER SCENE. Dallas police officer J.D. Tippit was patrolling his usual beat in south Oak Cliff on November 22, 1963. Around 1:14 p.m., he approached a man walking down East Tenth Street who roughly matched the police radio report of the suspect in the shooting of Pres. John F. Kennedy. After exchanging words with the man through the open car window, Tippit stopped to further investigate. As Tippit exited his police car and approached, the man, who was indeed Lee Harvey Oswald, fired three shots into Tippit's chest with a .38-caliber pistol. Oswald then delivered a kill shot to the fallen officer's right temple. Oswald was arrested a few blocks away for "acting suspiciously" when he entered the Texas Theater without a ticket. (SFM; DTH Collection.)

```
    LSC992 NSA554

    DA351  D LLN364 PD FAX DALLAS TEX 24 608P CST

    MRS JOHN F KENNEDY

        WASHDC

    MAY I ADD MY SYMPATHY TO THAT OF PEOPLE ALL OVER THE WORLD.

    MY PERSONAL LOSS IN THIS GREAT TRAGEDY PREPARES ME TO SYMPATHIZE

    MORE DEEPLY WITH YOU

        MRS J D TIPPIT DALLAS TEX

    (34).
```

MARIE TIPPIT'S TELEGRAM. Officer J.D. Tippit's wife, Marie, sent Jackie Kennedy this condolence via telegram. Officer Tippit was later awarded the Medal of Valor from the National Police Hall of Fame, the Police Medal of Honor, the Police Cross, and the Citizen's Traffic Commission Award of Heroism. He left behind a wife and three young children. (JFK.)

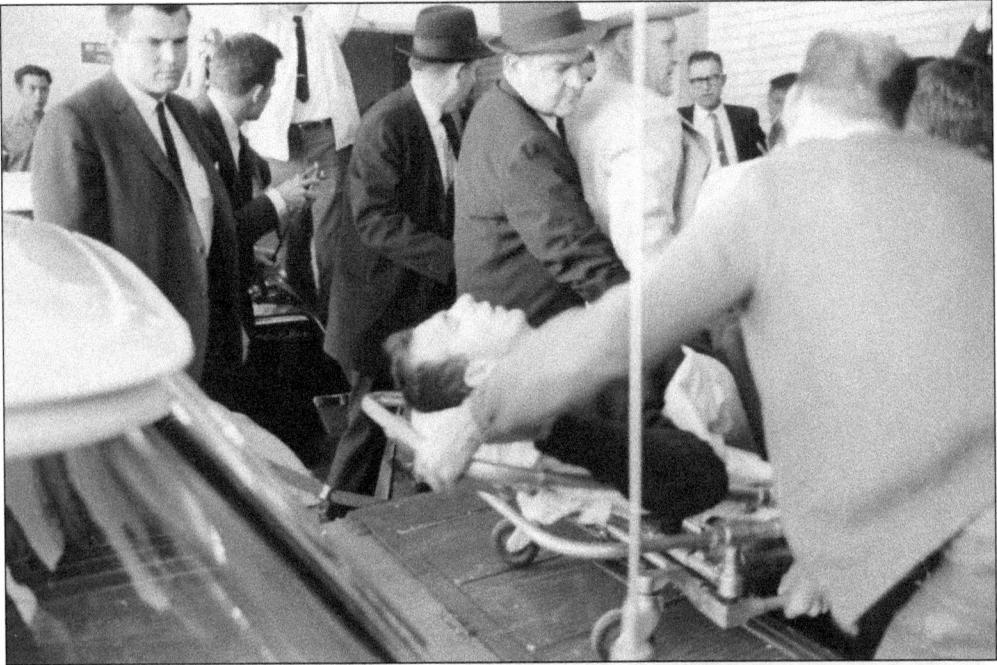

LEE HARVEY OSWALD IS SHOT. Oswald was charged with the murder of Officer J.D. Tippit on November 23 and with Kennedy's assassination early the next morning. As Oswald was being escorted to an armored car for transfer to the Dallas County Jail, Jack Ruby stepped out of a crowd of reporters and fired a Colt Cobra .38 revolver into Oswald's abdomen at 11:21 am. Oswald is shown here being transported into the Parkland Memorial Hospital emergency room. (SFM.)

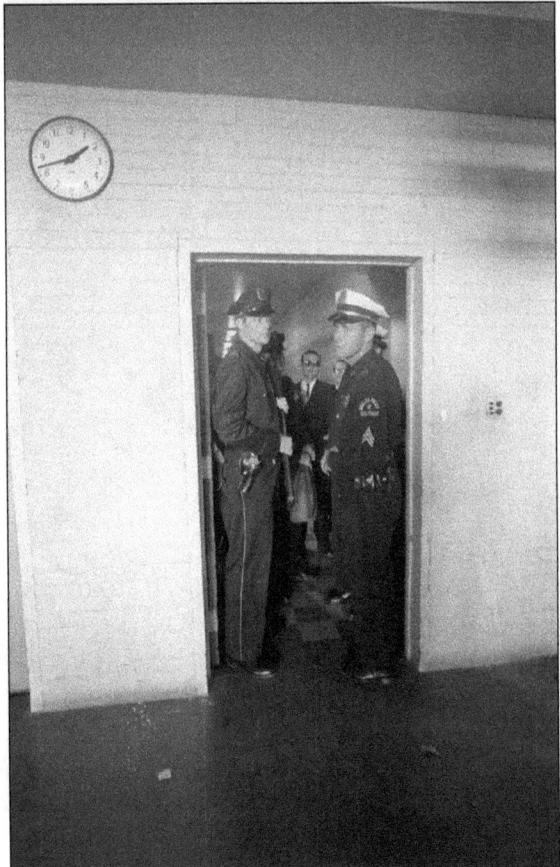

GUNS AND POLICE RETURN TO PARKLAND. Two days after the assassination of President Kennedy, police and guns returned to the Parkland Memorial Hospital after Oswald arrived. Oswald was treated in Trauma Room Two and rushed to surgery. (SFM; DTH Collection.)

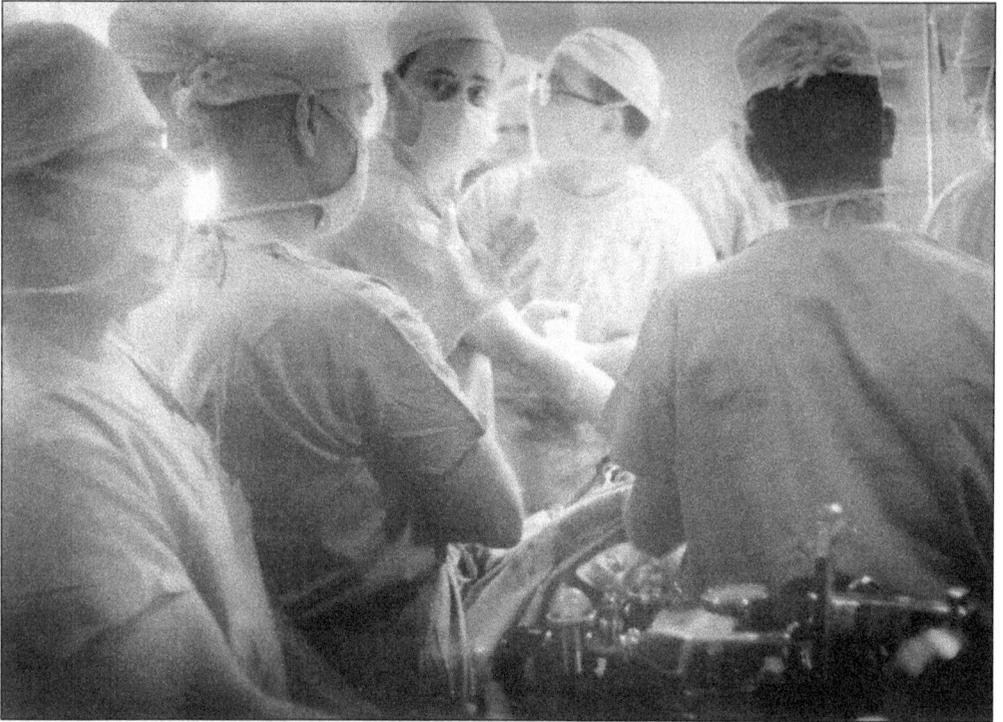

LEE HARVEY OSWALD IN SURGERY AT PARKLAND. Oswald did not survive his injuries; he died in the operating room at 1:07 p.m. (BU; photograph by J. Gary Shaw.)

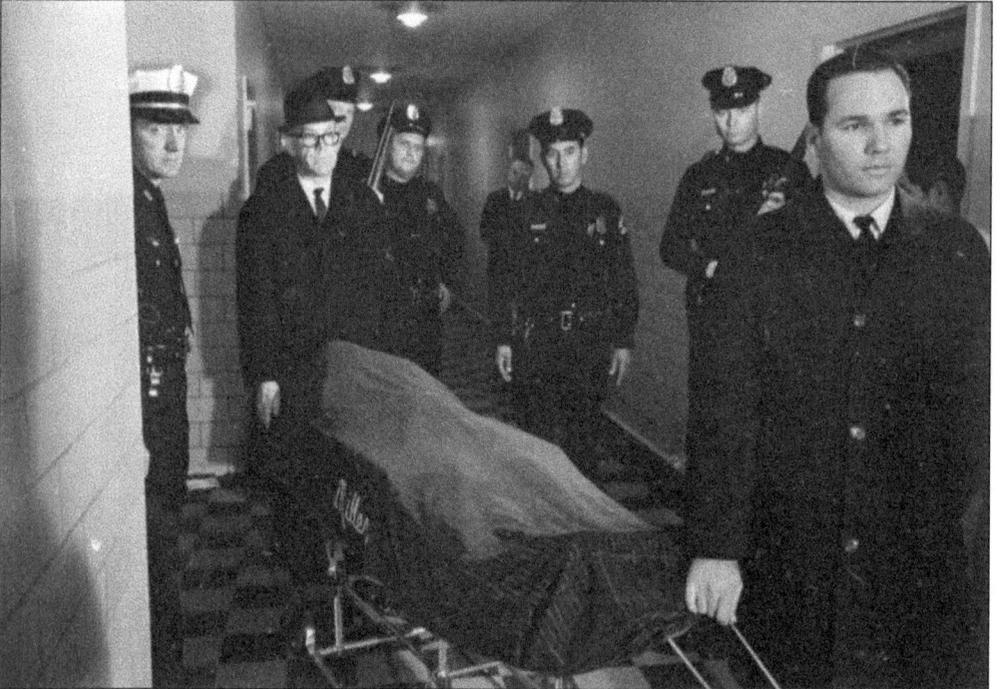

OSWALD'S BODY LEAVING PARKLAND. Following his autopsy in the Parkland morgue, the Miller Funeral Home removed Lee Harvey Oswald's body on November 24, 1963. (UTA; FWST.)

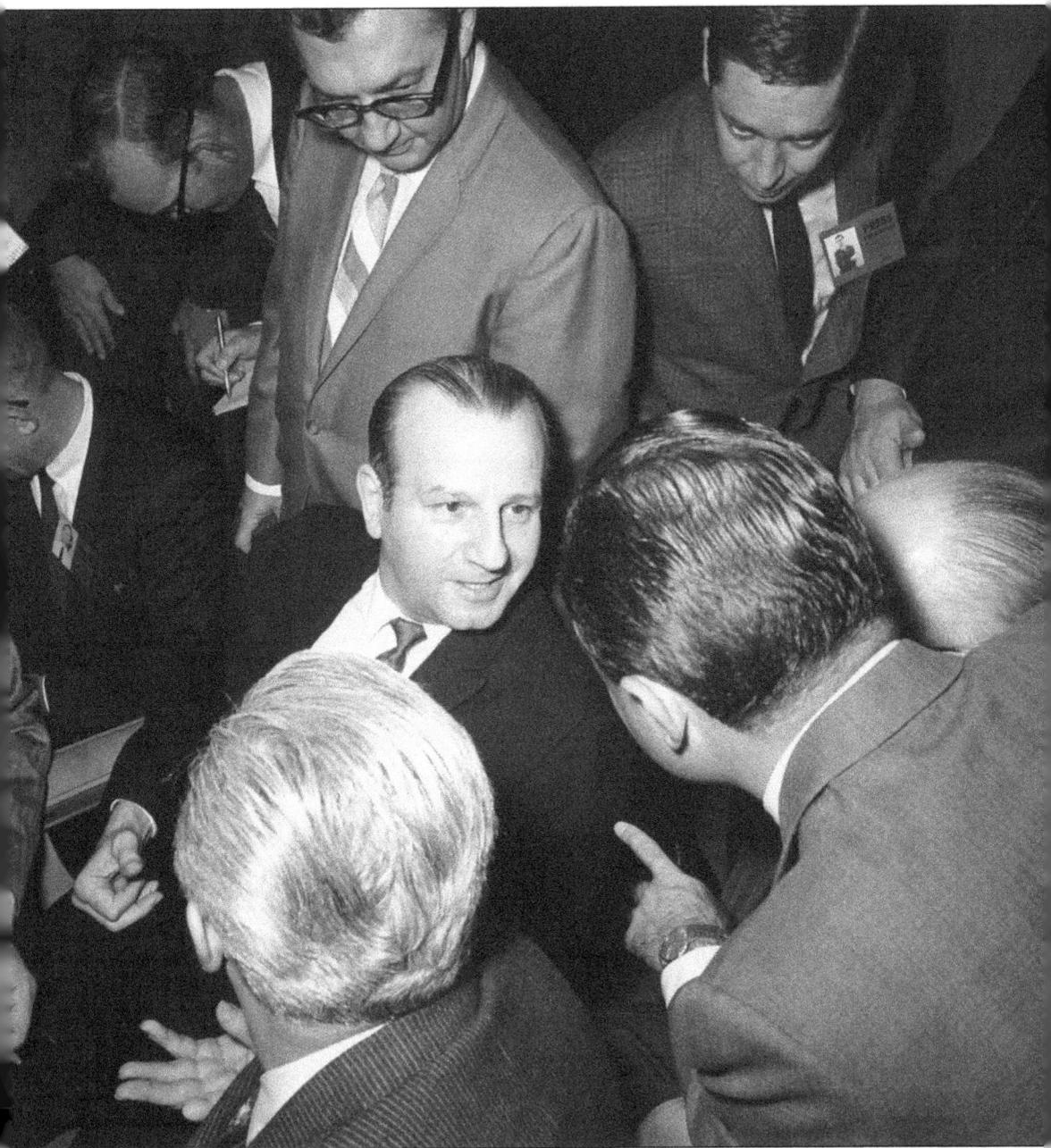

JACK RUBY IN COURT, 1964. Born Jacob Rubenstein, Jack Ruby gunned down Lee Harvey Oswald on November 24, 1963, in the basement of the old Dallas City Hall. Ruby was sentenced to death for the murder in 1964. He stated he shot Oswald to prevent "Mrs. Kennedy the discomfiture of coming back to trial" and to help Dallas redeem itself. In 1966, the Texas Court of Criminal Appeals granted Ruby a second trial. Ruby was admitted to Parkland Memorial Hospital on December 6, 1966, with pneumonia. He was diagnosed with advanced lung cancer and died at Parkland on January 3, 1967—one month before his new trial date. (SFM; photograph by Bill Winfrey.)

DALLAS COUNTY HOSPITAL DISTRICT

Office Memorandum
November 27, 1963

To: All Employees

At 12:38 p.m., Friday, November 22, 1963, President John F. Kennedy
and Texas' Governor John Connally were brought to the Emergency Room of
Parkland Memorial Hospital after being struck down by the bullets of an
assassin.

At 1:07 p.m., Sunday, November 24, 1963, Lee H. Oswald, accused
assassin of the late president, died in an operating room of Parkland
Memorial Hospital after being shot by a bystander in the basement of
Dallas' City Hall. In the intervening 48 hours and 31 minutes Parkland
Memorial Hospital had:

1. Become the temporary seat of the government of the United States.

2. Become the temporary seat of the government of the State of Texas.

3. Become the site of the death of the 35th President.

4. Become the site of the ascendency of the 36th President.

5. Become site of the death of President Kennedy's accused assassin.

6. Twice become the center of the attention of the world.

7. Continued to function at close to normal pace as a large
 charity hospital.

What is it that enables an institution to take in stride such a
series of history jolting events? Spirit? Dedication? Preparedness?
Certainly, all of these are important, but the underlying factor is
people. People whose education and training is sound. People whose
judgment is calm and perceptive. People whose actions are deliberate
and definitive. Our pride is not that we were swept up by the whirlwind
of tragic history, but that when we were, we were not found wanting.

C. J. Price
Administrator

LETTER TO PARKLAND MEMORIAL HOSPITAL EMPLOYEES. This letter from hospital administrator
C. Jack Price details the historic 48-hour ordeal at Parkland Hospital. (PH.)

TRAUMA ROOM ONE, C. 1973. Trauma Room One remained in use for thousands of other major trauma victims over the next decade, with little change other than a small lock to keep out the curious. This photograph was taken a decade after President Kennedy's death and just before the emergency room was remodeled. (SFM; photograph by Don Pyeatt.)

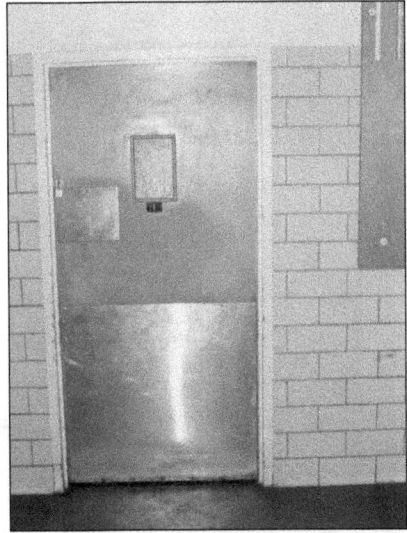

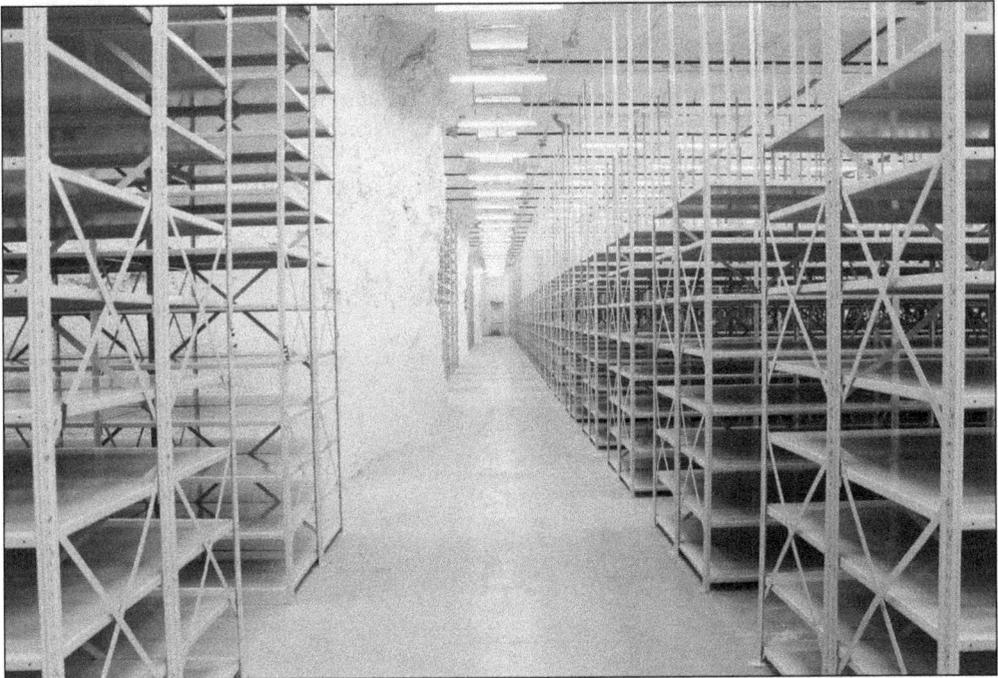

STORAGE FACILITY, KANSAS. Prior to the remodeling of the hospital, Parkland administrators asked the Smithsonian if they wished to acquire Trauma Room One and its medical equipment. The JFK Presidential Library was consulted and concluded it should be given to the National Archives. While Parkland's goal may have been historical preservation, the library's goal was to keep the room and its contents "out of the hands of anyone who might seek to use them in any inappropriate way." Trauma Room One was dismantled on August 17 and 18, 1973. The door, cabinets, lights, ceiling tiles, plumbing, dust, and debris were packed into crates and barrels. In 2008, the remains of Trauma Room One were moved from Fort Worth to the Lenexa Federal Records Center in Kansas. "It's in a secure location," the Central Plains Region administrator stated. "Basically, it's not to be examined, not to be shown to the press, not to be photographed, not to be exhibited to the public." (Hunt Midwest.)

TRAUMA ROOM ONE SIGN. When Parkland Hospital's Trauma Room One was dismantled and removed, an ambulance driver believed that the door's sign, at least, should be preserved for history, and it was removed prior to the room's removal in 1973. This sign is likely all that current or future generations will ever see of Trauma Room One. (Timothy Stiles and SFM.)

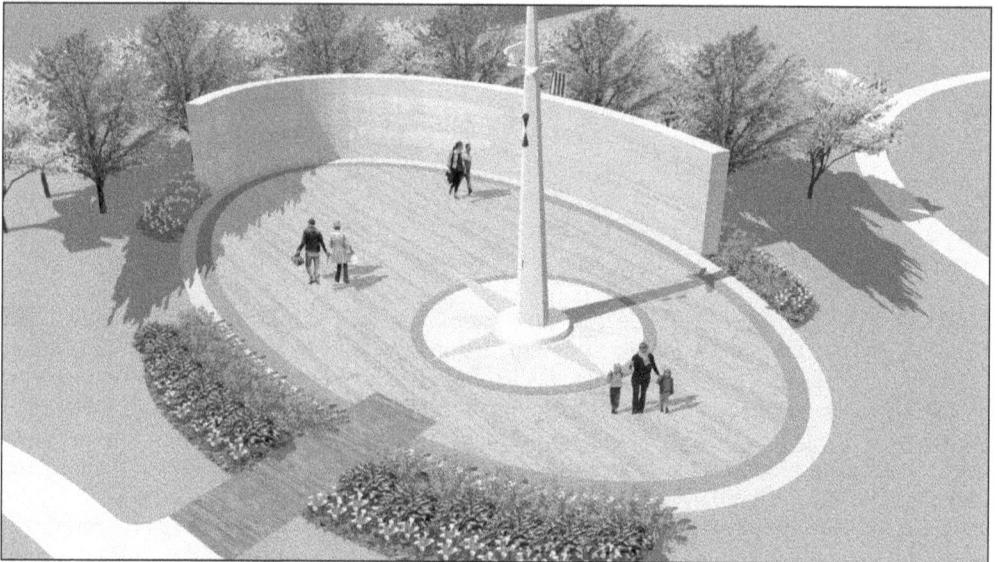

PLANNED JOHN F. KENNEDY MEMORIAL GARDEN AT THE NEW PARKLAND. The indoor Kennedy tribute at Parkland was moved across the street to the New Parkland in 2015. An outdoor memorial garden is planned to be completed by 2016. (PH.)

Four

FIFTY YEARS OF GROWTH

Parkland Memorial Hospital and UT Southwestern Medical School began an accelerated construction phase in the mid-1960s and 1970s. Southwestern Medical School affiliated with the University of Texas in 1949 and became one of the nation's most respected medical schools. Parkland established itself as a busy labor and delivery center, with high-risk obstetrics and a neonatal intensive-care unit. Transplant services expanded, and Parkland's emergency room's triage system and trauma care became the accepted standard across the country and beyond. Parkland and Southwestern affiliated with many area hospitals by providing teaching staff and residents.

UT Southwestern Medical School's physical expansion surpassed that of Parkland as it grew to multiple campuses. Education, research, and patient care remained the mission of the medical school, which also expanded to offer degrees in nutrition, physician assistance, and radiation therapy, as well as several graduate biomedical programs. UT Southwestern added six Nobel Prize winners to its faculty, more than any other university. The full-time teaching faculty grew from around 100, in the 1950s, to over 2,300 by 2015, including 23 members of the National Academy of Sciences. Karl Hoblitzelle's prediction, made in the 1950s, became a reality: "These buildings, these towers of hope for the future will in the not-too-distant day stand in the midst of a medical center second to none".

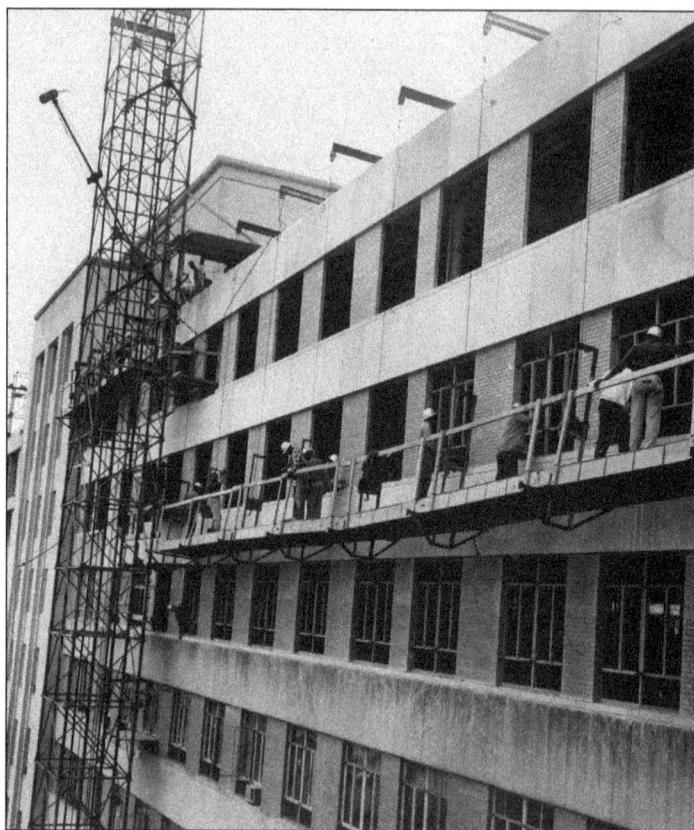

CONSTRUCTION
BEGINS, 1964. After
10 years in the Harry
Hines Boulevard
location, Parkland
Memorial Hospital and
Southwestern Medical
School were ready to
update and expand. (PH.)

PARKLAND GETS THREE
NEW FLOORS. Voters
approved a $7.5-million
bond for the expansion
of the hospital. The
subtle difference in
color of the bricks used
in the addition is still
apparent today. (UTSW.)

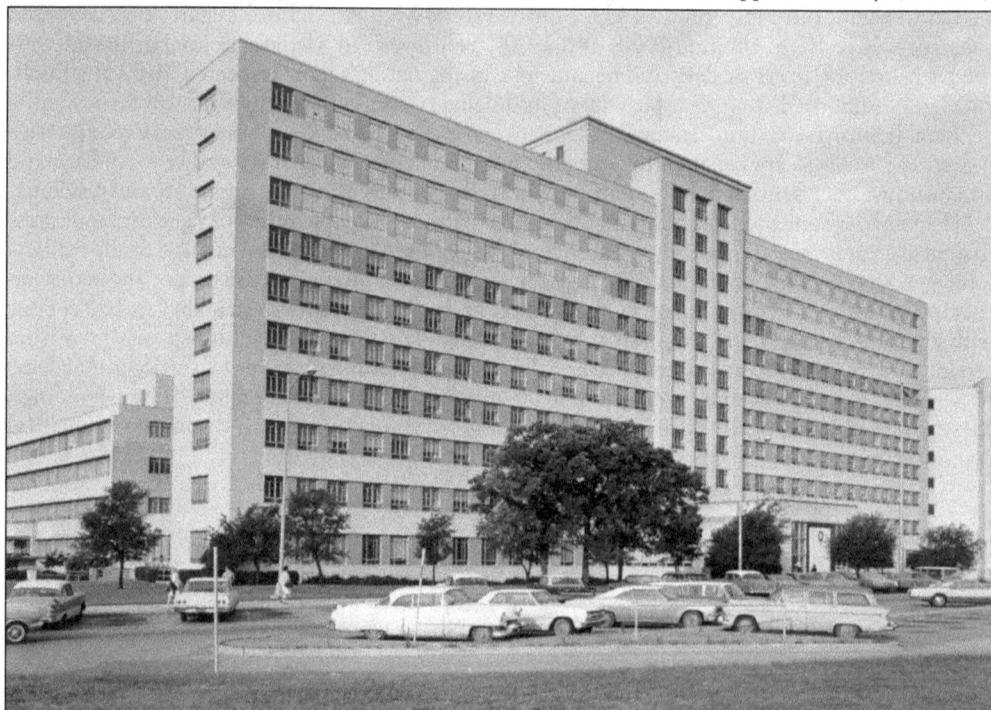

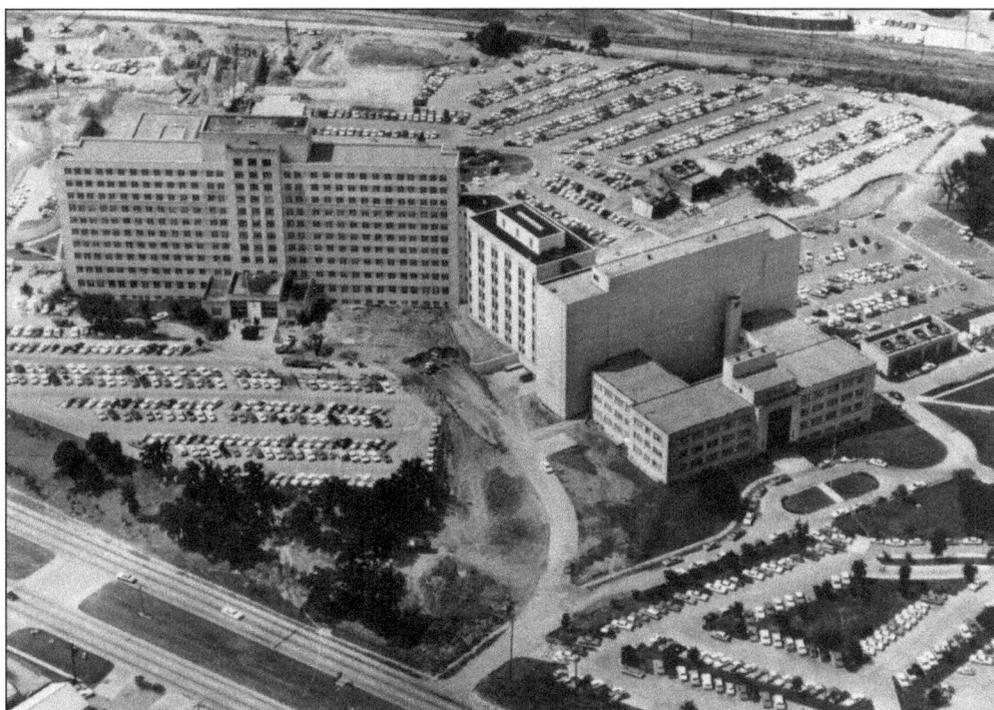

Dan Danciger Research Building. In the mid-1960s, UT Southwestern completed the Danciger building, which physically connected Parkland to Southwestern. (UTSW.)

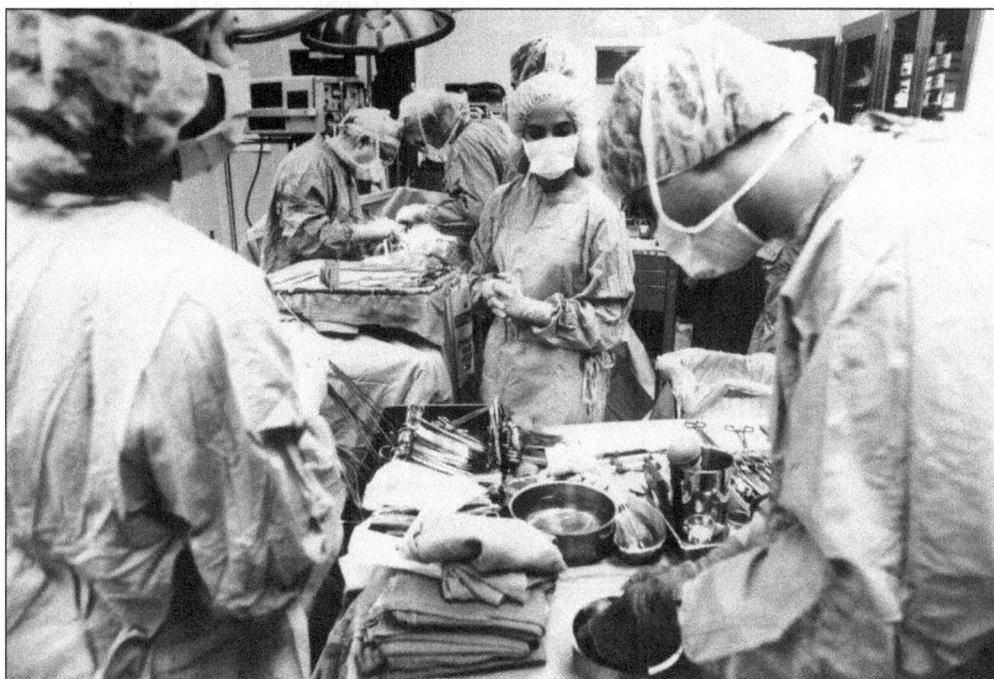

First Kidney Transplant at Parkland. In 1964, Dr. Paul Peters performed the first successful kidney transplant in Texas at Parkland. The first Dallas corneal transplant was performed at Parkland in 1955. (PH.)

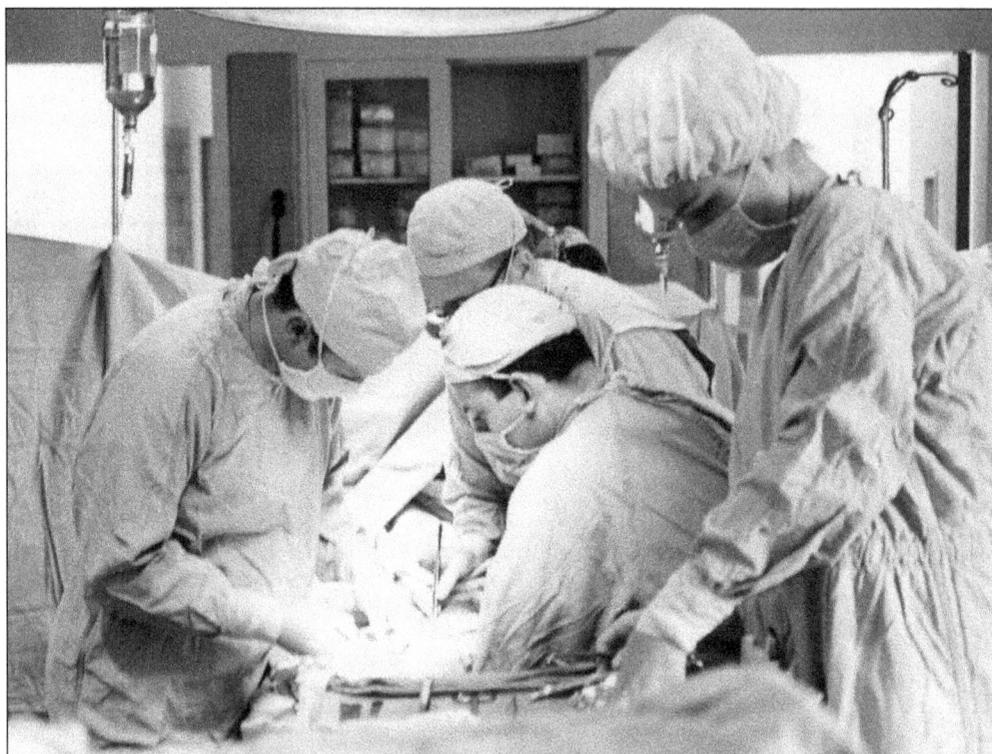

PARKLAND'S FIRST HEART TRANSPLANT. A team led by Dr. Watts R. Webb performed Dallas's first heart transplant in June 1968. This was also the first female heart transplant ever performed. (UTSW.)

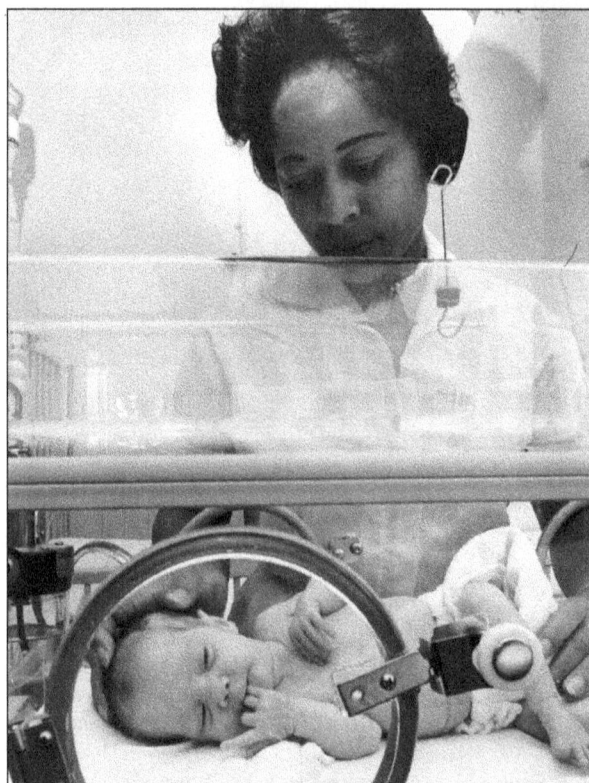

NEONATAL INTENSIVE CARE. Parkland opened its first premature nursery in 1968 and Dallas's first neonatal intensive care unit in 1973. (PH.)

PEDIATRIC CARE. Parkland continued to provide pediatric trauma care until 1995, when the affiliated Children's Medical Center began taking all patients under eight years old. Children's Medical Center is part of the Parkland/UT Southwestern campus on Harry Hines Boulevard. (UTSW.)

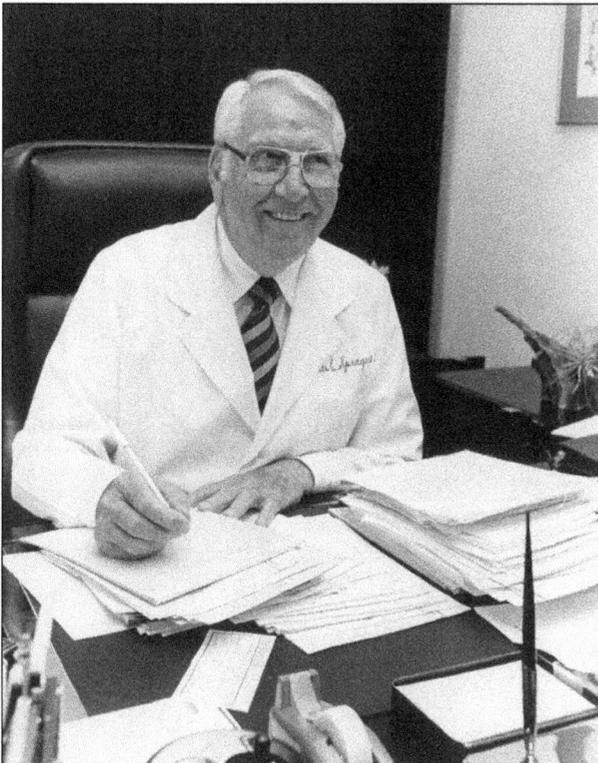

DR. CHARLES SPRAGUE. Dr. Sprague was named dean of the medical school in 1967. That same year, UT Southwestern medical students were ranked number one in the nation on Part II of the National Boards, an exam that measures the quality of graduates' education. Five years later, Dr. Sprague became the first president of UT Southwestern Medical Center. (UTSW.)

Dr. Donald W. Seldin. Dr. Charles Sprague and Dr. Seldin attracted outstanding leaders to Southwestern. Their influence helped propel UT Southwestern and Parkland Hospital into becoming one of the most respected medical centers in the nation. (UTSW.)

Dr. Jack A. Pritchard. Dr. Pritchard became UT Southwestern's chair of obstetrics and gynecology in 1975 and served for 20 years. He helped create a modern system that became standard care for dealing with prenatal issues and high-risk pregnancies. (UTSW.)

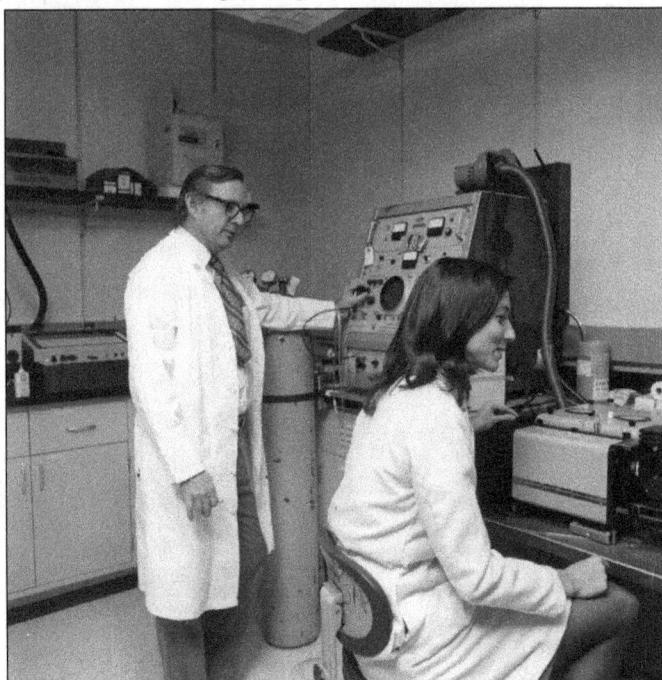

Ronald W. Estabrook, PhD, and the University Colleges. Dr. Estabrook (left) served as chair of the biochemistry department for 14 years and was the first dean of the department. UT Southwestern Medical School's six colleges are named for Drs. Edward H. Cary, Gladys Fashena, Donald W. Seldin, Charles Sprague, Estabrook, and Jack A. Pritchard. (UTSW.)

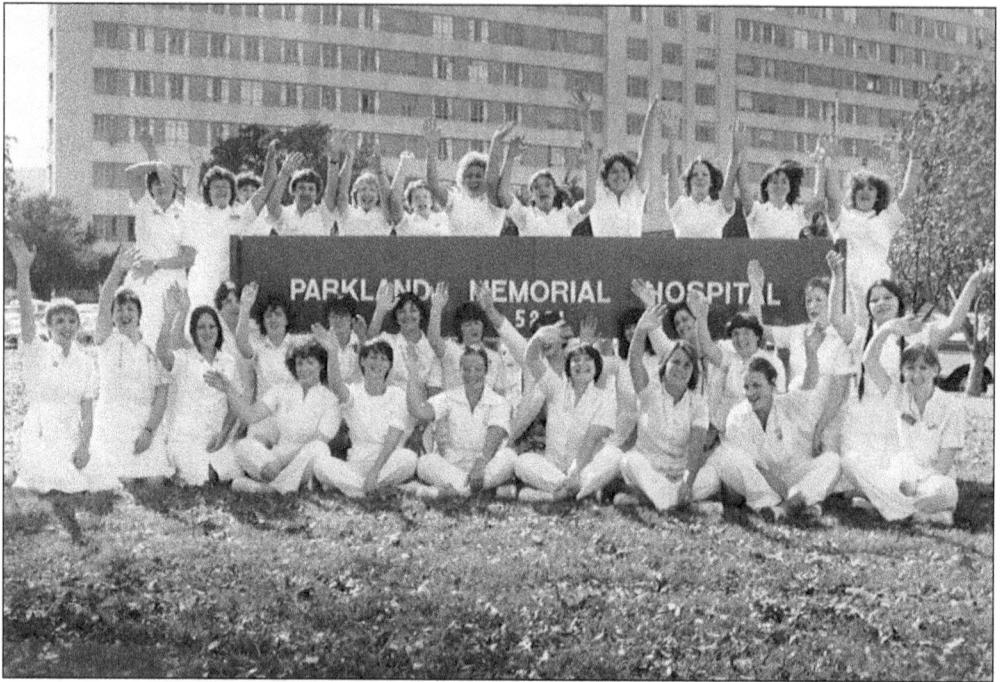

BRITISH NURSES AT PARKLAND IN 1969. In the late 1960s, the rapidly growing Parkland Memorial Hospital had to recruit nurses from overseas due to a shortage of homegrown nurses. (PH.)

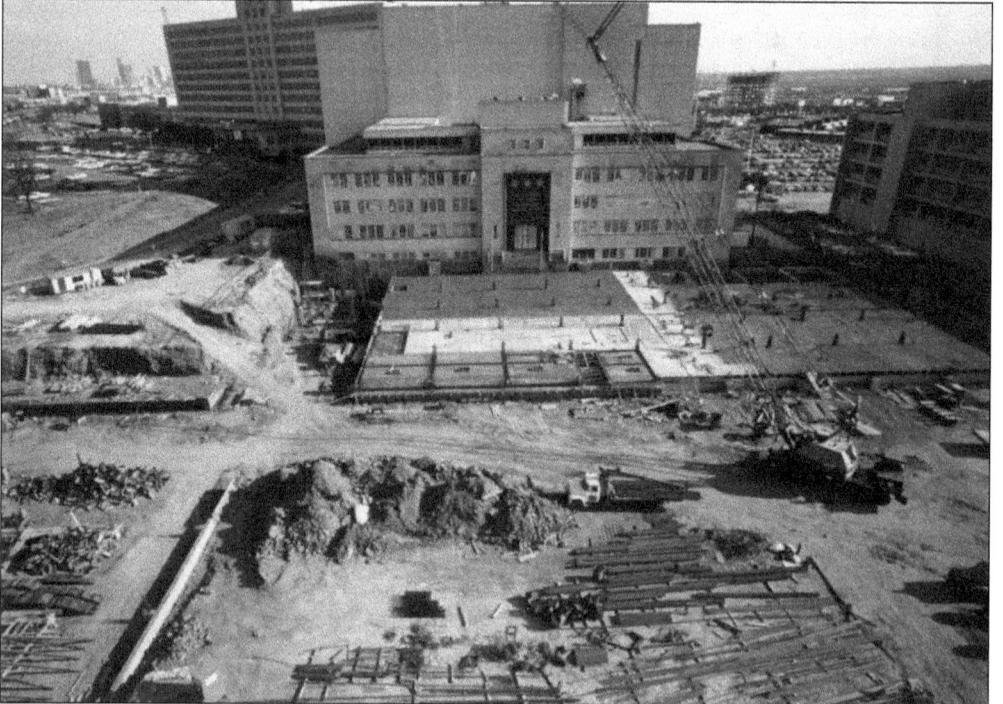

EXCAVATION FOR UT SOUTHWESTERN MEDICAL SCHOOL EXPANSION. In the early 1970s, UT Southwestern began a major expansion that would forever change the appearance of the school. (UTSW.)

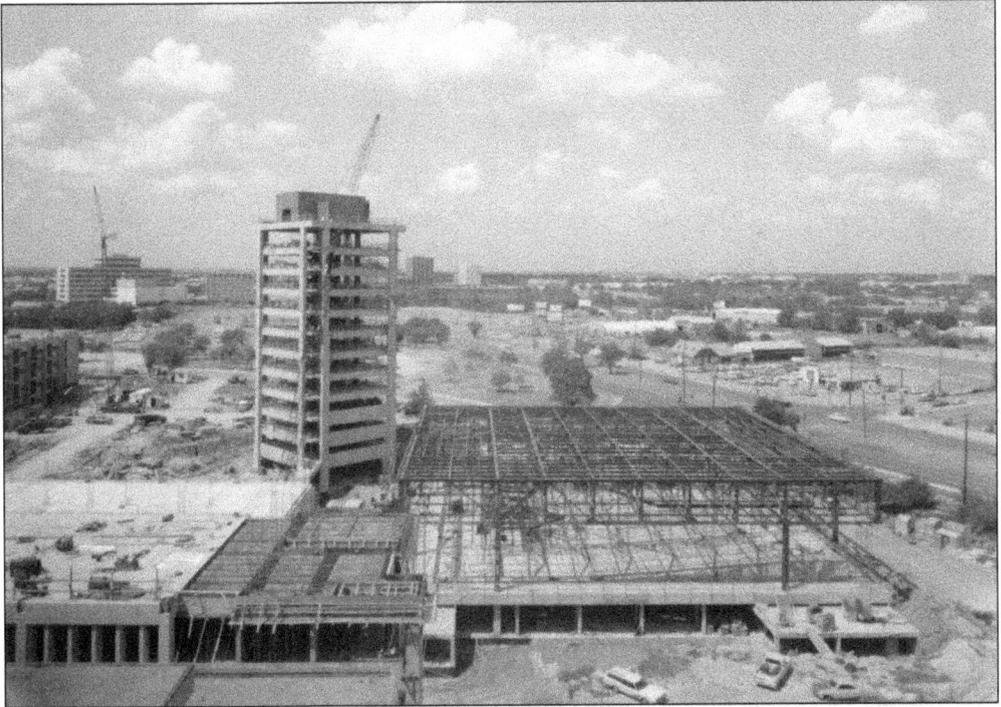

VIEW FROM PARKLAND. The major project added one million square feet of new space for education and research, more than doubling the existing size of UT Southwestern. (UTSW.)

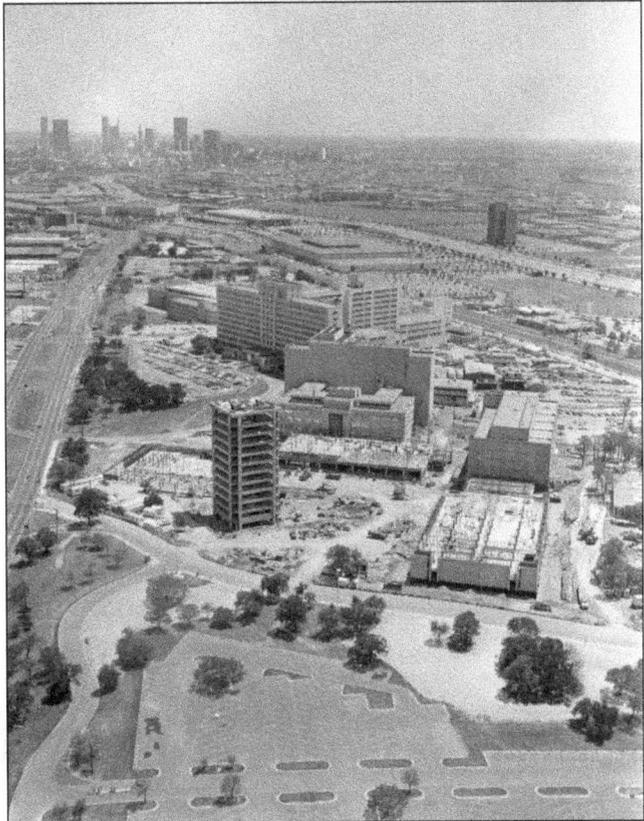

CONSTRUCTION WITH DOWNTOWN DALLAS IN BACKGROUND. Federal, state, and significant private funding paid for the $40-million expansion of UT Southwestern. (UTA.)

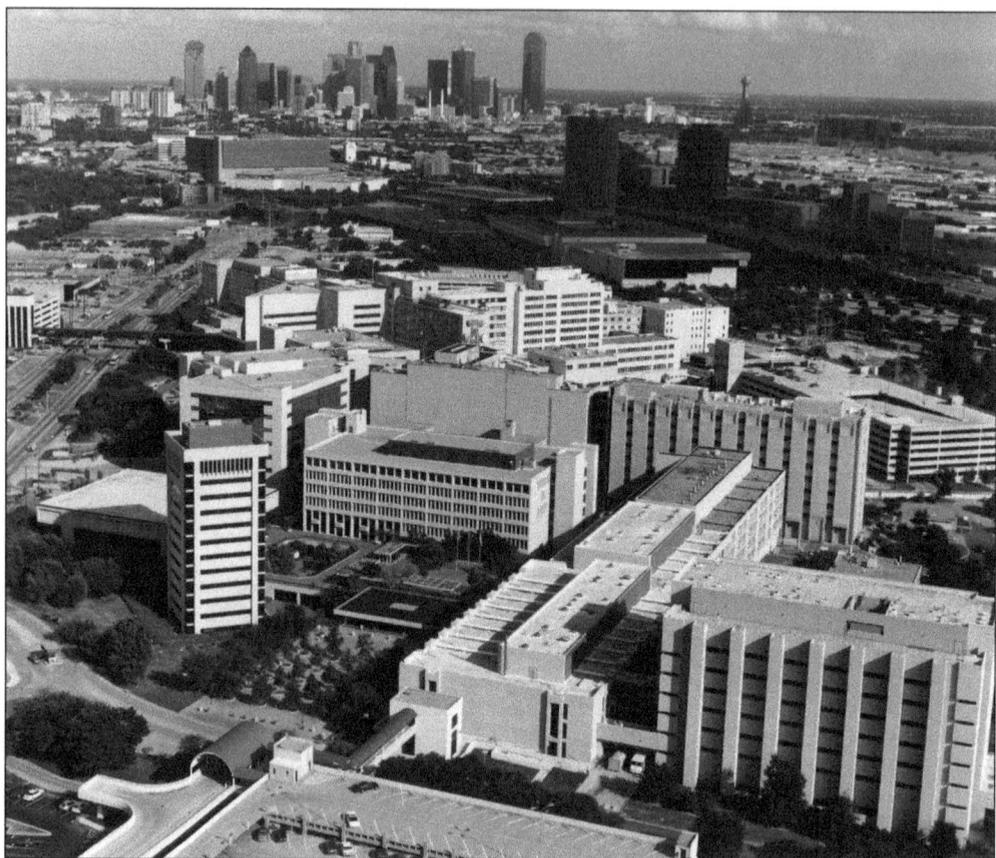

A New Look and Name for UT Southwestern. The Eugene McDermott Administrative Tower, Plaza and Lecture Rooms; the Tom and Lula Gooch Auditorium; the Fred F. Florence Bioinformation Center; the Harry S. Moss Clinical Science Building; the Philip R. Jonsson Basic Science Research Building; and the Cecil and Ida Green Science Building became the new face of the UT Southwestern campus. In 1972, the school rebranded itself as the University of Texas Health Science Center at Dallas, consisting of 12 educational and research buildings. In 1987, it became the University of Texas Southwestern Medical Center at Dallas. (UTSW.)

New Parkland Clinical Tower Construction, c. 1981. An $80-million bond election allowed Parkland to modernize and add the north tower, bringing a new look to the front of the hospital. Construction began in 1981. (PH.)

DR. BRYAN WILLIAMS. Dr. Williams (seated at center) served as Associate Dean for Student Affairs from 1970 to 1990. He was a favorite of the medical students, and the school's Bryan Williams, MD, Student Center was named in his honor. Dr. Williams was one of the first UT Southwestern staff members elected to the National Academy of Sciences. (UTSW.)

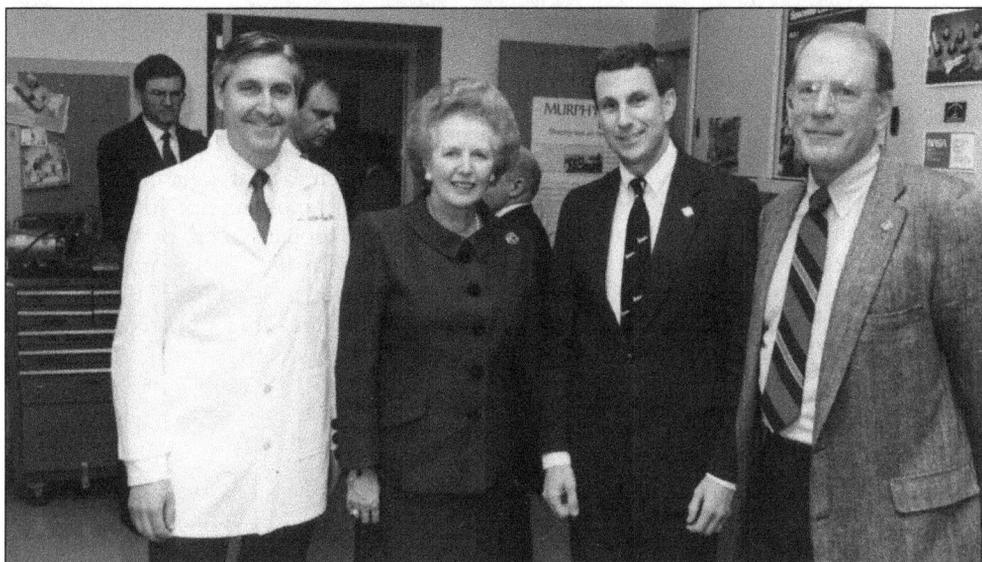

DR. WILDENTHAL WITH MARGARET THATCHER. Dr. C. Kern Wildenthal (far left) served as the president of UT Southwestern from 1986 to 2008. During his leadership, UT Southwestern more than quadrupled in size. On March 20, 2015, the C. Kern Wildenthal Research Building on the school's north campus was named in his honor. Thatcher (second from left) toured the campus in 1991. At far right is Dr. C. Gunnar Blomquist, director of NASA's Specialized Center of Research and Training at UT Southwestern. Dr. Drew Gaffney (second from right), cardiologist, was also a NASA astronaut. (UTSW.)

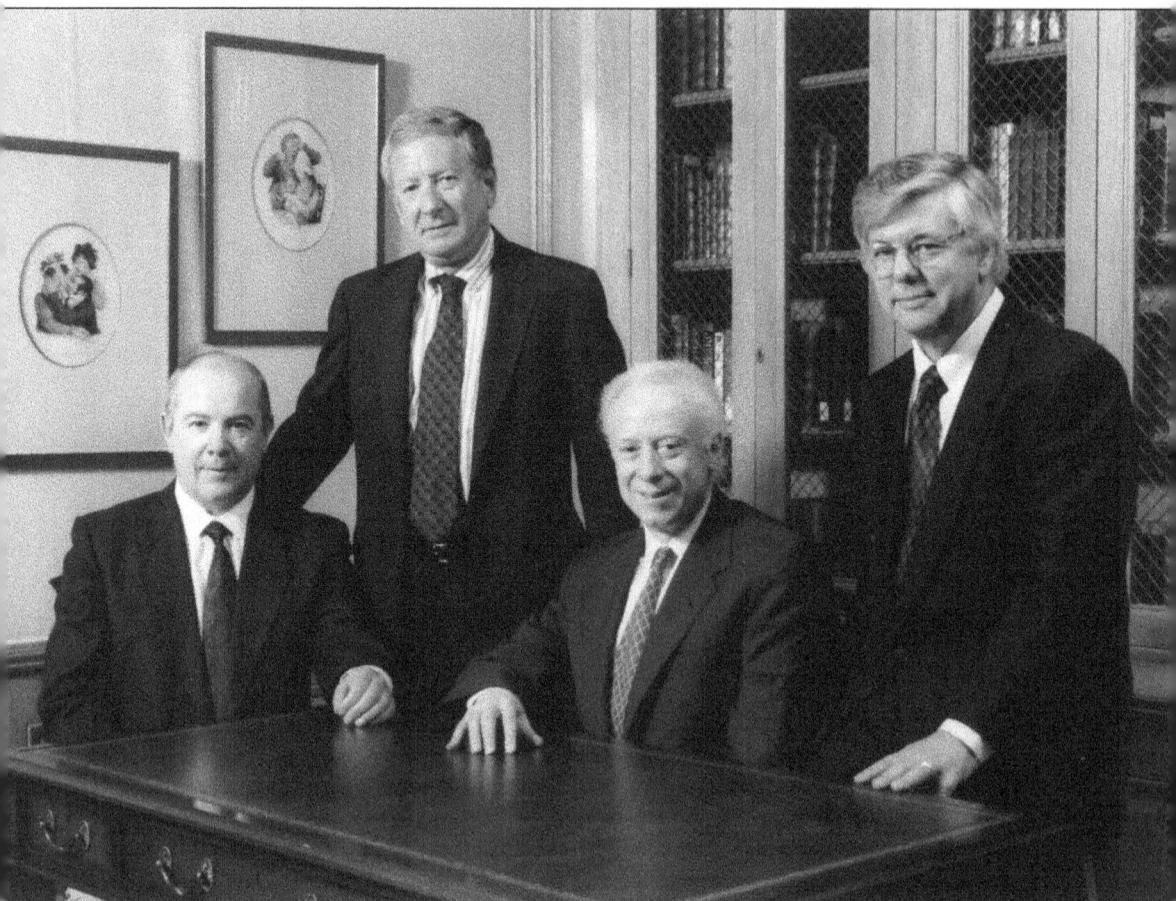

Nobel Laureates. UT Southwestern has been home to six Nobel Laureates, more than any other university. Four of them are pictured here; they are, from left to right, Johann Deisenhofer, who won a Nobel in 1988 for describing proteins involved in photosynthesis; Alfred Gilman, who won a Nobel in 1994 for his work discovering the role of G-proteins in cell communication; and Joseph Goldstein and Michael Brown, who won a Nobel in 1985 for research regarding cholesterol metabolism. Not pictured are Bruce Beutler, who won a Nobel in 2011 for immune system investigation, and Thomas C. Südhof, who won a Nobel in 2013 for brain cell synaptic communication. (UTSW.)

NATIONAL ACADEMY OF SCIENCE MEMBERS, 2009. UT Southwestern is now home to 23 NAS members, many of whom are pictured here. The school also boasts 19 members of the Institute of Medicine and 16 members of the Academy of Arts and Sciences. (UTSW.)

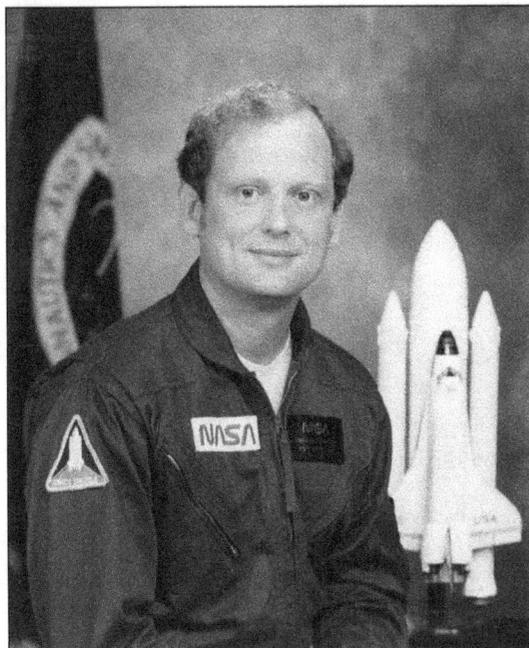

ASTRONAUTS AT UT SOUTHWESTERN. Dr. Norman Thagard (pictured) received his doctor of medicine degree from UT Southwestern before becoming an astronaut, and he has since logged more than 140 days in space over the course of several missions. Jay Clark Buckey Jr., MD, was a NASA Space Biology Fellow at UT Southwestern. In 1998, he spent 381 hours in space on board the *Columbia* space shuttle. Drew Gaffney, MD, was a cardiology fellow at UT Southwestern from 1975 to 1977. He was a member of the June 1991 NASA STS-40, the first space lab dedicated to biomedical studies; his team completed 18 experiments in nine days. (NASA.)

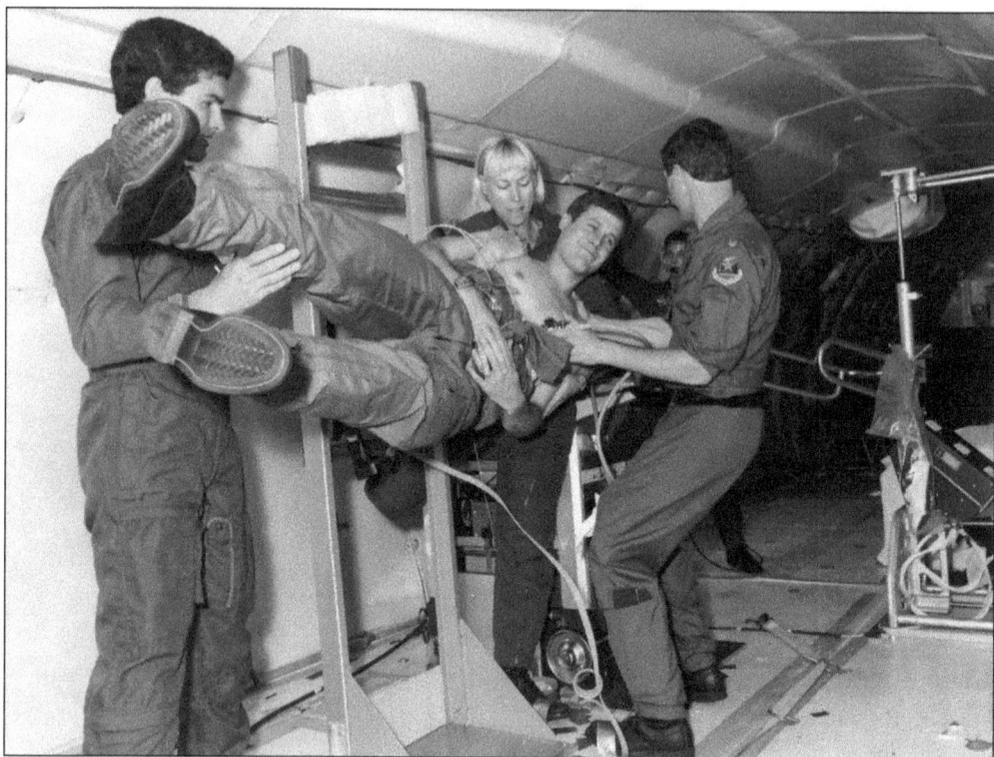

NASA Weightless Research. UT Southwestern has received numerous grants from NASA, including a 1993 grant to study the effects of weightlessness on physiology and a 2005 grant to study the effects of radiation on astronauts. Jay Clark Buckey Jr. is the physician/astronaut floating in the center of this picture. (NASA.)

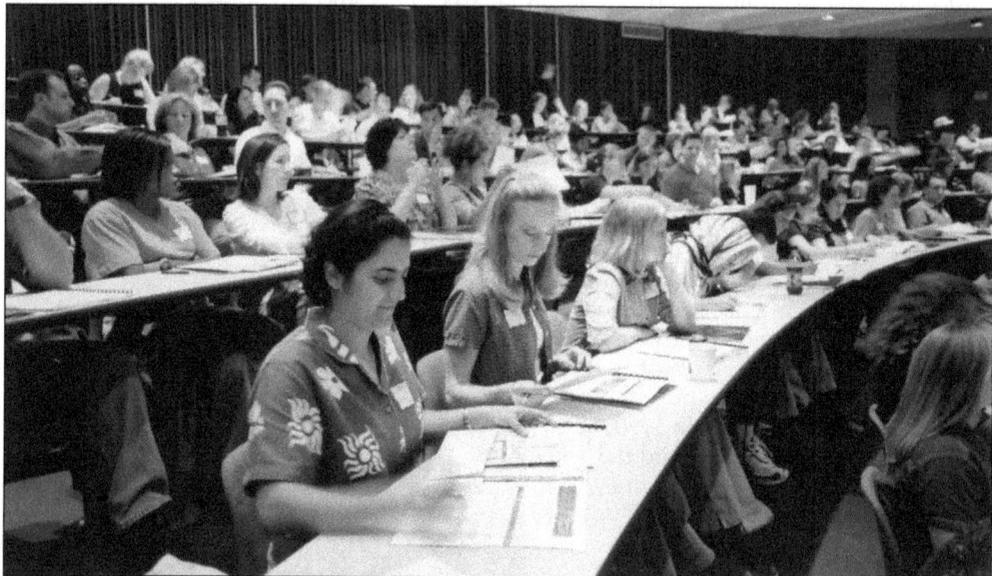

Freshman Orientation. The Eugene McDermott auditoriums were completed in the 1970s and continue to serve as a primary teaching area for medical students, residents, and Dallas-area doctors. (UTSW.)

JURASSIC PARKLAND. Although training for four years to become a physician is serious business, there is often some comic relief. Each year, the graduating class creates a movie—in good (and sometimes not-so-good) humor—looking back on their education. (UTSW.)

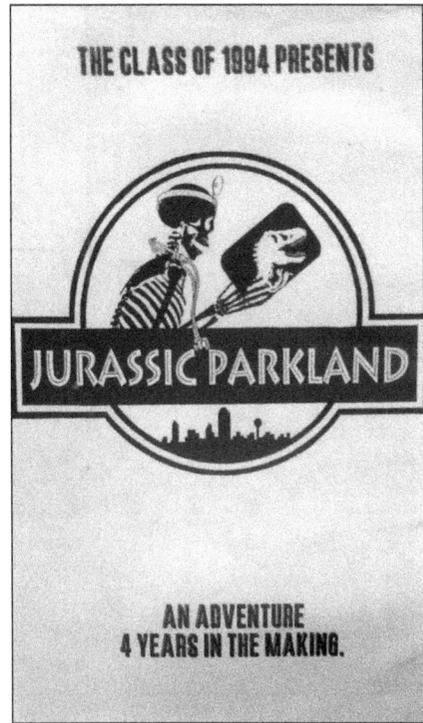

THE CLASS OF 1994 PRESENTS

JURASSIC PARKLAND

AN ADVENTURE
4 YEARS IN THE MAKING.

ANATOMY STUDIES, 1970. Three students study a model of a human brain in preparation for a neuroanatomy quiz. (UTSW.)

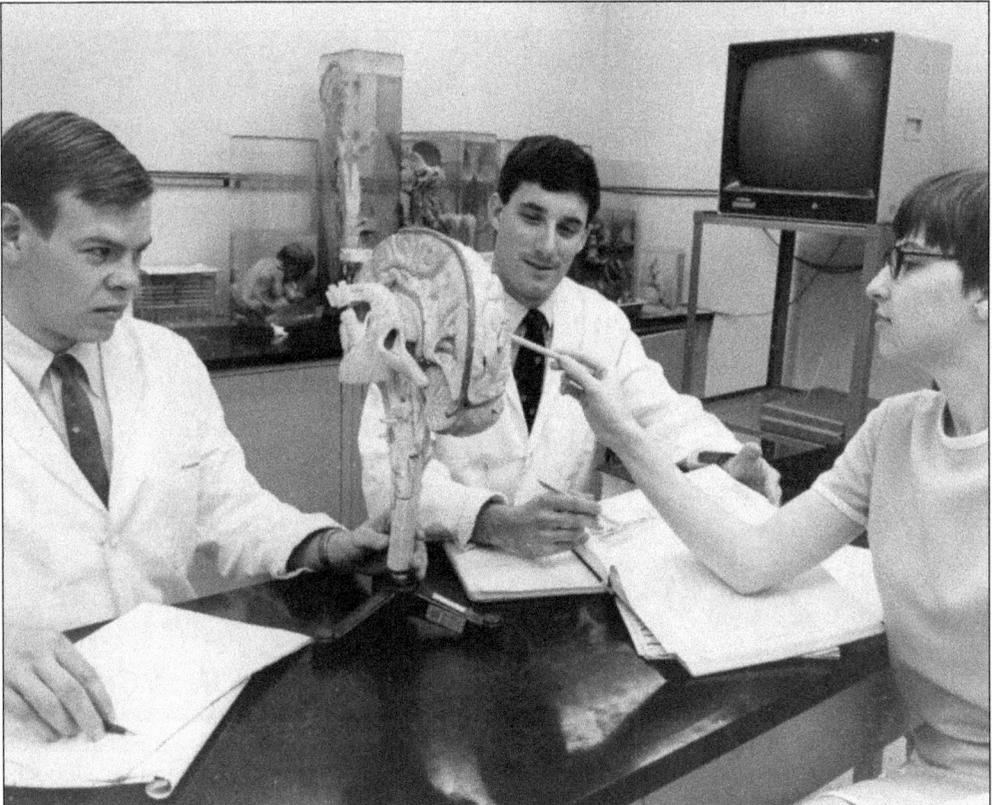

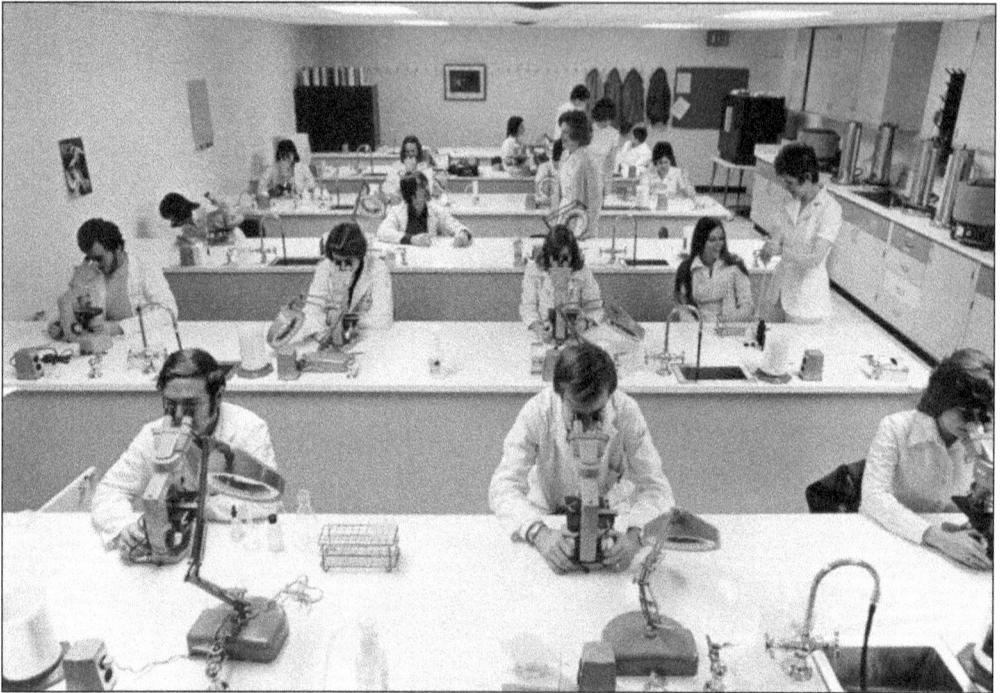

MICROBIOLOGY LAB, 1975. The more modern science building facilities offer a sharp contrast to the 1940s-era microbiology lab. (UTSW.)

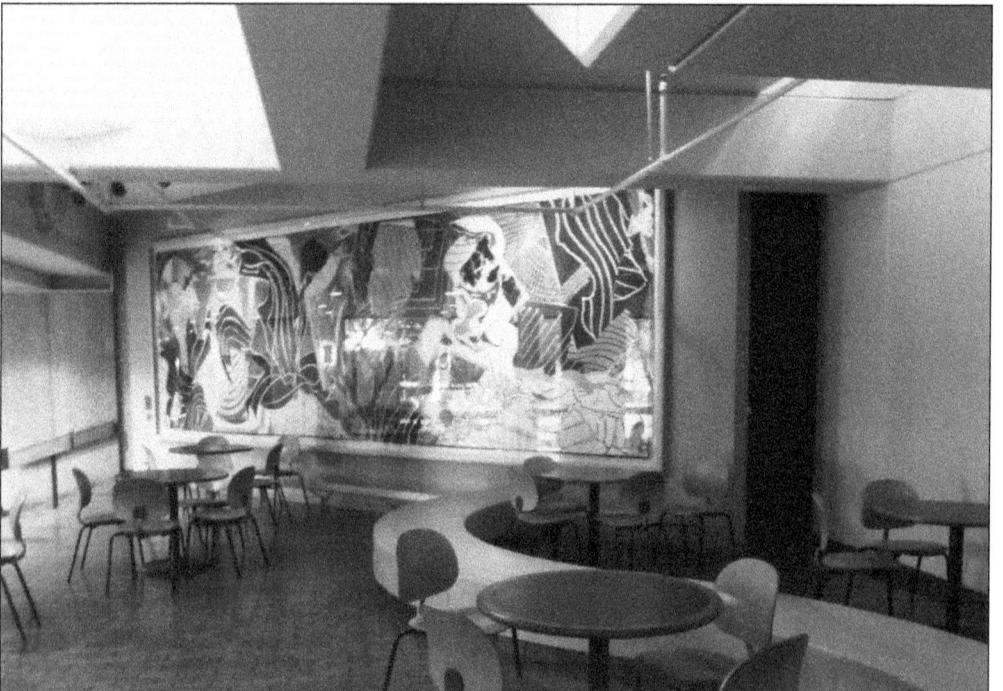

ART ON THE UT SOUTHWESTERN CAMPUS. UT Southwestern is more than a medical school. Thanks to the influence of Dr. Donald W. Seldin, Margaret McDermott, Tom and Lula Gooch, and others, it has also become a place for art appreciation. (JWB.)

TAPESTRIES AT THE UNIVERSITY HOSPITAL. Murals, paintings, and tapestries adorn the walls at UT Southwestern and its university hospitals. A spectacular glass sculpture by Dale Chihuly welcomes visitors to the lobby of the Seay Biomedical Building on the north campus. (UTSW.)

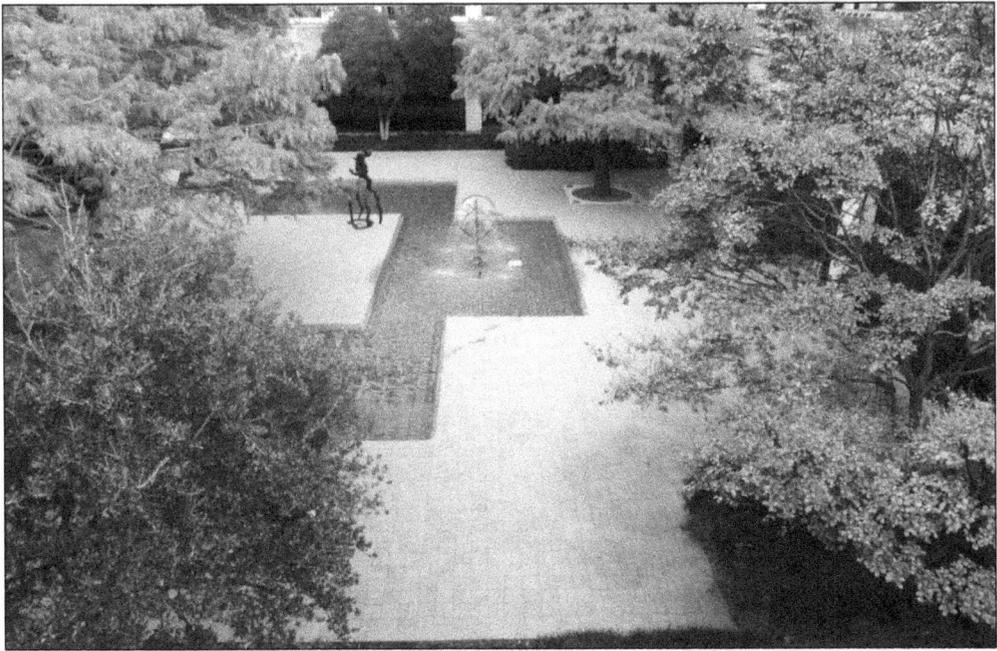

SCULPTURES AND FOUNTAINS. Tree groves, bird sanctuaries, hiking and bike trails, and fountains are scattered throughout the campus, which spans more than 230 acres. (JWB.)

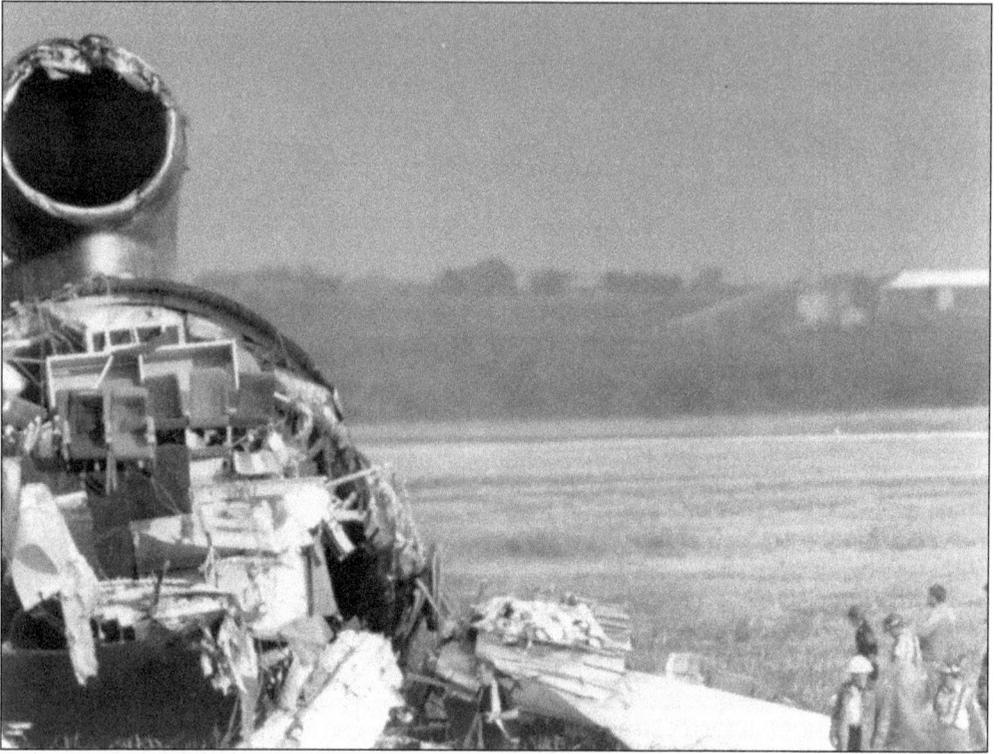

DELTA AIR LINES FLIGHT 191. Dallas is home to one of the country's largest airports. When a fiery crash occurred at takeoff on August 2, 1985, many area hospitals activated emergency response teams to cope with the disaster. Parkland treated 21 patients, many of whom were in the burn unit. (PH.)

EMERGENCY ROOM. Parkland's ER was the first Level I Trauma Center in Texas. (PH.)

NORTH CAMPUS, 2015. The north campus started as a 30-acre gift from the John D. and Catherine T. MacArthur Foundation in 1987, and 15 research, education and patient care buildings have been completed there. In 1999, another 50 acres were added to the north campus, which now includes student housing, walking trails, gardens, sculptures, and tree groves. (JWB.)

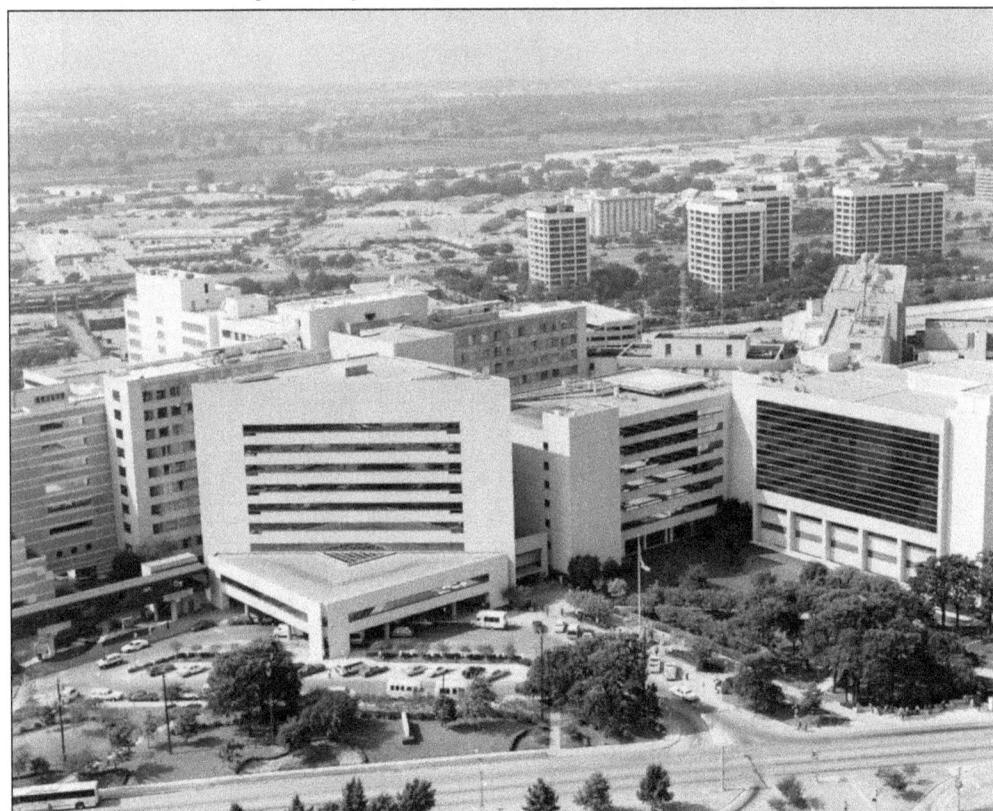

AERIAL VIEW OF PARKLAND HOSPITAL. In 2013, Parkland staff delivered 10,326 babies, performed 20,014 surgical procedures, saw 153,915 emergency-room cases, and delivered care to more than one million outpatients. (PH.)

UT Southwestern Medical Center. In addition to the programs offered at the medical school, the UT Southwestern Graduate School of Biomedical Sciences has twelve doctoral programs, and the School of Health Professionals offers six degrees. About 3,000 research projects are underway in any given year. Medical school faculty and residents provide care to 92,000 inpatients and 2.1 million outpatients annually. In 2014, the center had about 2,360 full-time faculty members, over 1,500 medical residents, and 959 medical students. (UTSW.)

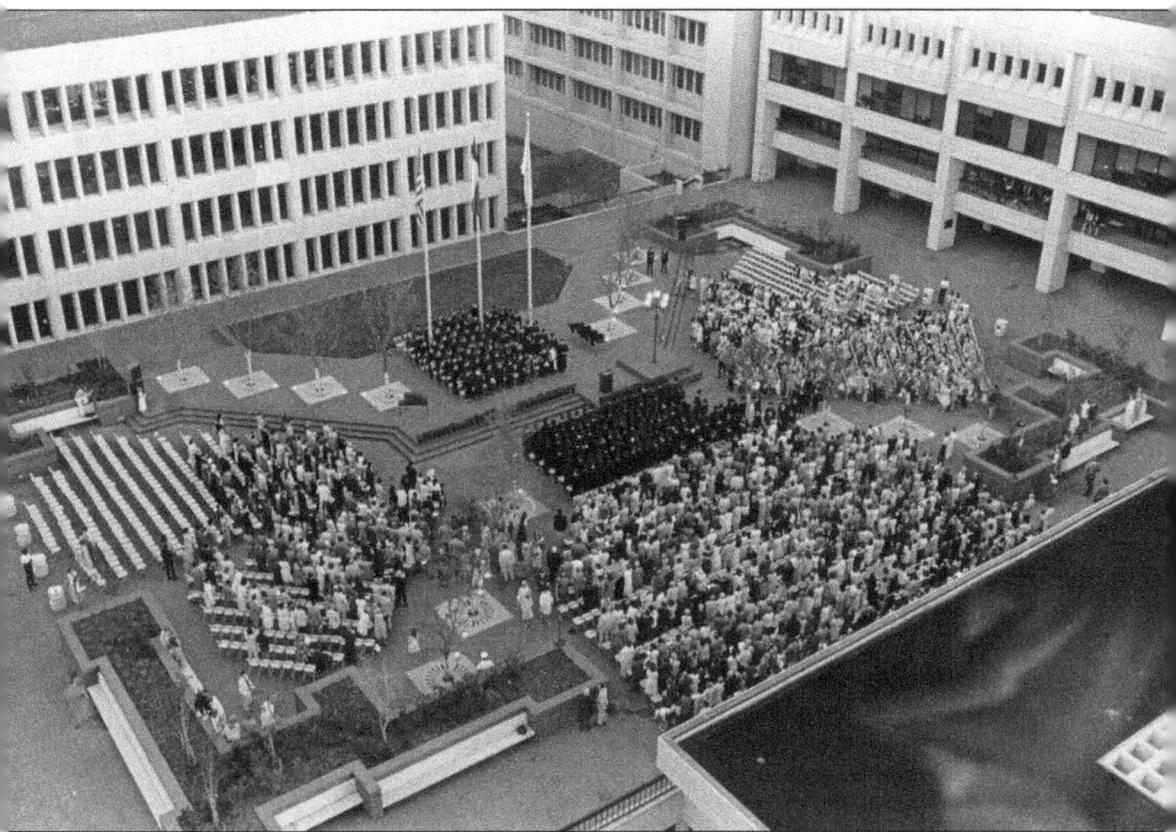

OUTDOOR GRADUATION CEREMONY AT MCDERMOTT PLAZA. Weather permitted an outdoor commencement on the McDermott Plaza in 1975. Prior to graduation, another annual ceremony takes place after students apply for their postgraduate specialty training; without knowing where they will be accepted, students gather for a Match Day celebration. This annual tradition is a very emotional event; everyone is watching everyone else open an envelope and discover where they will be spending the next phase of their lives. In a moment, the past is over, and the future awaits. "It is really exciting, yet really sad," said a senior at the March 20, 2015, Match Day. (UTSW.)

THE 1954 PARKLAND MEMORIAL HOSPITAL. At the time of this writing, the fate of the former Parkland Memorial Hospital remains unknown. (UTSW.)

Five

OLD PARKLAND IS REBORN

In 1954, after 60 years at Maple Avenue, it was time for Parkland Hospital to move to its new state-of-the-art facility on Harry Hines Boulevard. The old hospital had served its purpose, but the aging facility could no longer be part of the future plans for the new, modern medical center. Parkland Hospital officially relocated in 1954; Southwestern Medical School and the Parkland School of Nursing followed starting in 1955. To avoid confusion, the old Parkland was rebranded as Woodlawn Hospital, which remained open as a psychiatric and isolation hospital for another 20 years.

In 1974, the hospital's days as a healthcare facility came to an end, and ownership of the building was transferred to Dallas County. Over the following years, the county used the space to house various enterprises, including a minimum-security prison, a rehab facility, a rape crisis center, and a law-enforcement academy. Eventually, the county closed the facility, and it sat vacant for more than a decade before the Dallas County Hospital District repurchased the building from Dallas County in 1994.

In 2006, Harlan Crow, of Crow Holdings, had a vision to turn the old Parkland building into a private business campus and relocate his headquarters there. Over the next nine years, Crow passionately restored the 1913 Parkland Hospital and the 1922 Nurses Quarters. He added seven new buildings to the campus, each of which complemented the architecture of the original hospital. More than an office park, the meticulously planned Old Parkland contains sculpture gardens and artwork worthy of a museum. Many of the artifacts Crow put on display pay tribute to the country's founding fathers and the principles upon which the United States was established. Old Parkland has ensured that the original Parkland Hospital campus will continue to be a relevant part of Dallas for generations to come.

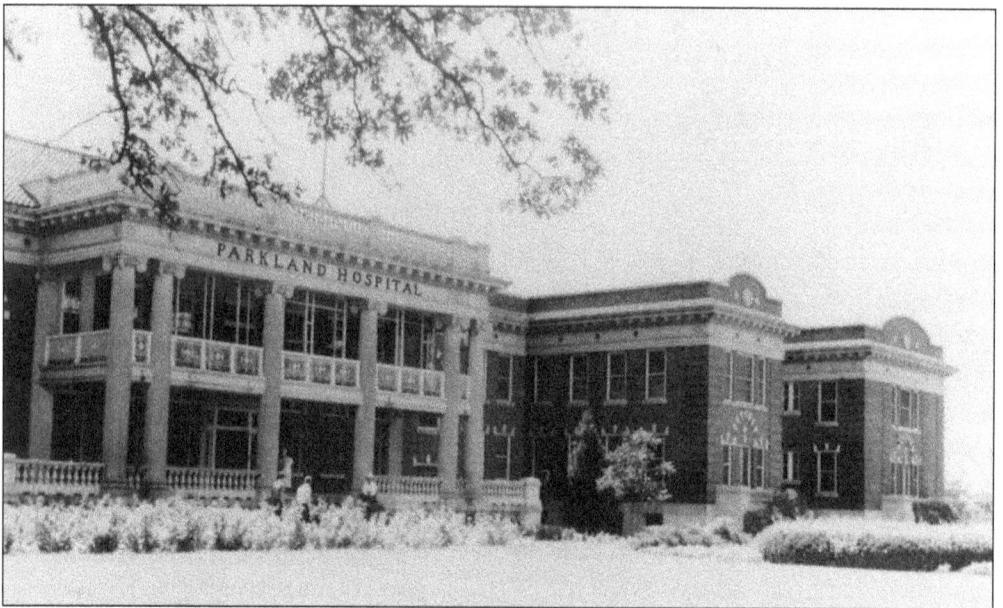

THE OLD PARKLAND REMAINS OPEN IN A LIMITED CAPACITY. After Parkland moved to Harry Hines Boulevard in 1954, the old Parkland remained open as a psychiatric and isolation hospital. After September 1954, the Maple Avenue building became known as Woodlawn Hospital. (UTSW.)

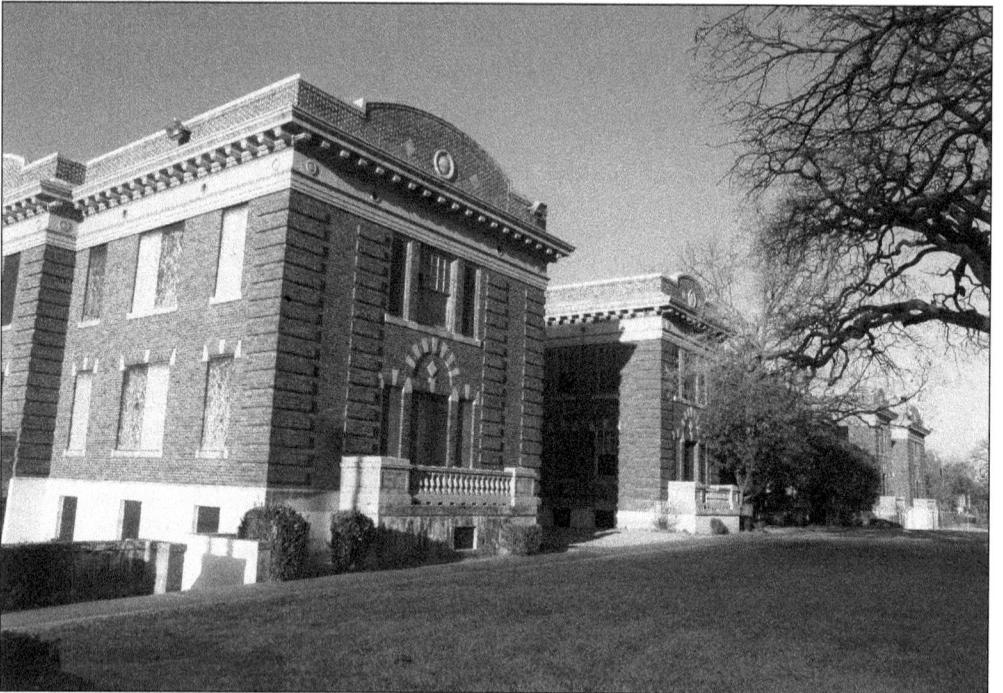

WOODLAWN TRANSFERRED TO DALLAS COUNTY. In January 1974, Woodlawn (old Parkland) closed forever as a hospital. Ownership of the campus was transferred to Dallas County. The former hospital served a variety of roles over the next few years, including as a minimum-security prison, rape crisis center, police training academy, county fire marshal's office, and an alcohol- and drug-rehabilitation center. (OP; photograph by Skeeter Hagler.)

DALLAS COUNTY CLOSES THE WOODLAWN FACILITY. County services housed at Woodlawn were eventually transferred to other facilities, and in the 1980s, the county closed the building and installed a fence around the property. (OP; photograph by Skeeter Hagler.)

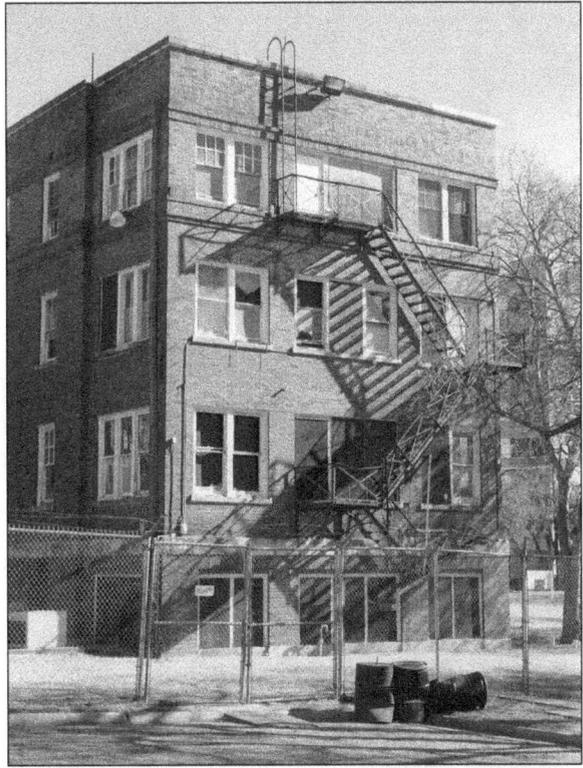

ABANDONED OLD PARKLAND. After Dallas County closed the building, vandals, graffiti artists, and the homeless became the new tenants in the historic landmark. (OP; photograph by Skeeter Hagler.)

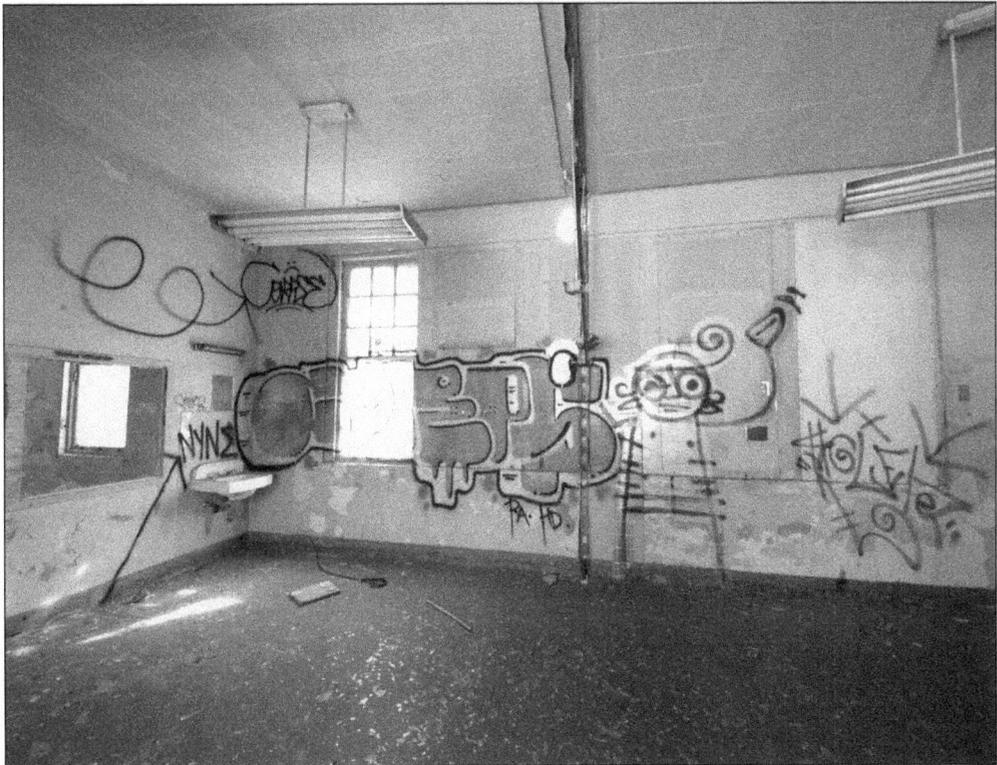

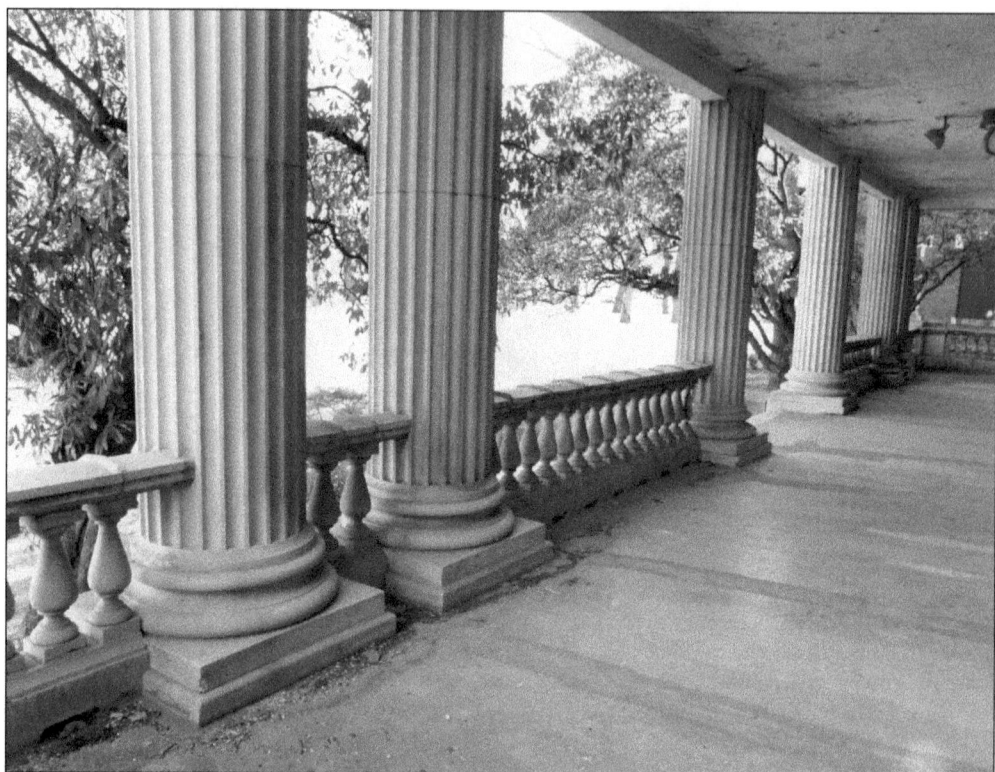

THE OLD FRONT PORCH. Despite decades of neglect and overgrowth, the aging Parkland Hospital retained an undeniable architectural elegance. (OP; photograph by Skeeter Hagler.)

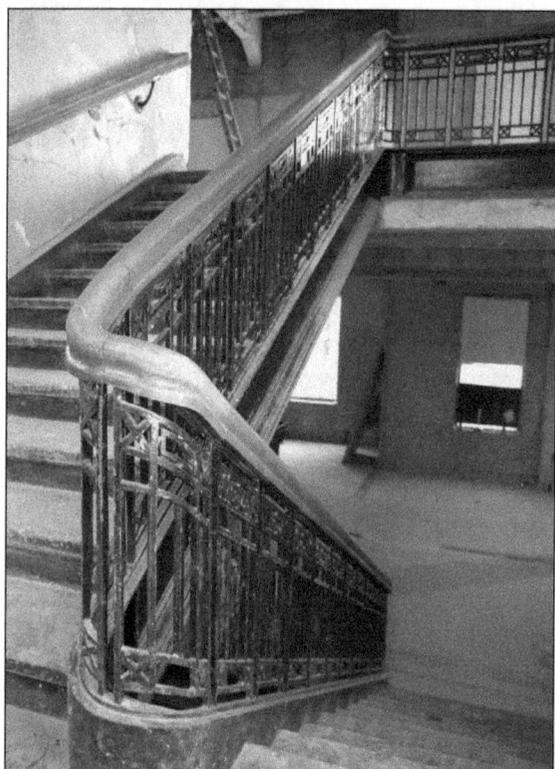

INTERIOR STAIRCASE. The interior of the abandoned former hospital and prison is pictured here around 2005. (OP; photograph by Skeeter Hagler.)

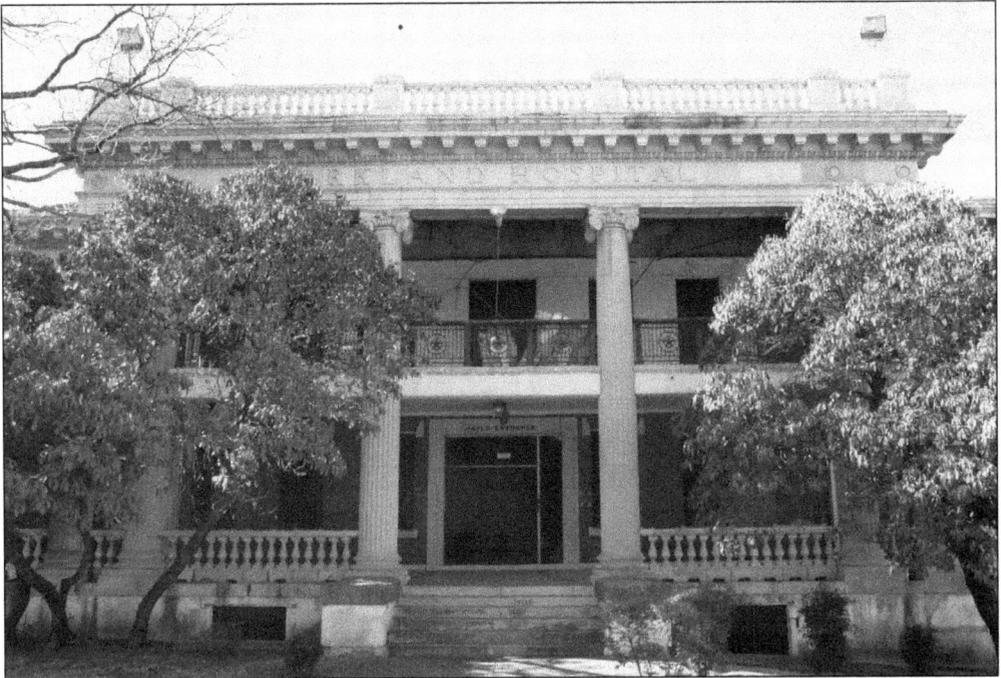

OLD PARKLAND FOR SALE, 2005. In 1994, the Dallas County Hospital District repurchased the campus for $1.3 million with a dream of returning patient care and teaching to the old hospital. More practical and urgent patient-care considerations for the hospital district pushed the nostalgic renovation of the old hospital to the back burner, and the property went back on the market in 2005. (OP; photograph by Skeeter Hagler.)

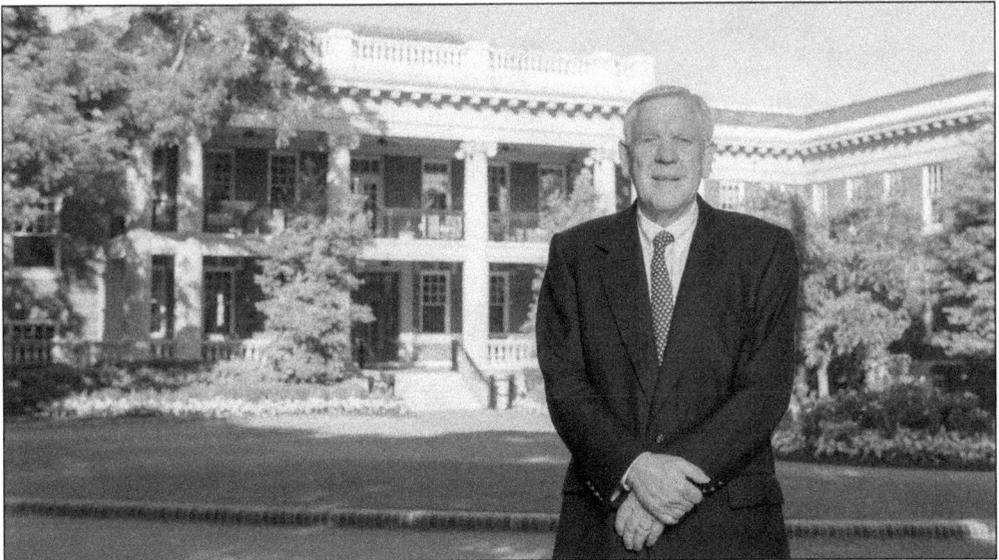

HARLAN CROW. In 2006, Harlan Crow—a man with both vision and financial ability—stepped into the picture and purchased Old Parkland from Dallas County. Seeing the area as more than just a real estate investment, Crow fell in love with the old buildings and oversaw a remarkable transformation of the historic campus over the next nine years. Crow is also a contributor to the Southwestern Medical Foundation and the Parkland Foundation. (OP.)

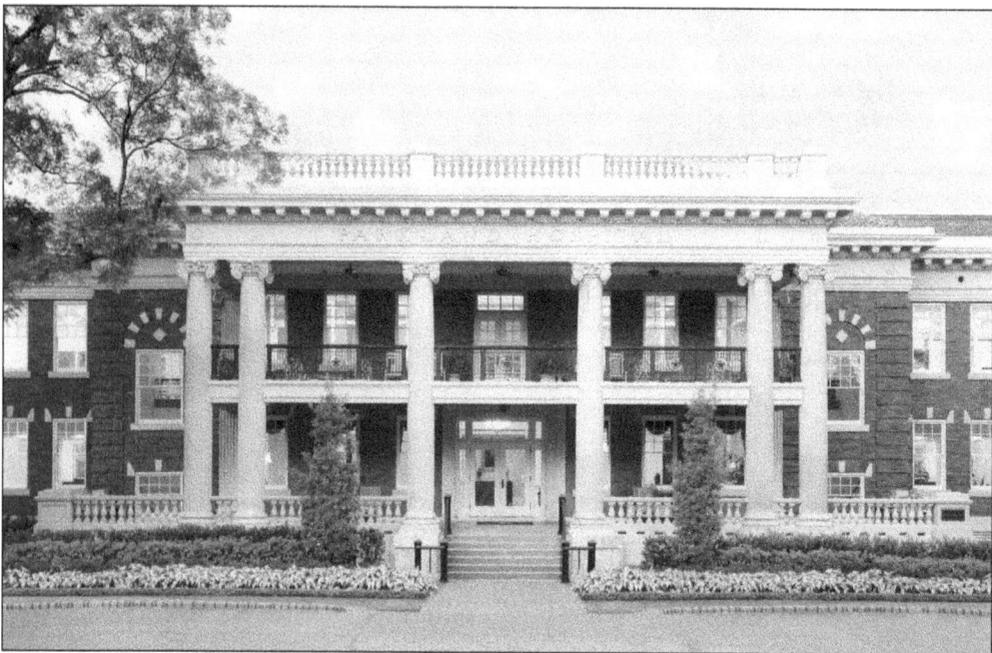

"Old Main" at Old Parkland. The 1913 Parkland Hospital building is pictured here after its elegant restoration. (OP; photograph by Matchbox.)

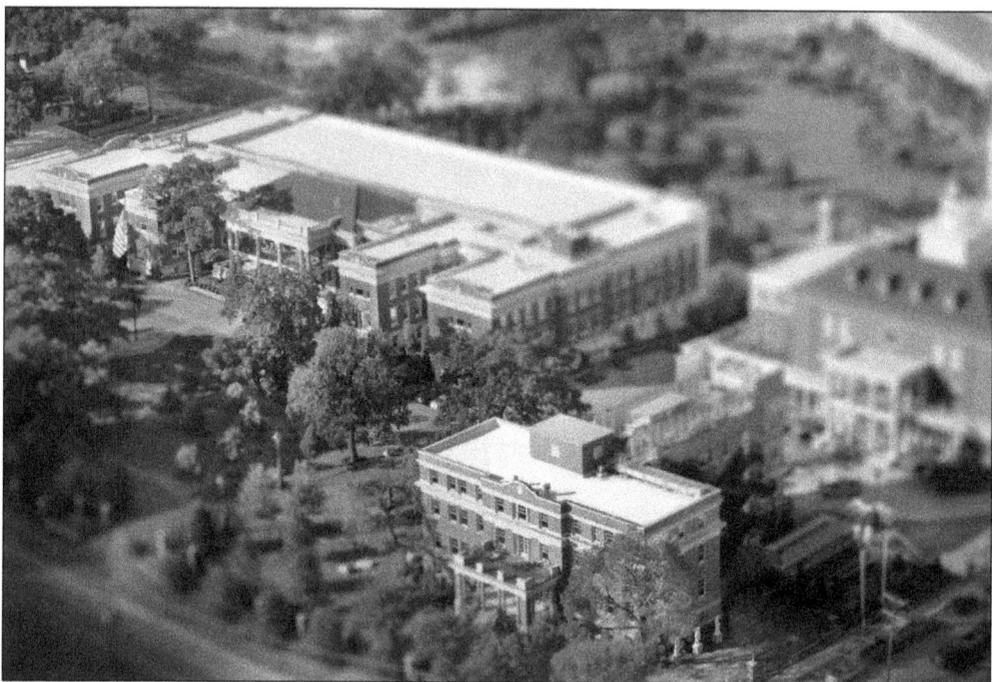

Restored Hospital and Nurses Quarters. Herbert Greene designed the 1913 Parkland Hospital (center) and the 1922 Nurses Quarters (front right). They are shown here following their restoration in 2009. (OP.)

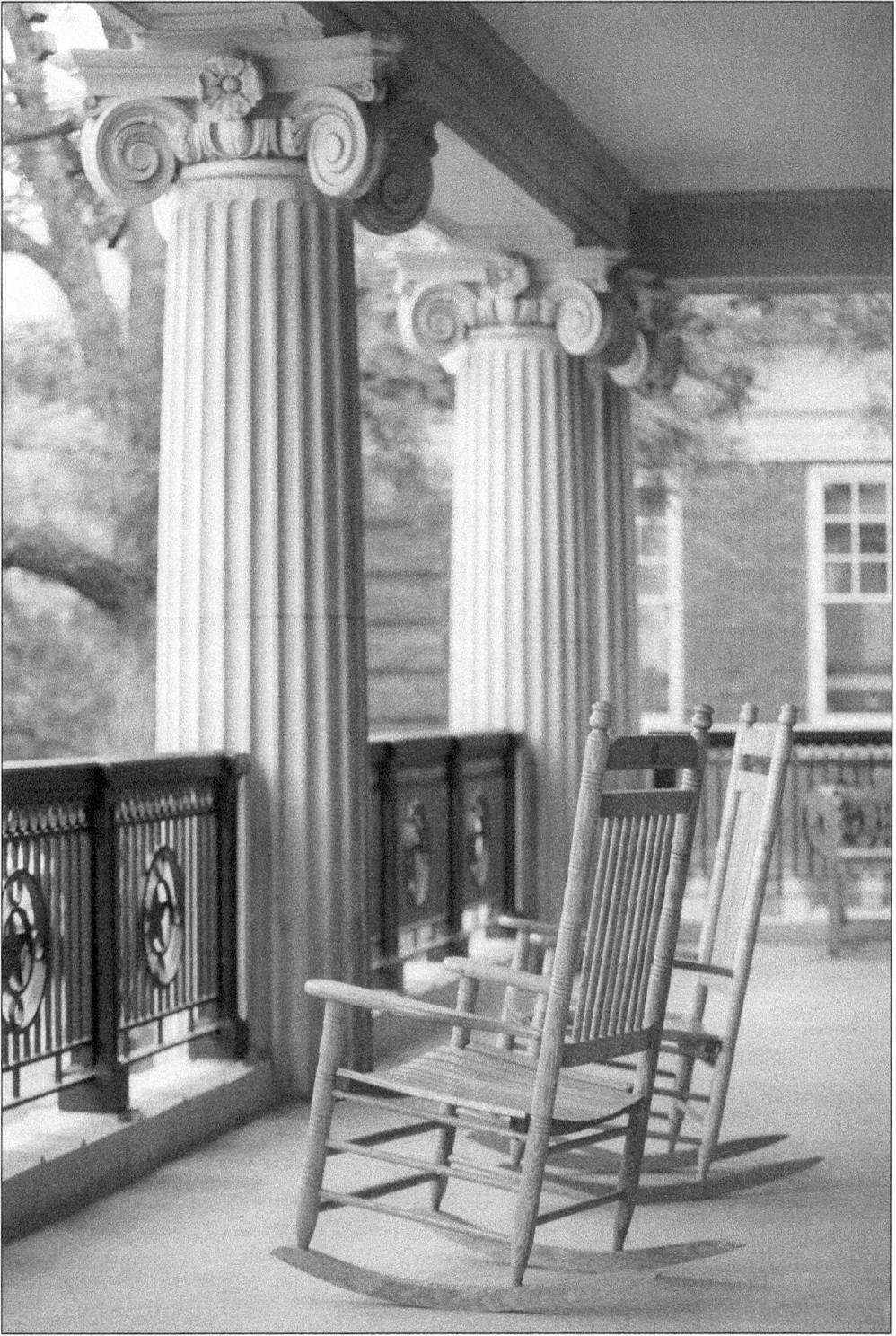

RESTORED FRONT BALCONY. With Harlan Crow overseeing the project, the Dallas-based design firm Good, Fulton, and Farrell undertook the renovation of the 1913 hospital. (OP.)

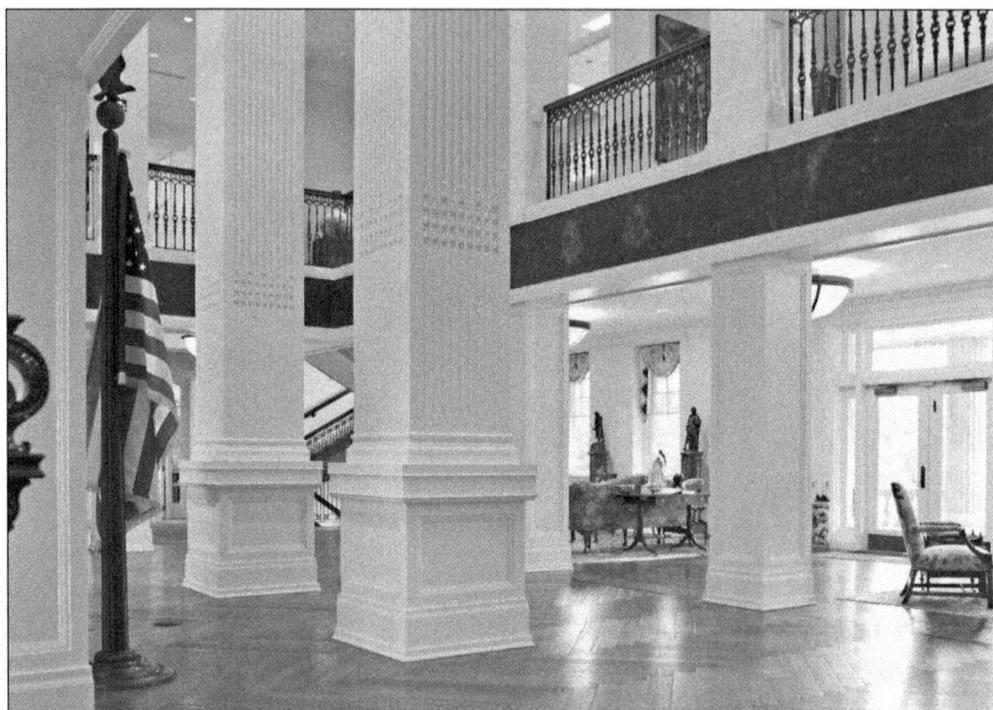

LOBBY AT THE OLD MAIN BUILDING. The re-engineered lobby occupies the first two floors of the former hospital, now known as Old Main. (OP.)

RESTORED NURSES QUARTERS INTERIOR. Today, the former dormitory features meeting and event spaces and a private tavern for the campus. (OP; photograph by Paul Go Images.)

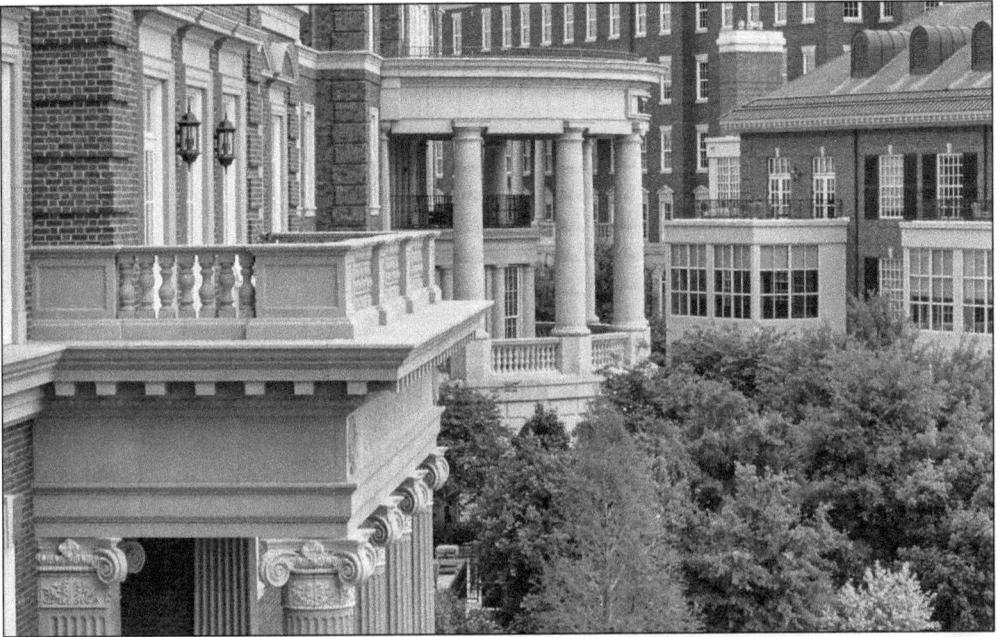

ARCHITECTURAL STYLE AT OLD PARKLAND. As Harlan Crow added new buildings of similar architectural style and size, the property took on a campus-like feeling. Woodlawn Hall, Maple Hall, and Regan Place were the first new buildings added to the Old Parkland campus. (OP.)

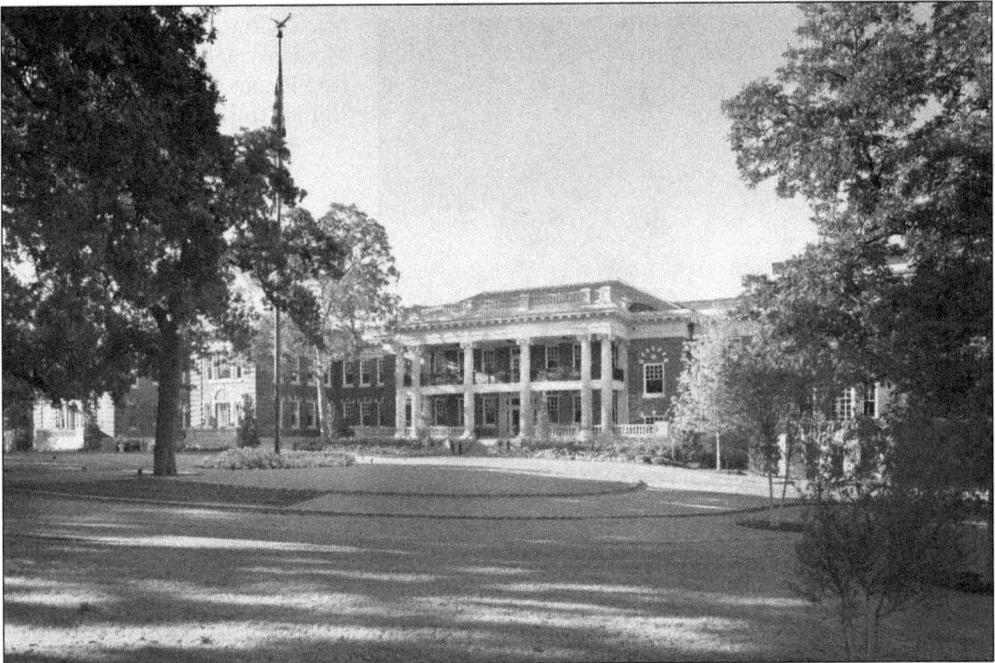

OLD PARKLAND CAMPUS. The classic architecture is surrounded by open spaces, porches, and an abundance of trees. Harlan Crow's father, real estate developer Trammell Crow, was often quoted as saying, "Trees are the answer." (OP.)

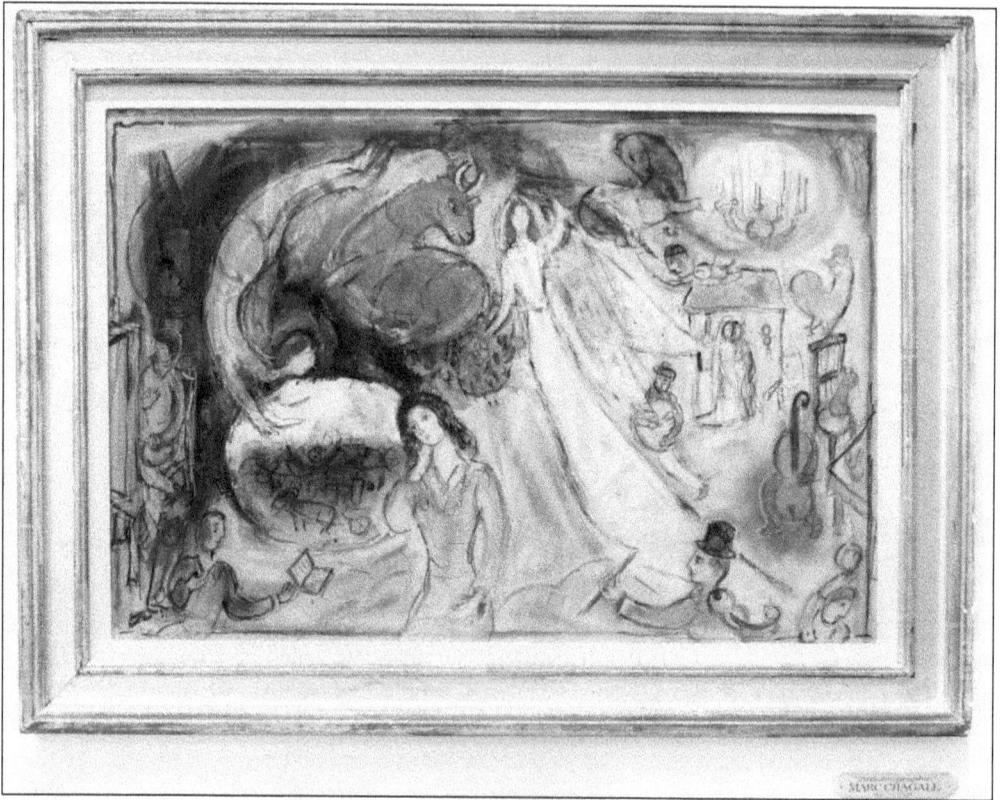

MARC CHAGALL PAINTING.
Museum-quality art is displayed
throughout the campus.
(Elizabeth Lavin, *D* Magazine.)

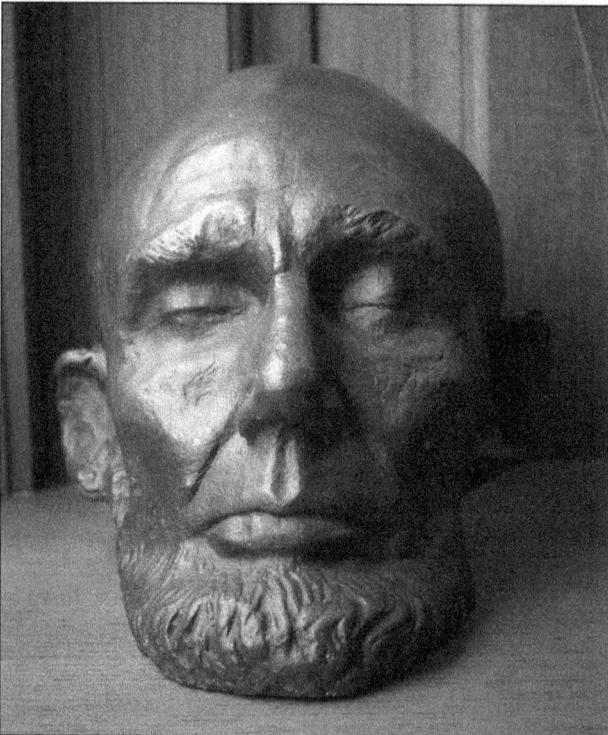

**PRES. ABRAHAM LINCOLN'S
"LIVING MASK."** Much of the
art and artifacts at Old Parkland
relates to the early history of the
United States and pays tribute to
the country's founding fathers.
(Elizabeth Lavin, *D* Magazine.)

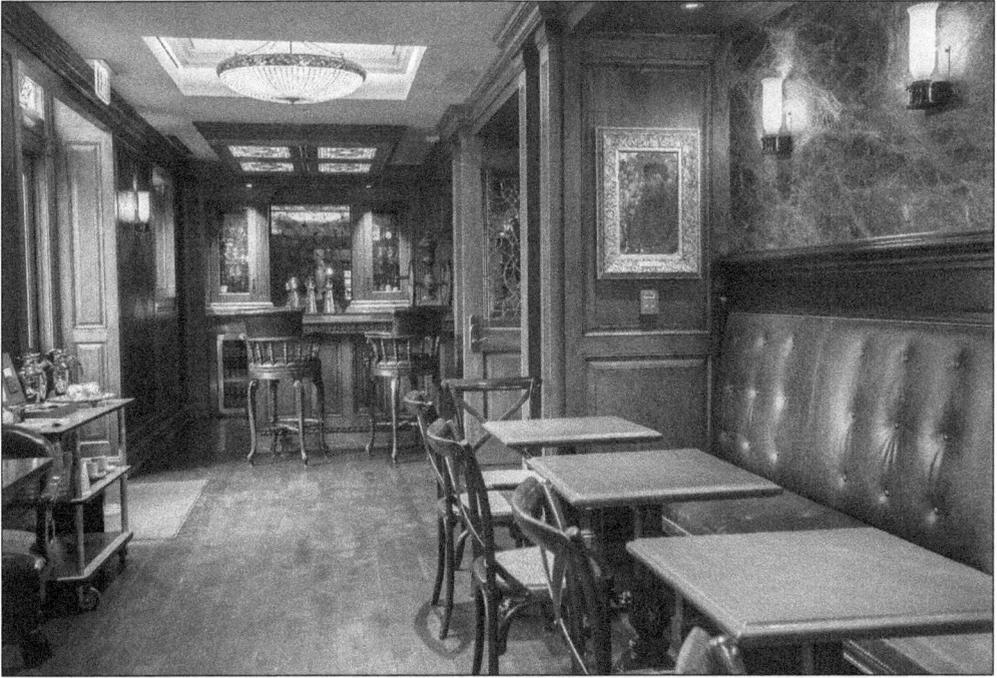

THE OLD PARKLAND CAMPUS TAVERN. Facilities at the restored Old Parkland include a tavern, a fitness facility, a barbershop, a jogging trail, restaurants, event spaces, and concierge services. (OP; photograph by Paul Go Images.)

THE PECAN ROOM. Pictured here is a session from the 2015 Old Parkland Debates; the winner that year was from Cambridge University. Future debates will be held in a 150-seat debate chamber in the Pavilion Building. (Steve Foxall.)

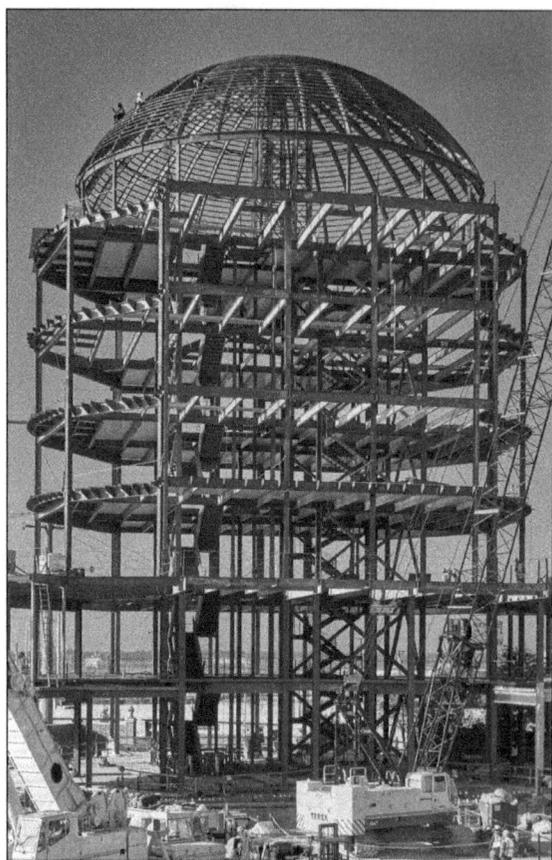

CONSTRUCTION ON THE WEST CAMPUS. Parkland Hall's dome became one of the landmark features of the West Campus. (OP; photograph by Mark Mathews.)

CONSTRUCTION NEARING COMPLETION, 2015. This image shows the construction of Oak Lawn Hall, Parkland Hall, Commonwealth Hall, and the Pavilion Buildings. (OP; photograph by Mark Mathews.)

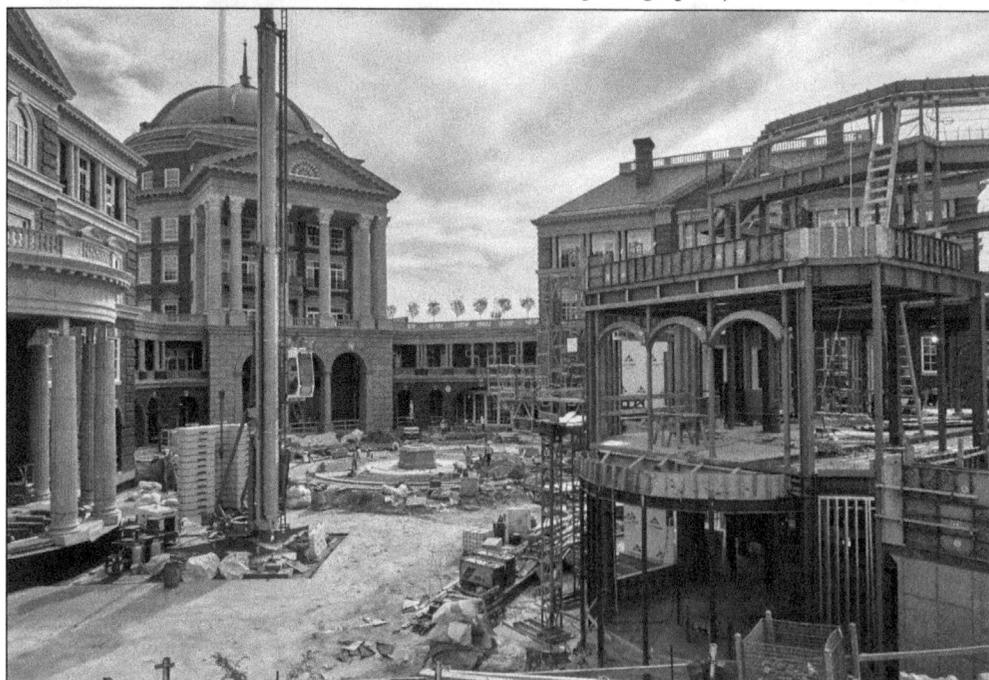

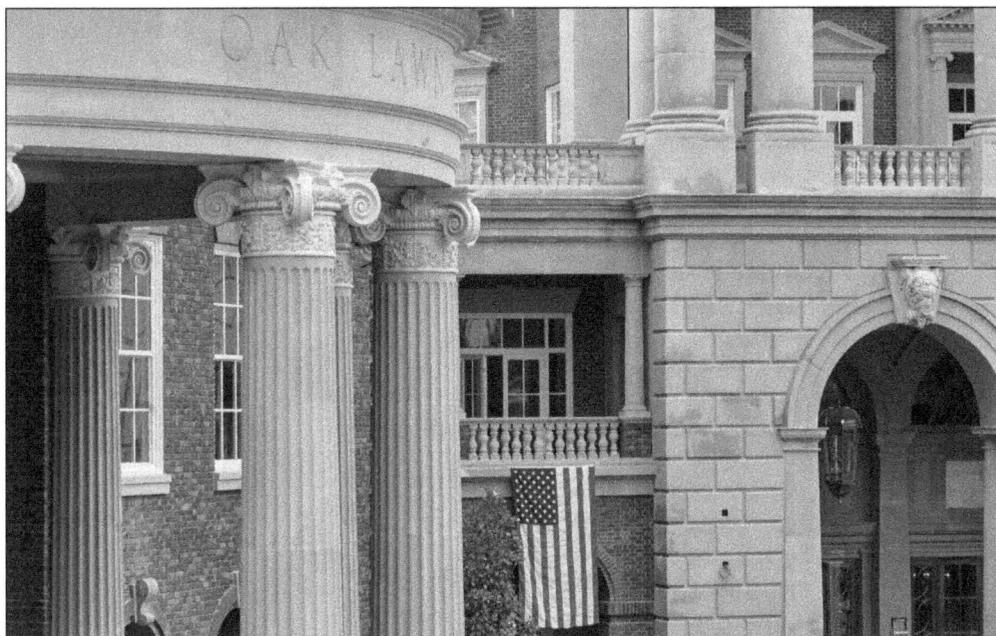

ARCHITECTURAL DETAIL. The architectural style at Old Parkland is described as Jeffersonian and American Classicism. (OP; photograph by Mark Mathews.)

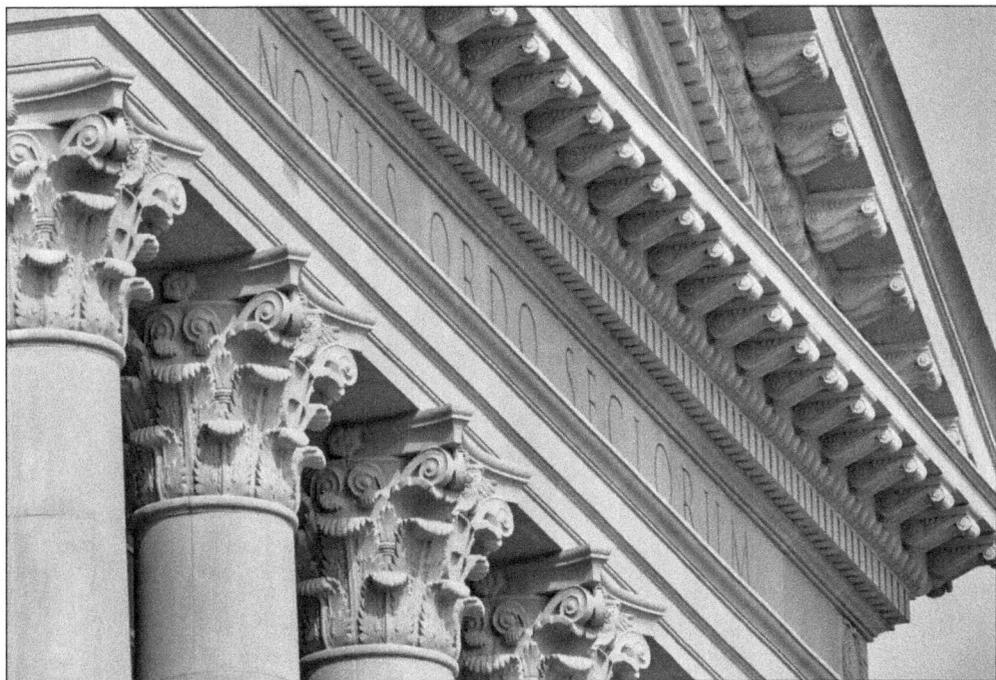

CORINTHIAN COLUMNS AT PARKLAND HALL. The frieze above the columns reads *Novus Ordo Seclorum*, a phrase which is also on the great seal of the United States. It means "New Order of the Ages" and has been printed on the reverse side of the dollar bill since 1935. (OP; photograph by Mark Mathews.)

OLD PARKLAND OAK LAWN ENTRY GATE. The cartouche above the entrance has a Texas State Seal and is engraved with "1894," the year that the first Parkland Hospital opened on this site. (OP; photograph by Mark Mathews.)

PARKLAND HALL AND THE WEST CAMPUS AT OLD PARKLAND. On the west campus of Old Parkland, Parkland Hall is a noticeable new landmark for the Oak Lawn neighborhood. (OP; photograph by Mark Mathews.)

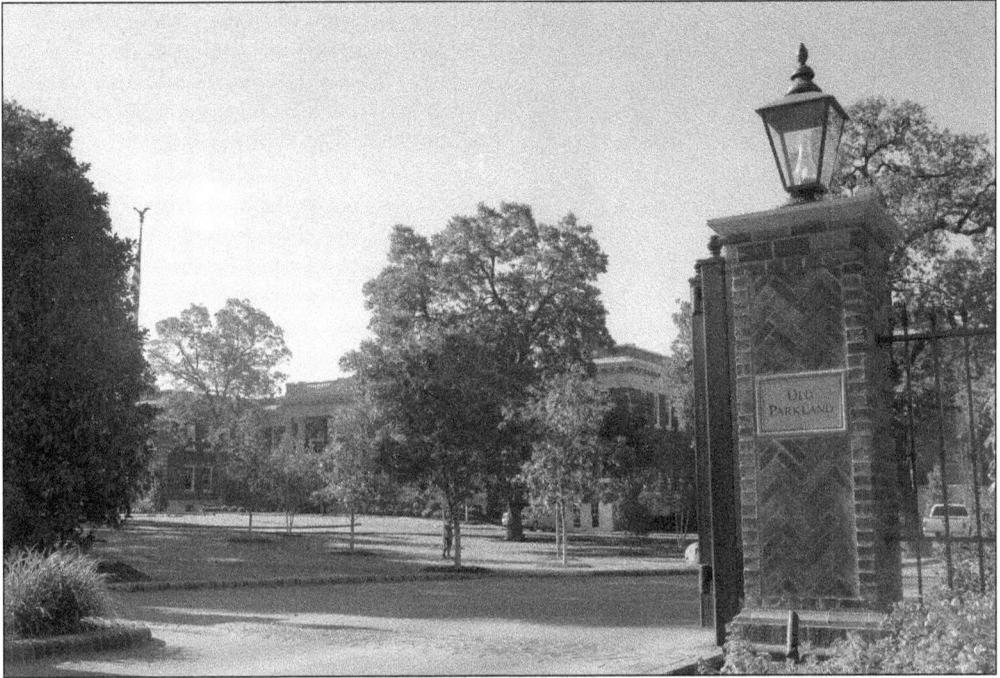

OLD PARKLAND ENTRANCE. The grounds at Parkland Hospital were always known for their trees, and many of the original trees remain in place. The walkways and sculptures among the grounds are reminiscent of the property's origins as a park. (OP.)

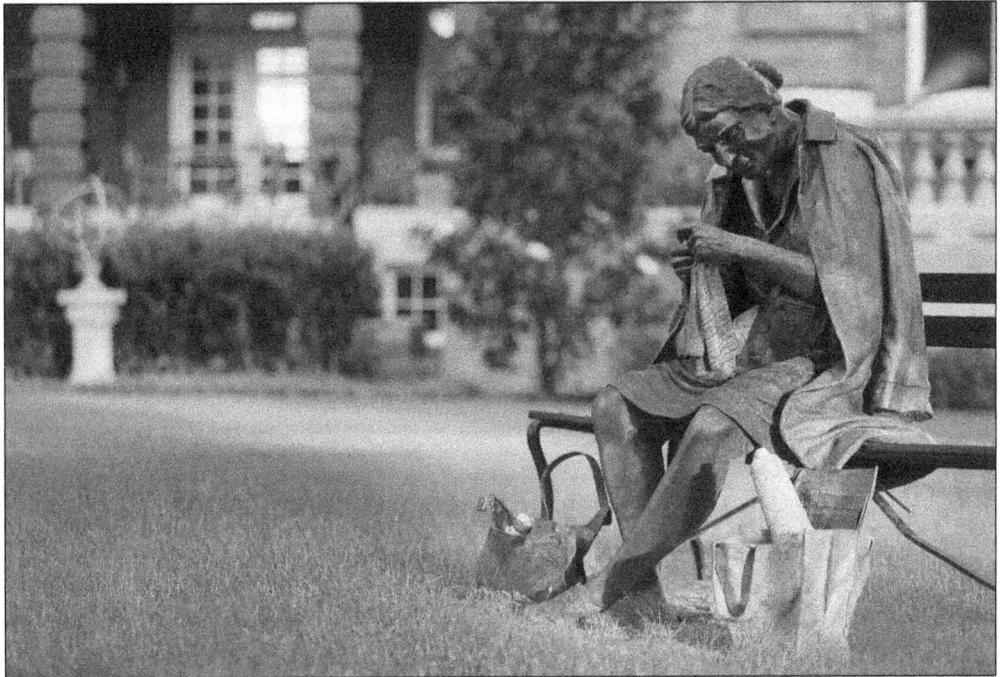

GETTING INVOLVED, BY J. SEWARD JOHNSON. Sculptures by Auguste Rodin, Chas Fagan, Zenos Frudakis, and others are situated throughout the Old Parkland campus's lawns and courtyards. (OP.)

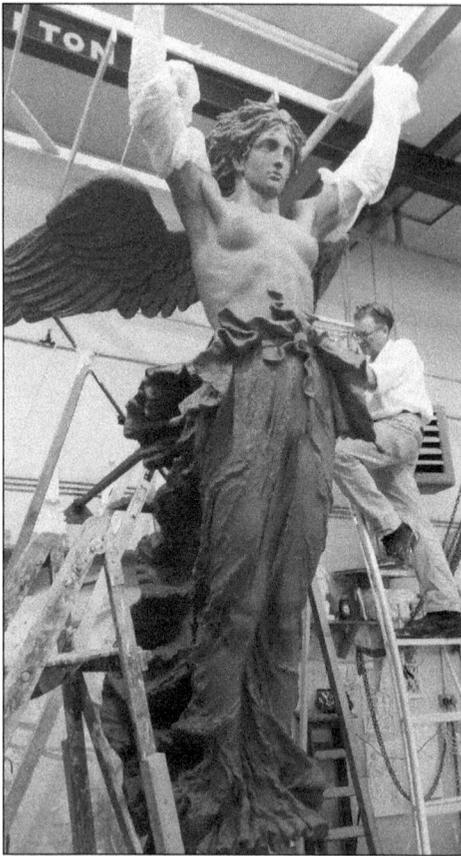

EOS, THE GODDESS OF DAWN. Alexander Stoddart (pictured) was commissioned to create a 45-foot-tall bronze column topped with this Eos sculpture. (OP; photograph by David Mitchell.)

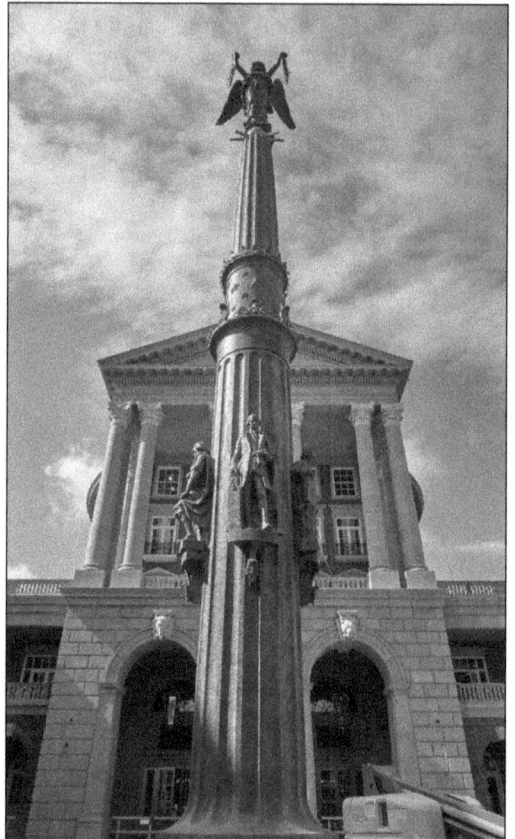

THE COMPLETED BRONZE COLUMN AND EOS SCULPTURE. The courtyard sculpture also depicts James Madison and Thomas Jefferson, two of the founding fathers of the United States, along with John Locke and Adam Smith, two of the most influential thinkers of the Enlightenment. At the top, Eos, the goddess of dawn, stands on a golden sphere representing the rising sun. (OP; photograph by Mark Mathews.)

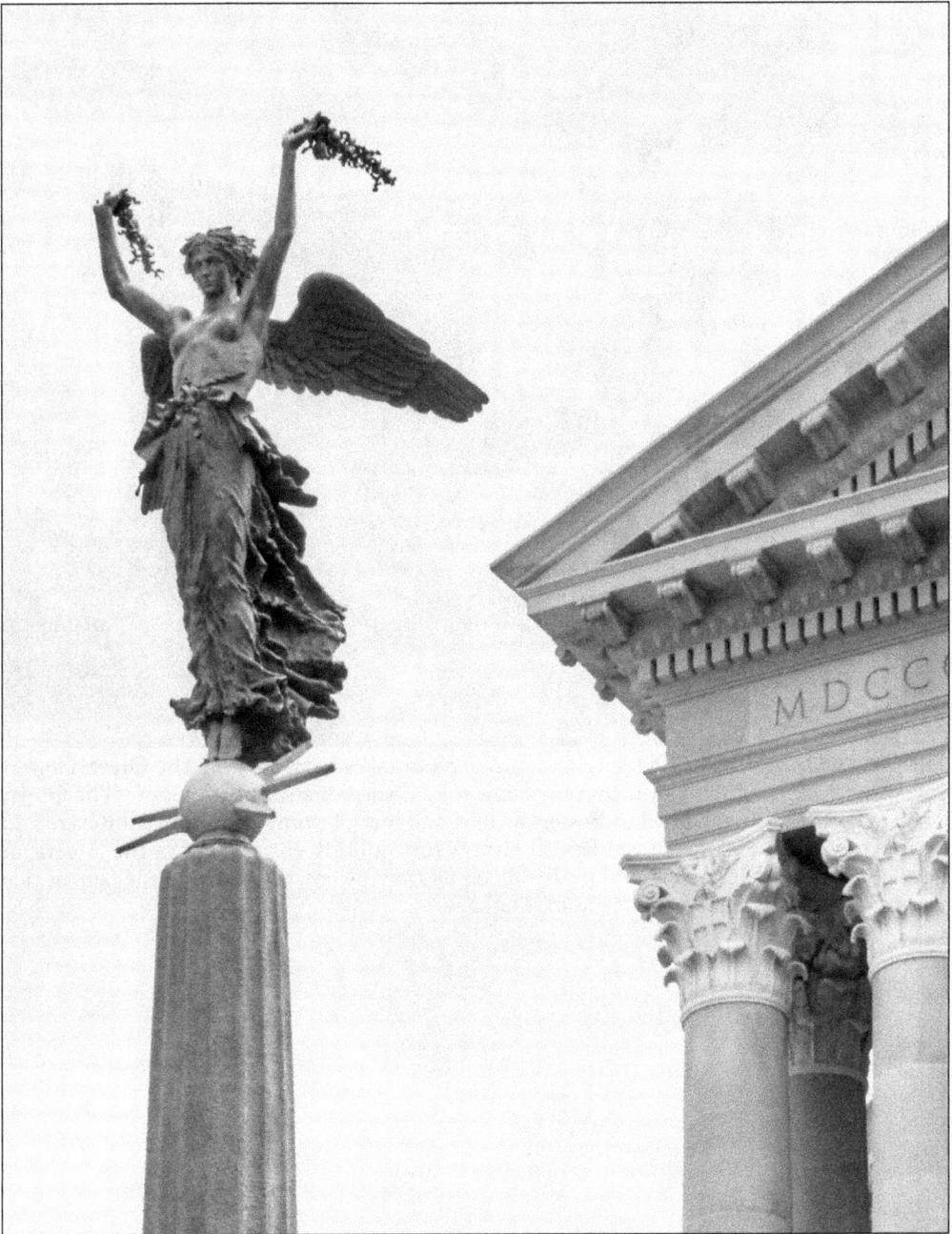

EOS WITH PARKLAND HALL IN BACKGROUND. The history of the United States is an important part of the Old Parkland campus, with the Eos sculpture serving as perhaps the most visually dramatic example. Speaking of the sculpture, Harlan Crow states, "Its monumental scale is such that it's pretty important as art and very important to me as a philosophical statement linking the American Republic to its intellectual grounding and the British and Scottish explosion of enlightenment." (OP; photograph by Mark Mathews.)

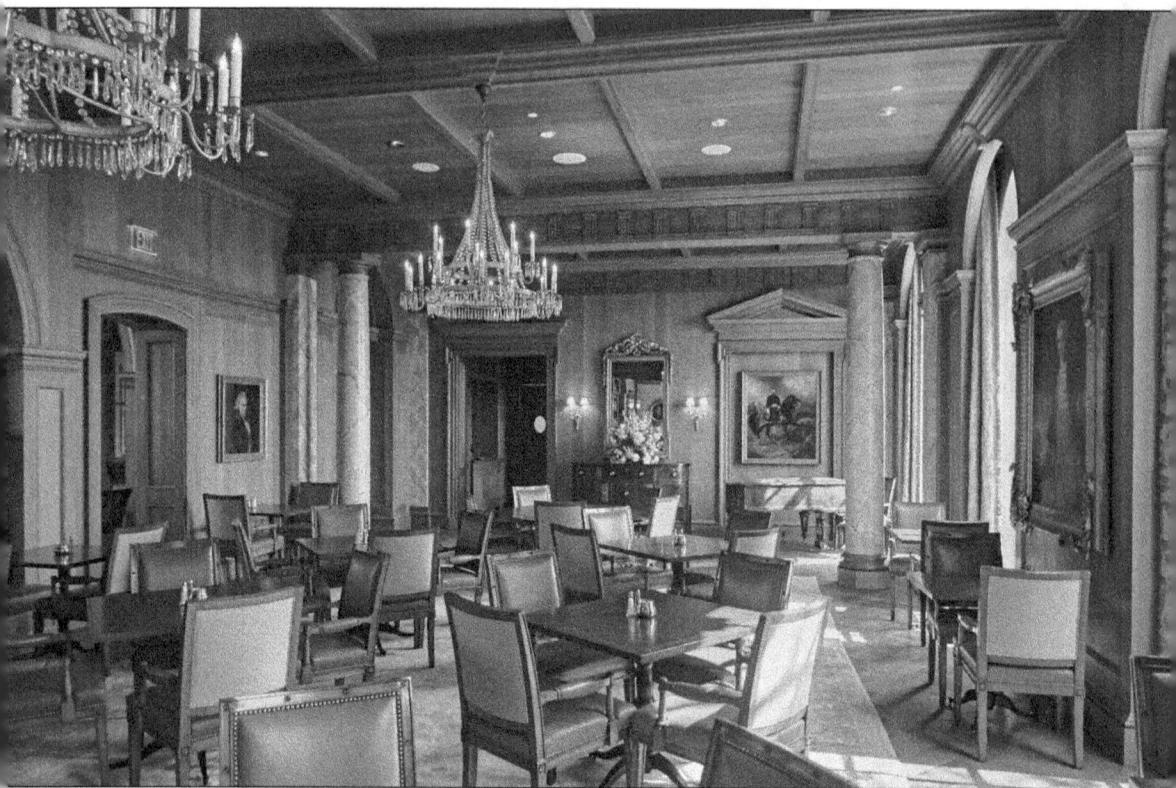

THE GREEN DRAGON. The Old Parkland dining room takes its name from the Green Dragon Tavern in Boston, which played an important role in the American Revolution. The Green Dragon Tavern was established in Boston in 1654 and was a favorite haunt of Paul Revere and John Hancock. The plans for the British Army's first military engagement of the American Revolutionary War were overheard in the Green Dragon Tavern, thus starting the famous ride of Paul Revere. (OP; photograph by Mark Mathews.)

GEORGE WASHINGTON SCULPTURE.
Many sculptures at Old Parkland depict
the nation's founding fathers. Here,
George Washington adorns the porch
leading into the Parkland Hall lobby.
Washington is flanked by two bronze
medallions representing the United
States' first official coin and a 1754
symbol that encouraged colonial unity.
(OP; photograph by Mark Mathews.)

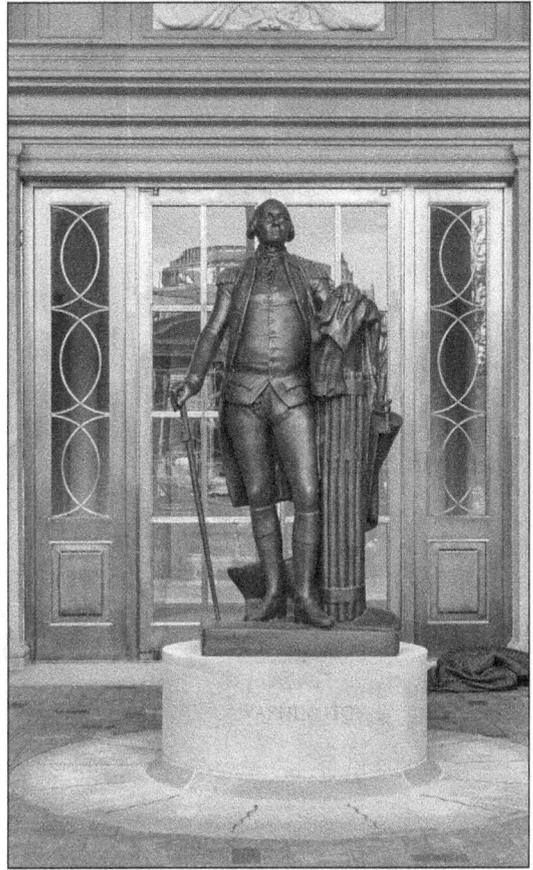

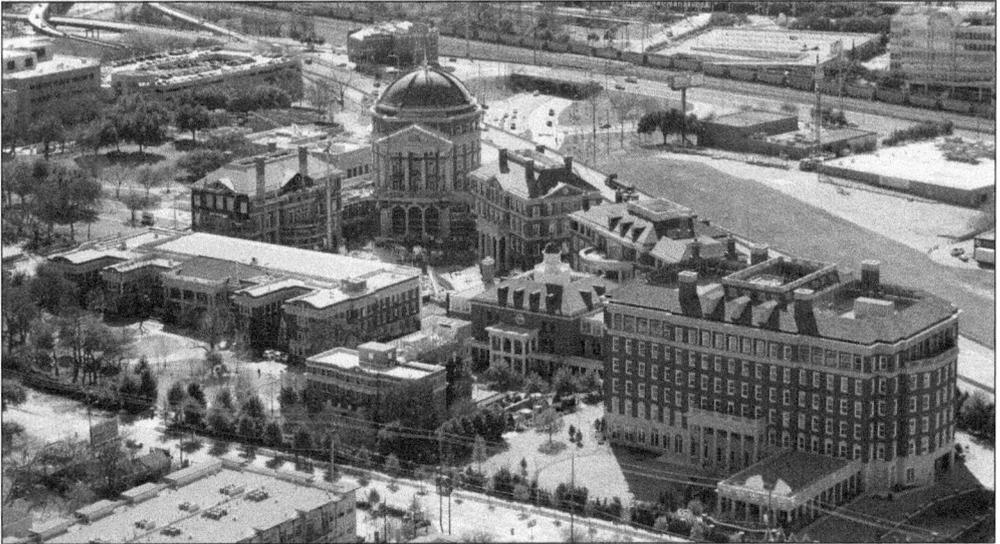

OLD PARKLAND, 2015. The 9.5-acre campus, a sanctuary with peaceful landscapes and productive
workspaces in the midst of urban chaos, makes an impressive architectural contribution to the
city of Dallas. The headquarters of the Southwestern Medical Foundation are currently housed
at Old Parkland. (OP; photograph by Jim Wilson.)

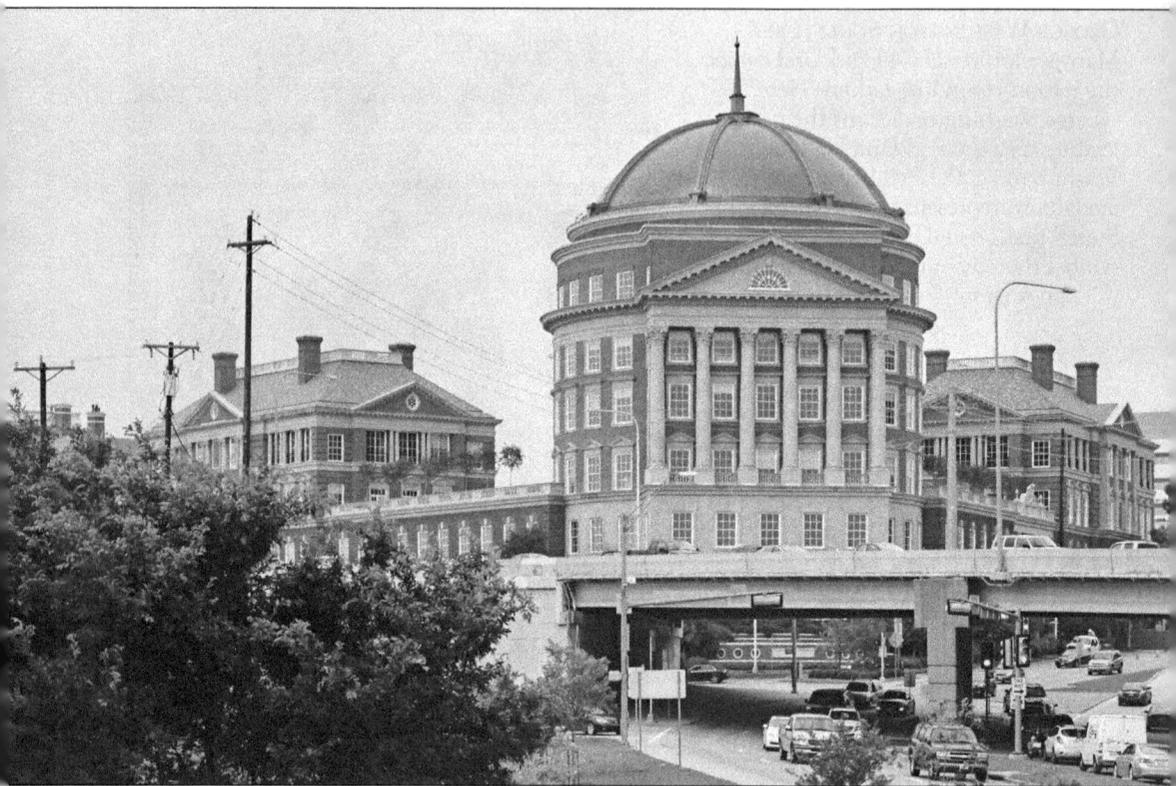

Parkland Hall and the Campus Facing Downtown Dallas. Reflecting on Old Parkland, owner/developer Harlan Crow stated, "When my father talked about churches and buildings at universities, he would say: 'When you approach the door of a place of worship or a place where you are going to educate our kids, you ought to stand up straight, your heart ought to be elevated, you ought to feel like this is a big deal.' I think our society has too many buildings where none of that enters your cosmos, psyche, or soul." Crow's Old Parkland campus will be in the psyche and soul of Dallas for generations to come. (OP; photograph by Mark Mathews.)

Six

The Medical Center Looks to the Future

By 2010, Parkland Hospital began facing a recurrent problem. As in 1913 and 1954, what was once a new, state-of-the-art hospital was becoming aged. When patients moved into Parkland Memorial Hospital in 1954, MRIs and CT scans did not exist, laparoscopic surgery was unheard of, there was no cardiac cath lab or GI lab, and many of today's medical specialties did not yet exist. Although near-constant remodeling and additions kept the hospital's structure current, the time had come for a new state-of-the-art facility.

Voters again approved a bond, and plans were drawn up, with construction commencing in 2010. The five-year project concluded with patients moving into New Parkland on August 20, 2015. Funding for the $1.3-billion facility was provided through public and private sources, with the Parkland Foundation contributing $150 million—an impressive charitable sum for a public county hospital. New Parkland will have 862 beds, and the 1954 Parkland Memorial Hospital building will shutter most of its patient services. Parkland owns and runs 20 other facilities and clinics, which will remain open. The new hospital's official name is Parkland Health and Hospital System, but it is commonly referred to as "New Parkland."

UT Southwestern Medical Center also completed a major hospital project in 2014—the William P. Clements Jr. University Hospital, which replaced another outdated facility, the 1963 St. Paul Hospital. Originally called St. Paul's Sanatorium, it helped usher Dallas into the modern medical age when it opened in 1898.

Today, it is possible to view the 1913 Old Parkland, the 1954 Parkland Memorial Hospital, the abandoned 1963 St. Paul Hospital, the 2014 Clements Hospital, and the 2015 New Parkland from a vantage point on the top floors of the research buildings on UT Southwestern Medical Center's north campus.

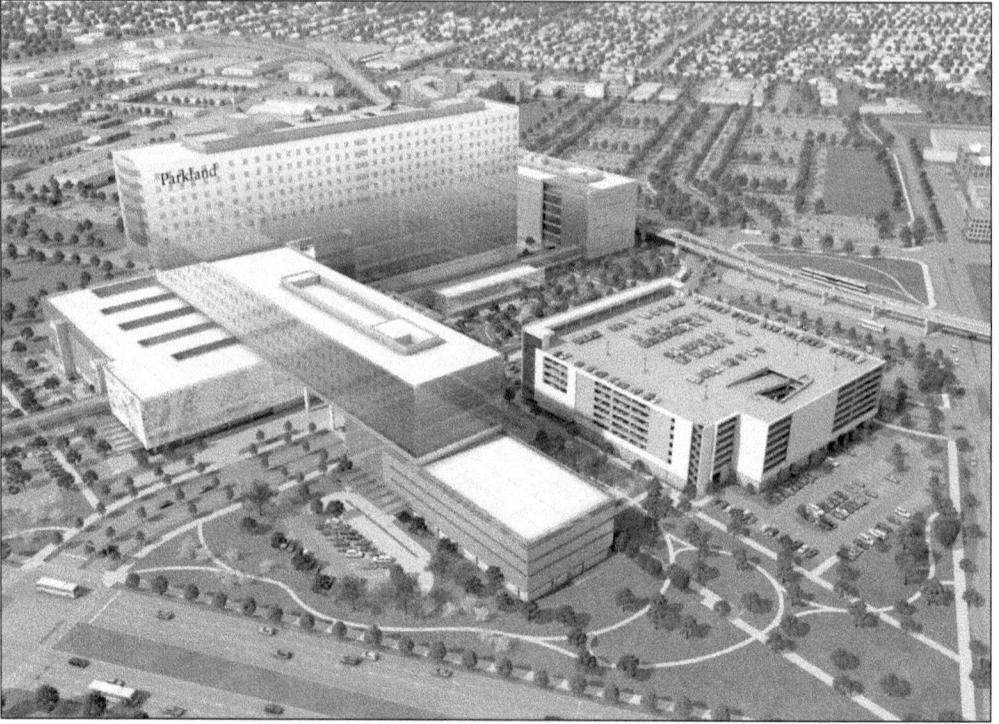

CONCEPT DRAWING FOR NEW PARKLAND. An HDR and Corgan joint venture developed the master plan for the New Parkland design. Construction was managed by the BARA Team (Balfour Beatty Construction, Austin Commercial, H.J. Russell & Company, and Azteca Enterprises). (PH.)

CONSTRUCTION WORKER. Construction began on New Parkland in October 2010. The 1954 Parkland Memorial Hospital and its more recent additions are visible in the background. (PH.)

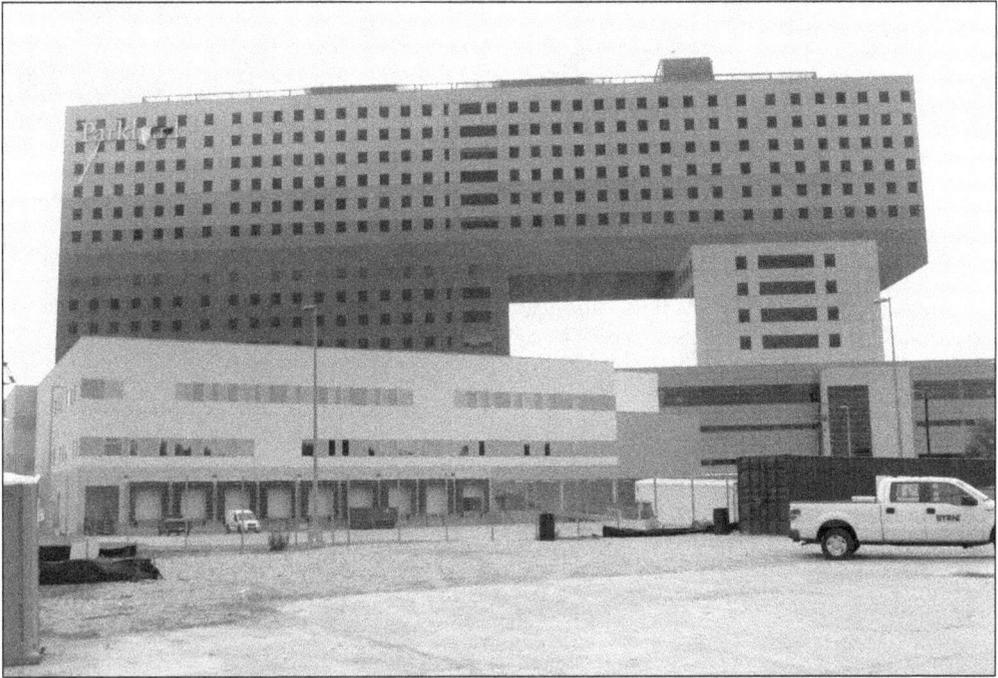

NEW PARKLAND SIGN. In this early 2015 photograph, the New Parkland logo is partially unveiled. The building's design features two sections cantilevered atop each other. (JWB.)

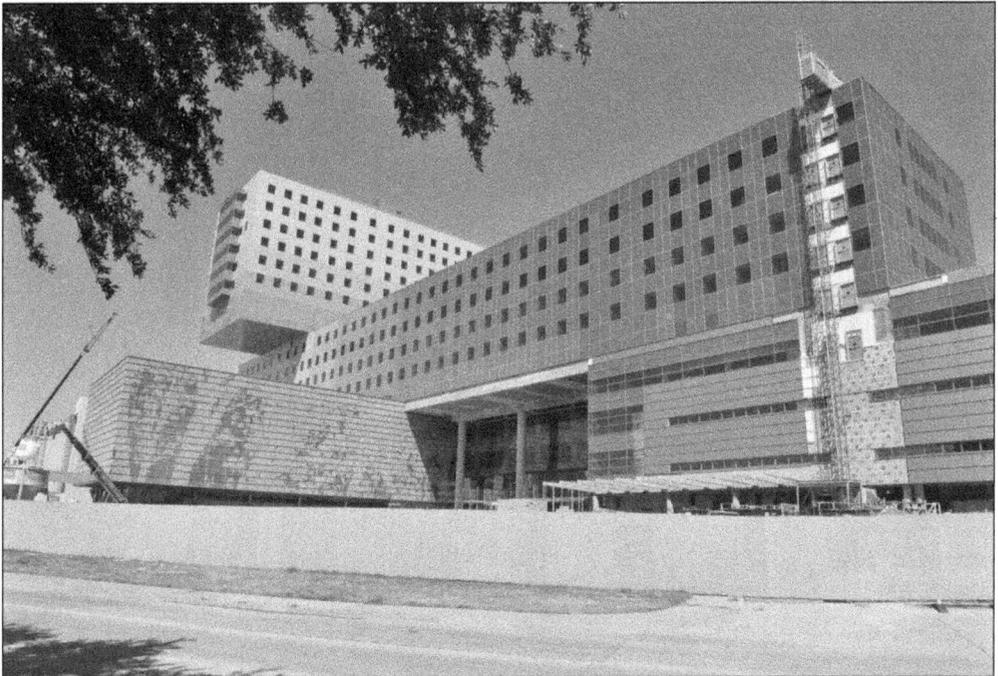

CONSTRUCTION FACING HARRY HINES BOULEVARD. The new hospital is about twice the size of the 1954 Parkland Memorial Hospital. Parkland will continue to serve as a teaching hospital for the UT Southwestern Medical Center. (PH.)

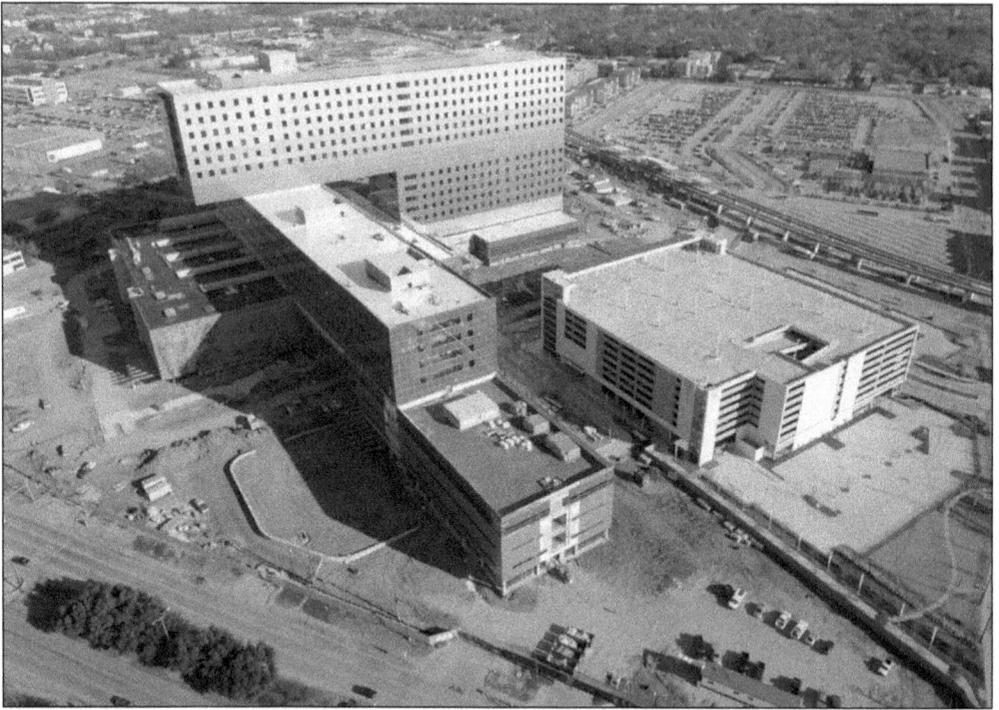

AERIAL VIEW OF CONSTRUCTION NEARING COMPLETION, 2015. At the time, New Parkland was the largest hospital construction project in the United States. (PH.)

PROXIMITY TO UT SOUTHWESTERN MEDICAL CENTER. Although Harry Hines Boulevard is a busy thoroughfare with six-plus lanes, New Parkland is literally across the street from the 1954 Parkland Memorial Hospital and UT Southwestern Medical Center. (JWB.)

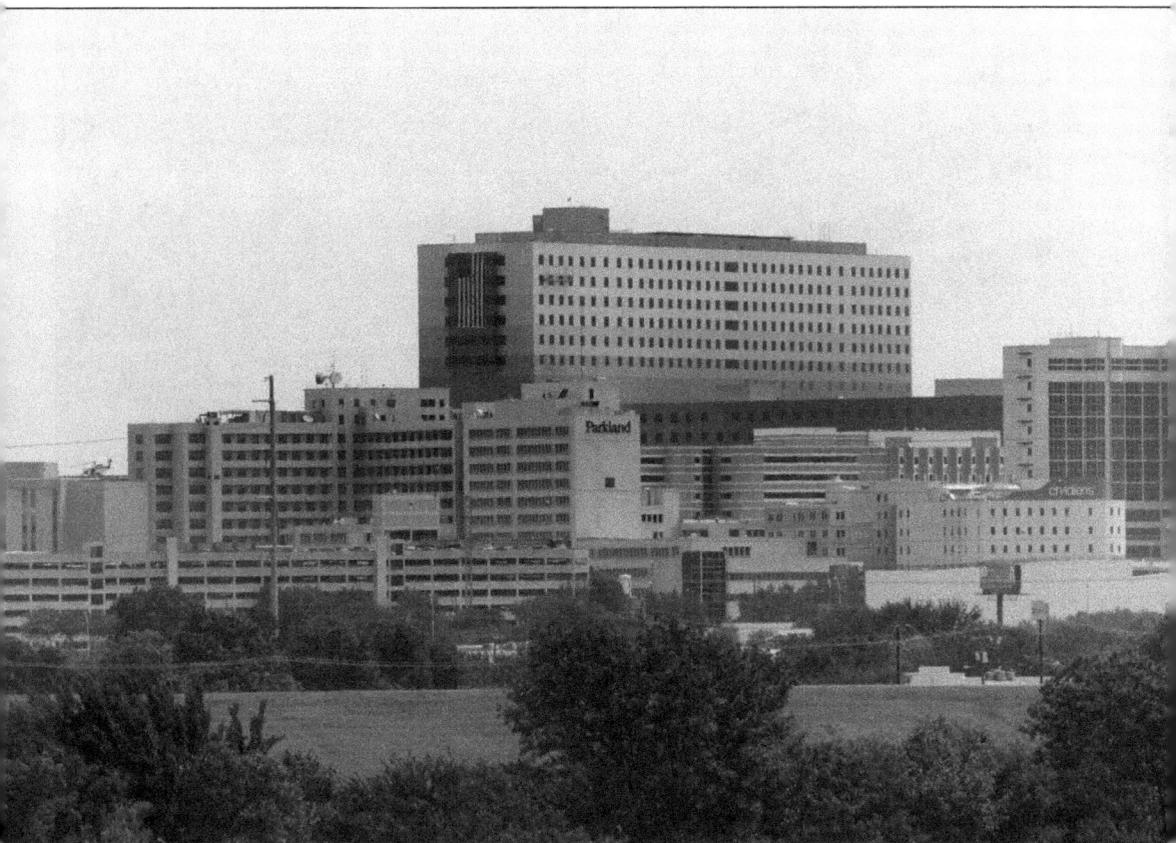

NEW PARKLAND BEHIND THE 1954 PARKLAND. The new, 17-floor hospital dwarfs the prior Parkland in the foreground. To the right is the Children's Medical Center, also a UT Southwestern Medical Center–affiliated hospital. (PH.)

THE SKYBRIDGE. This walkway spans Harry Hines Boulevard and links New Parkland with the existing medical center. (JWB.)

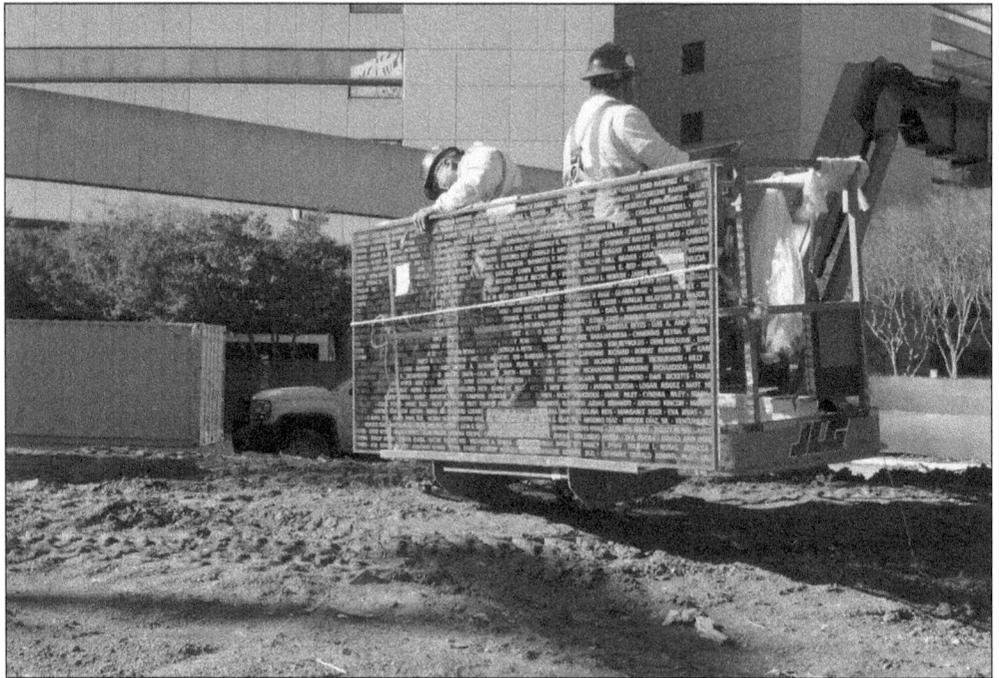

CONSTRUCTION OVER HARRY HINES BOULEVARD. Workers installed glass panels to complete the skybridge. (JWB.)

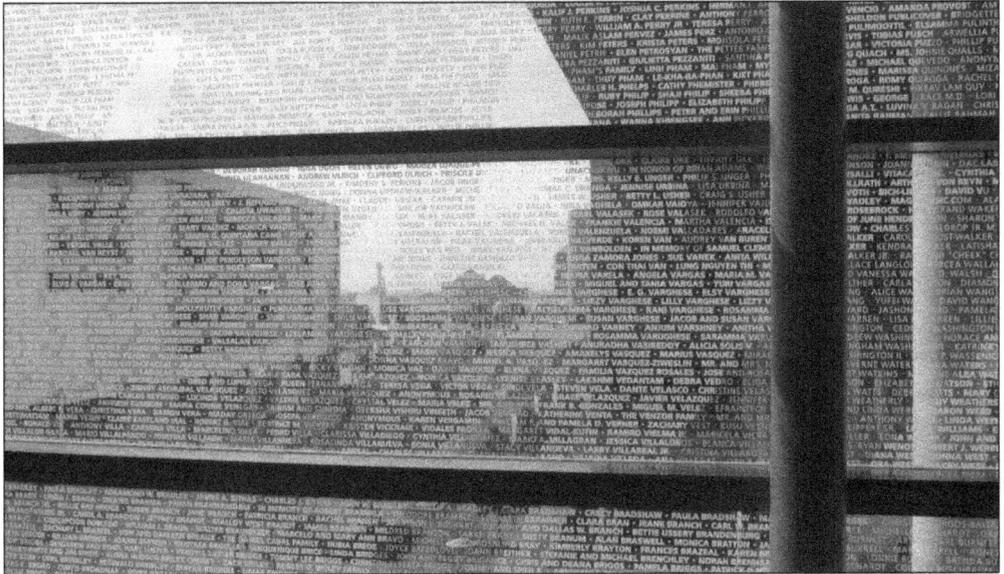

ETCHED GLASS PANELS. The glass panels for many parts of New Parkland contain the etched names of thousands of contributors whose $150 million in donations helped make construction possible. (JWB.)

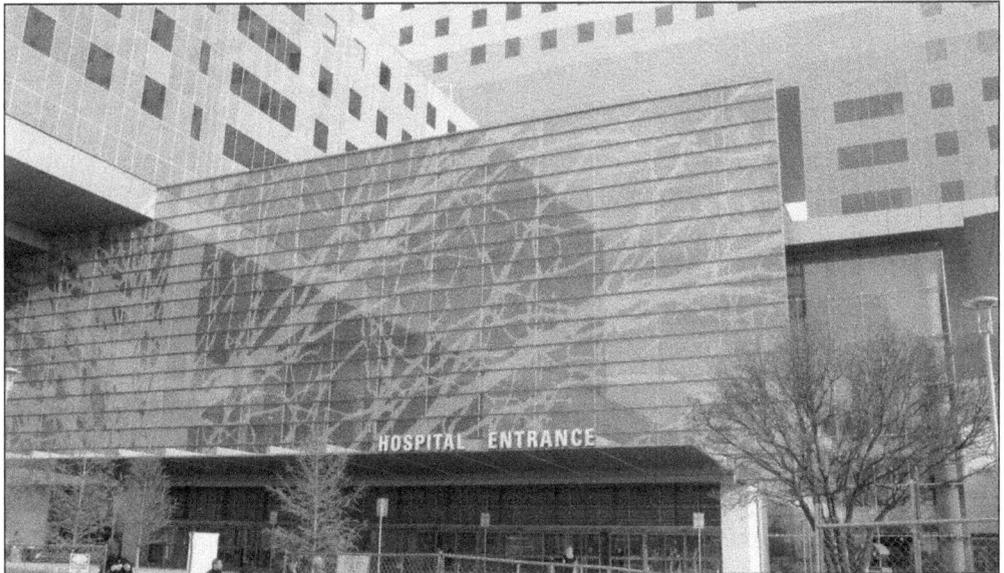

NEW PARKLAND ENTRANCE. The glass entrance is also etched with names of contributors; these names are designed to resemble tree branches from a distance. The tree theme is a reminder that the original Parkland was located in a former park shaded by trees. (JWB.)

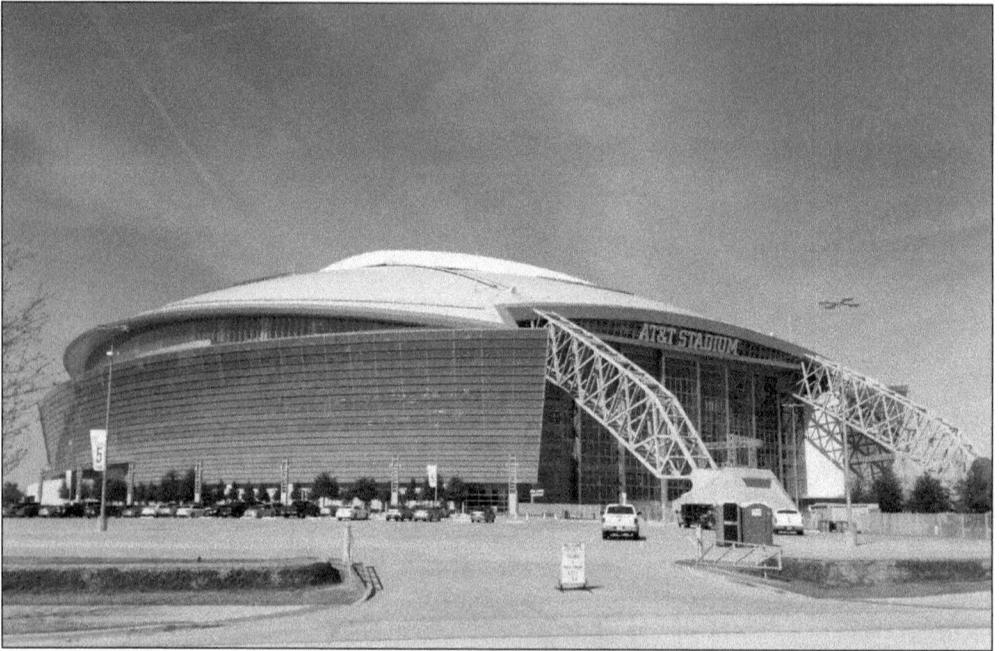

DALLAS COWBOYS FOOTBALL STADIUM. Here are a few comparisons between New Parkland and another recent, large Dallas-area construction project. (JWB.)

	New Parkland	Dallas Cowboys Stadium
Size (million square feet)	2.7	3
Acres	64	73
Height (feet)	300	292
Capacity	862 beds	80,000 seats
Cost	$1.3 billion	$1.2 billion

NEW PARKLAND AND THE DALLAS SKYLINE. New Parkland has two helicopter pads, a 13,000-square-foot kitchen, check-in kiosks similar to those at airports, and a 141,000-square-foot imaging center. A high-security wing houses a jail, separate from the public areas, where Parkland treats inmates from Dallas County jails. (JWB.)

THE MAIN LOBBY. New Parkland opened to the public for the first time on April 11, 2015, when people were allowed to tour the new space. The new Parkland Hospital formally opened on August 20, 2015. (JWB.)

DR. RON ANDERSON, MD. Prior to the opening of the new hospital, a statue of Dr. Ron Anderson, MD, was dedicated in the foyer of New Parkland on August 14, 2015. The late Dr. Anderson served as CEO of Parkland Hospital from 1982 until 2011. He is often remembered as a champion for improving healthcare for the needy and medically underserved. (PH.)

HALLWAY AT NEW PARKLAND. New Parkland has 862 private rooms with high-tech windows that allow for natural light. Seven miles of pneumatic tubes send items traveling around the hospital at 60 miles per hour; the tubes are used, along with pharmacy robots, to dispense and deliver medical specimens and medications. (JWB.)

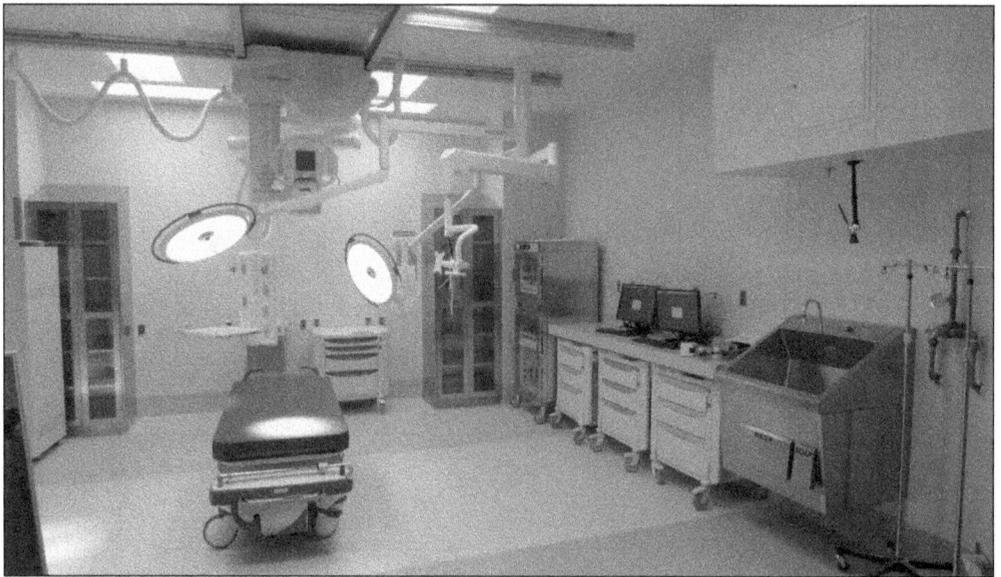

MAJOR TRAUMA ROOM. The emergency room features 120 treatment rooms. This is the updated, 2015 version of the famous 1963 Parkland Memorial Hospital Trauma Room One. (JWB.)

LABOR AND DELIVERY. The 48 high-tech, modern delivery rooms permit mother, baby, and family with a comfortable space featuring high-tech communication. Nearby, 96 neonatal intensive-care rooms increase capacity fivefold from the prior facility. (JWB.)

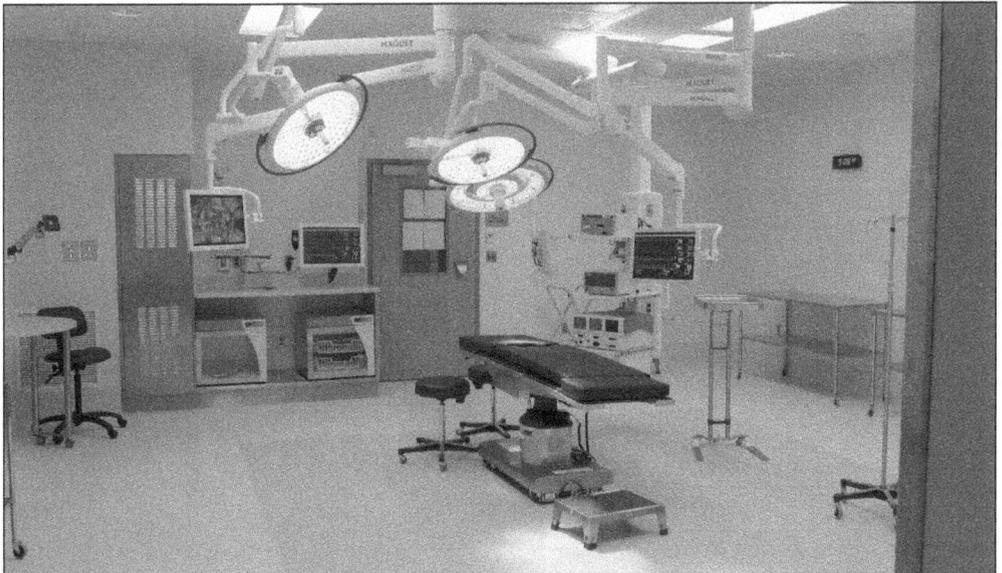

OPERATING ROOM SUITE. The 27 operating rooms are nearly double the size of the ones at the 1954 Parkland. With the touch of a button, surgical teams can view X-ray and CT scan images. (JWB.)

Nurses' Station Awaits Opening Day. In addition to a traditional central nurses' station, New Parkland will have a nurses' workstation outside of every patient room. (JWB.)

One of Two Chapel/Meditation Rooms. Several features, including this stained-glass window, were transplanted from the 1954 hospital. (JWB.)

NEW PARKLAND LANDSCAPING. One of the original concepts by the design team involved creating a hospital within a park, much like the original 1894 Parkland Hospital. (JWB.)

GARDENS ON NEW PARKLAND GROUNDS. New Parkland has a Wellness Garden and a planned John F. Kennedy Memorial Garden surrounding the hospital. (JWB.)

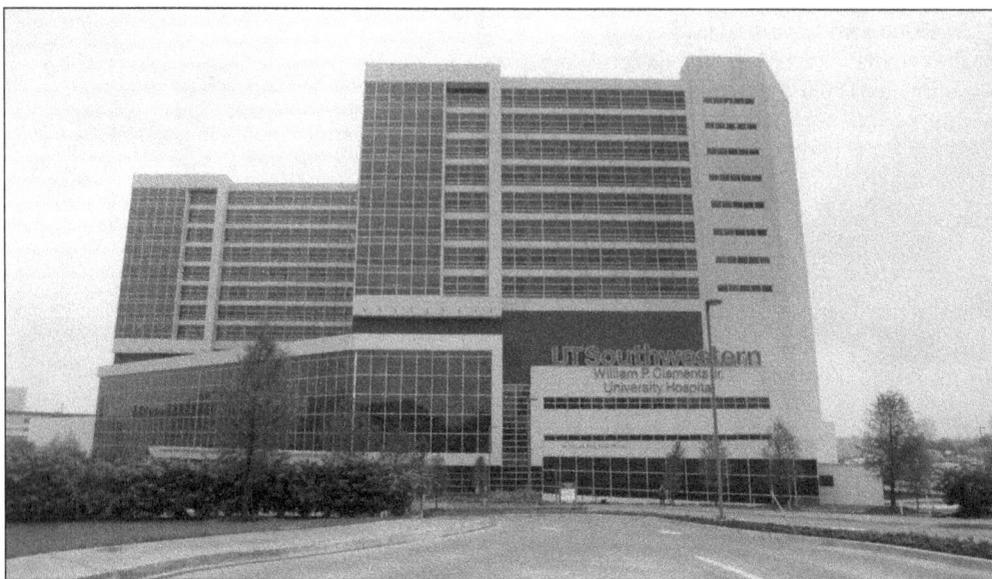

WILLIAM P. CLEMENTS JR. UNIVERSITY HOSPITAL. Clements, the former governor of Texas, made the single largest contribution to UT Southwestern—$100 million. The medical center's 460-bed, $800-million, 12-floor teaching hospital opened on December 6, 2014, with the transfer of 200 patients from St. Paul's Hospital. Clements Hospital also features 35,000 square feet dedicated to research and education. (JWB.)

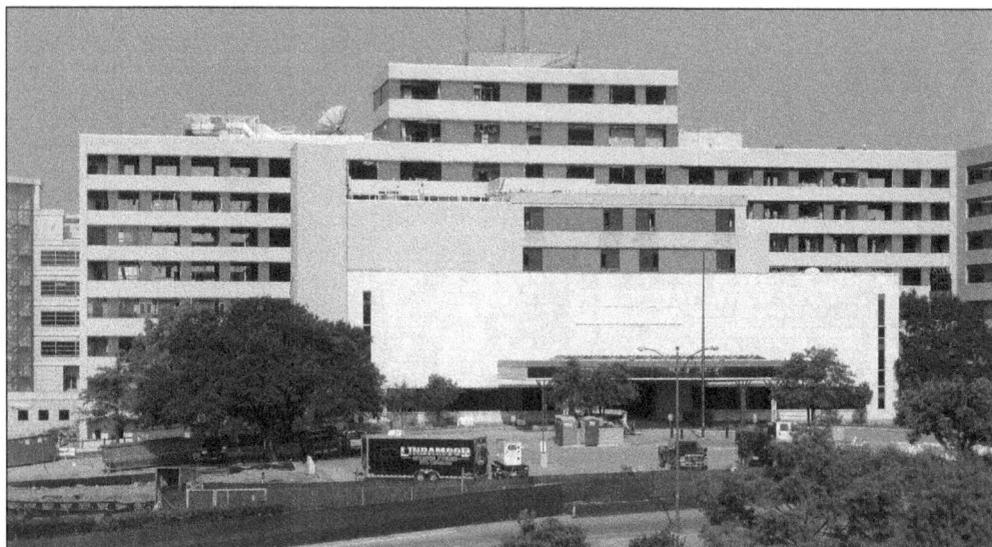

OLD ST. PAUL'S HOSPITAL. St Paul's was an important part of Dallas medical history from 1898 until 2014. In July 2015, demolition began on the shuttered and fenced-in 1963 St. Paul's Hospital. (JWB.)

Dr. Donald W. Seldin Plaza.
Dr. Donald Seldin arrived at
Southwestern Medical School
in 1951, while the school was
housed in temporary, decaying
plywood barracks on Oak Lawn
Avenue. He became one of the
most distinguished educators in
the history of internal medicine
and the intellectual father of
UT Southwestern. On March
16, 2015, Dr. Seldin was honored
with the dedication of this statue
sculpted by Zenos Frudakis.
The sculpture features Seldin
at the chalkboard during one
of his famous lectures. Situated
at the entrance to the medical
school, the statue will greet
incoming generations of future
medical students. (JWB.)

New Parkland Opens. The first
of approximately 600 patients
traveled across the skybridge
to the new Parkland Hospital
beginning on the morning of
Thursday, August 20, 2015. (JWB.)

Visit us at
arcadiapublishing.com

www.ingramcontent.com/pod-product-compliance
Lightning Source LLC
Chambersburg PA
CBHW050713110426
42813CB00007B/2173